S. Tschudi Madsen

Art Nouveau

Translated from the Norwegian by
R.I. Christopherson

World University Library

McGraw-Hill Book Company
New York Toronto

To Ambrosia

© S. Tschudi Madsen 1967
Translation © George Weidenfeld and Nicolson Limited 1967
Reprinted September 1970
Library of Congress Catalog Card Number: 66-24159
Phototypeset by BAS Printers Limited, Wallop, Hampshire, England
Manufactured by LIBREX, Milan, Italy

Contents

Re-read

1 Introduction

The period at the turn of the century, now distant enough in time to be considered in its true perspective, has long furnished a fruitful field of study for the art historian. Surprisingly enough, however, a full understanding of the architecture and applied art of this period has always lagged noticeably behind the interest shown in its literature, painting, and sculpture. A broader understanding of the applied art of the period, its problems and stylistic expression – in short, of Art Nouveau – belongs only to the years after the Second World War. One of the reasons for this is that in the 1920s and 1930s, though highly esteemed by certain of the *avant-garde* such as the Bauhaus group, the Art Nouveau movement was generally regarded as one of the many 'unsuccessful' stylistic phenomena of the nineteenth century. Another is that during the 1930s, with their hostility to ornamentation, it was looked upon as essentially an ornamental and external style. There were probably many people who sympathised with the householder in Granada who fixed a plaque to his Art-Nouveau-façade, bearing the legend: '*De esta fachada no es responsable el actual propietario.*' ('This façade is not the responsibility of the present owner.')

As a general rule it is true to say that the artifacts of one generation appear old-fashioned to the next. This applies even more when the products concerned are notably influenced by the trends of fashion. However, when they belong to the generation of one's grandparents, they immediately acquire a certain interest, especially if the standard of craftsmanship is high. Confronted with the artefacts of our great-grandparents, we feel we are on much safer ground in assessing their value: jewels have by now become family heirlooms, and pieces of furniture have acquired the status of antiques. The objects of the Art Nouveau period, however, have already reached this stage, long before the usual lapse of time.

This is in part due to the attraction which the high standard of craftsmanship of this period holds for us today, and partly because the very nature of Art Nouveau gave it at an early stage the appearance of a typical *style*, on a par with the independent expressions of previous periods. Apart from the purely artistic

7

1·1 Darvall: Screen for Upton Chapel,
Christ Church, Kennington Road, London,
1959. The last two decades have seen
a revival of interest in the decorative
play of Art Nouveau, especially among
architects and designers.

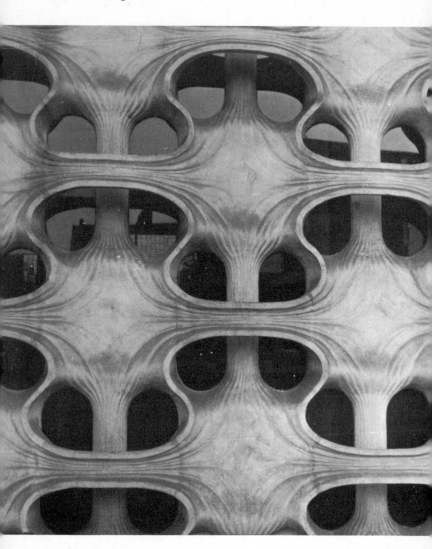

qualities of the style, which likewise appeal to our generation, there is possibly a more profound reason why we today should be in a position to appreciate it.

To a certain extent the Art Nouveau movement contained a compromise, a dualism: for ordinary everyday purposes its exponents thought and acted practically, without establishing a really far-reaching link with the aesthetic theories of their age. Theories remained locked up in the ivory tower. The intense interest which is shown today in the Art Nouveau period may, in fact, be due to our recognition of a similar dualism which existed then: between the weighty pressure of the materialistic and the technical development on the one hand, and, on the other, the artist's aesthetic approach and escape into trends whose problems are the concern only of the elect. Today's technical development may well fill us with astonishment and fear, and it is easy to identify ourselves with the idealistic Art Nouveau artists who with their aesthetic refinement found themselves in opposition to a similar development. There is also another factor that might explain our present admiration for and interest in the Art Nouveau style, which above all cultivated applied art, equating this genre with the pictorial arts. A similar development, as we know, has taken place since the Second World War: decorative art has achieved a level which calls for an appreciation on the artistic plane, while painting and sculpture have often cultivated the decorative potentialities of abstraction, precisely as under Art Nouveau. Architecture, painting, sculpture, and decorative art are now fused once again along lines similar to those of Art Nouveau.

There is certainly no denying the present interest in Art Nouveau. It is most evident in architecture, not only in the architectural ornamental idea in itself, and the more or less Art Nouveau-like decorations (figure 1.1), but equally in the asymmetrical and markedly plastic treatment of the mass of the building, as practised for instance by Gaudí at the turn of the century.

At the same time it is not surprising that people were long puzzled by the phenomenon of Art Nouveau. The term 'function' alone

gives some idea of the gulf separating the views on applied art and architecture. In the latter half of the nineteenth century function was expressed in decoration; in the first half of the twentieth century it was expressed through construction. Art Nouveau occupies historically an intermediate position between the two: the decoration is a symbol of function.

It was in Germany that art historians first turned their attention to the Art Nouveau style, turning first to the German version of it, *Jugendstil*. In 1925 Ernst Michalski published *Die Entwicklungsgeschichtliche Bedeutung des Jugendstils*, which was followed in 1934 by Fritz Schmalenbach's *Jugendstil, Ein Beitrag zur Theorie und Geschichte der Flächenkunst*, and in 1941 by Friedrich Ahlers-Hestermann's *Stilwende. Aufbruch der Jugend um 1900*. It is interesting to note however that as early as 1929 the versatile Spaniard Salvador Dali considered 'the delirious architecture of the Modern Style [i.e. Art Nouveau] as 'the most original and the most extraordinary phenomenon in the history of art.'[1]

With the publication in 1936 of Nikolaus Pevsner's *Pioneers of the Modern Movement* (new editions, *Pioneers of Modern Design*, 1949, 1960 and 1964), this phenomenon was placed in its international context, a process which was continued by Henry Hope's important but unpublished work on the sources of Art Nouveau. After the war came the first big exhibitions: Hans Curjel's in the Zurich Museum of Applied Art, *Um 1900. Art Nouveau und Jugendstil*, and Peter Floud's *Victorian and Edwardian Decorative Arts* in the Victoria and Albert Museum, London, both in 1952 and both with catalogues that were instructive in their different ways.

These were followed by a whole series of major and minor exhibitions, both national and international. Among the most important – each one also resulting in important publications – were the exhibition in the Museum of Modern Art, New York, with its publication *Art Nouveau Art and Design at the Turn of the Century* and the exhibition in Munich, with its catalogue *Aufbruch zur modernen Kunst*, both in 1958; and finally the exhibition in Paris in 1960–1, with its catalogue *Les Sources du XXe Siècle*,

which formed the basis for *The Sources of Modern Art* by J. Cassou, E.Langui and N.Pevsner, published in 1962. Mention should also be made of *Sezession – Europäische Kunst um die Jahrhundertwende*, published in Munich in 1964, and *Wien um 1900*, published in Vienna in the same year.

In the 1950s exhibitions were arranged of the work of the more outstanding artists of the period – of Henry van de Velde's work in Zurich, of Gaudí's and Tiffany's in New York and of Sullivan's in Chicago. In 1958 came Henry-Russell Hitchcock's *Architecture: Nineteenth and Twentieth Centuries*, the first serious study of Art Nouveau architecture. The work of Mackintosh was traced in an excellent monograph by Thomas Howarth, *Charles Rennie Mackintosh and the Modern Movement*, 1952. In 1956, in his *Sources of Art Nouveau*, the present author investigated the precursors and formal background of the style, while Renato de Fusco examined the Italian version of this style in *Il floreale a Napoli*, 1960. The same year also saw the publication of L.Gans's *Nieuwe Kunst*, which throws light on Dutch Art Nouveau, and in 1964 Elisabet Stavenow-Hidemark's comprehensive catalogue *Svensk Jugend* was issued in connection with the exhibition in Stockholm.

Three books by German authors have also recently appeared, each in its way of great importance. In 1959 Helmut Seling published *Jugendstil. Der Weg ins 20. Jahrhundert*, containing special articles by a number of scholars on various aspects of the style, and ranging from architecture to porcelain and theatrical décor. In 1962 came Robert Schmutzler's lavishly illustrated *Art Nouveau – Jugend* (English edition, 1964), which dealt not only with the development of the style, but with its precursors. In the following year Hans H.Hofstätter published his *Geschichte der europäischen Jugendstilmalerei*, a broad international survey of the style in painting, and Italo Cremona's *Il tempo dell' Art Nouveau* was published in 1964. The most recent in the field are Gerhard Bott's *Kunsthandwerk um 1900* and Maurice Rheims's *L'Art 1900*, both published in 1965. The many richly illustrated articles in architectural periodicals of the 1950s and 60s have helped to broaden our picture of the

style, as well as emphasising the interest it has aroused among contemporary architects. On the basis of this research it should be possible to give a comprehensive picture of the stylistic phenomenon of Art Nouveau, and of its background and development, even though a great deal of research still remains to be done.

Art Nouveau is a style with many roots and precursors, from the Pre-Raphaelite Movement to the Arts and Crafts Movement, from the Gothic Revival to the Celtic Revival, from William Blake to Walter Crane, from Orientalism to Symbolism and Historicism. We first come across it in England in the experimental and prolific Arts and Crafts milieu in the 1870s and 1880s, when it appeared in the form of what might be called Early English Art Nouveau or English proto-Art Nouveau. Among its leading exponents were Crane, Dresser, and Mackmurdo. It developed in the applied arts, with a special preference for the two-dimensional, in textiles, wallpapers etc. These trends suggest the Continental version. But the style of which the seeds had been planted was never to come to full fruition in Britain. Fully fledged Art Nouveau was not really established, the artists instead continued the cultivation of an elegant style developed from the Arts and Crafts Movement. The Continental upsurge of Art Nouveau in architecture and the applied arts was a relatively sudden phenomenon in the early 1890s, Art Nouveau emerging in Brussels in 1892–3 as a fully developed style in the dynamic and brilliant work of Victor Horta, with architects such as Hankar, Serrurier-Bovy, and van de Velde to support him. Here it developed not only in the applied arts, but as a new approach to interior decoration, and as a style in its own right in architecture. With van de Velde it crossed the border into Germany, where *Jugendstil*, a conscious search for renewal, came to fruition somewhat later, in the two centres of Munich and Darmstadt.

In Germany the style took its name from the periodical *Jugend*, started in 1896. It was, in fact, associated to a unique extent with periodicals. During the 1890s no less than a hundred art periodicals were founded in Europe. They were all of them the outcome of an

intense desire to renew art, and reflected the strong interest which existed particularly in the decorative arts. The spate of periodicals also helps to explain the rapid spread of the style. In French applied art the style assumed a more refined and elegant expression than anywhere else, continuing the best French traditions. Its natural centre was Paris, with such leading figures as the architect Hector Guimard and the jeweller René Lalique, while the glass artist Émile Gallé founded and led the Nancy School. It was in Paris, too, that the Art Nouveau style acquired its international centre. In 1895 Samuel Bing founded his shop *L'Art Nouveau* in the French capital, the firm giving its name to the style. In 1900 the height of Art Nouveau creative strength and popularity was reached with the great international exhibition.

If the term *High Art Nouveau* is to be permitted, it may be said to coincide with the second half of the 1890s, when the style flourished throughout Europe and invaded practically every genre. As a general rule the label Art Nouveau is not applied to painting, largely because it is so closely associated with architecture and the applied arts but also because quite different periods are used as sub-divisions in painting.

The development of the style in the latter half of the 1890s resulted in a wealth of national variations, each with its own particular characteristics. The development of the style in Scotland, coming relatively late, witnessed the birth of a very special and particularly sophisticated version centred in the Glasgow School, led by Charles Rennie Mackintosh. Holland had its own particular contribution, the emphasis being on a sober and somewhat English-inspired style of furniture design, while various Oriental stimuli also had their effect. In Scandinavia it fused at times with the medievally inspired dragon style, producing a vigorous and entirely independent style with marked national-romantic features. In Italy, where classical traditions were firmly entrenched in architecture and industrial art, it developed somewhat later, reaching its climax at the Turin Exhibition in 1902 with Sommaruga and d'Aronco as the leading architects. The dominant features here were

the links with England and a predilection for floral design. But the country in which the style evolved its most special form-language was Spain, where it was almost entirely confined to architecture, with one man – Antonio Gaudí – as its creative spirit. The style was mainly confined to Barcelona, where it not only made a surprisingly early entry but persisted for a number of years after Art Nouveau had reached its climax in the rest of Europe. In Switzerland it was painting, primarily in the work of Ferdinand Hodler, which made the most important contribution to the style. American Art Nouveau, instead of springing directly from Europe, appears to have developed as an independent style, with a marked bias for architecture – as Henry-Russell Hitchcock has shown – Sullivan being its leading personality. Tiffany's glass-work was equally individual. In the countries of Eastern Europe a floral Art Nouveau has recently been brought to light again. In these countries however the style did not achieve any particular eminence, nor can one say that it influenced the general development. In Austria, with artists such as Gustav Klimt and Otto Eckmann, the style flourished especially in painting and book illustration. In architecture the most significant figure was Joseph Hoffmann, but even before 1900 Otto Wagner had pointed the road ahead – which was to by-pass Art Nouveau.

A glance at the rectilinear Vienna style and its background would suggest that we are faced here with a 'counter-movement'. Although it embodies trends which contain essential elements of Art Nouveau, in other features, such as the hostility to ornament, it is entirely opposed to the style and spirit of Art Nouveau. In fact the Vienna Style, to a far greater extent than Art Nouveau, points to the Modern Movement and the stylistic development of the twentieth century.

2 The style defined

Conception of form

The principal ornamental characteristic of Art Nouveau is the asymmetrically undulating line terminating in a whiplike, energy-laden movement. This line may be elegant and graceful, as it was in Scotland (figure 2·1), or more ponderously dynamic and full of a rhythmical 'counter-movement' as in Belgium and France. At times it is linear, at times more plastic and full-bodied (figure 2·2). This is the common, recognisable and popular characteristic of the style. And yet this undulating line is only an external and limited aspect of Art Nouveau. However fascinating the ornamentation may be, it contains a deeper interest when seen in a larger context – in relation to an actual surface or to a three-dimensional object. In the latter case the ornament may flame, grow, coil, or nestle caressingly round the object. The style, in fact, has a tendency to engulf and transform the object and its material, until this material becomes an obedient mass in the thrall of linear rhythm. But the ornamentation can also pursue a separate aesthetic existence on the surface (figure 2·3). The proportions of the surface – its nakedness, its entire character, in fact – can be brought out by elegant, formally enclosed and well placed ornamentation. It is not surprising that the style proved a source of inspiration in the art of book illustration (figure 2·4) and poster design.

The ornamentation is always alive, restless, and at the same time balanced (figure 2·5). Unlike the static ornamentation of nearly all other stylistic periods, in Art Nouveau it is always at one and the same time moving and in a state of equilibrium. Deep down there is a striving to subdue movement by means of well-balanced harmony (figure 2·6).

If we penetrate still deeper into the nature of Art Nouveau ornamentation, we shall find that at times it may constitute a feature of the object which is endeavouring to express something. This may both apply to its function as an artefact and be a purely aesthetic element. We are here approaching the significance of Art Nouveau decoration as a symbolical factor. In this respect its

15

2·1 Margaret Macdonald: Vignette, 1901. The linear and two-dimensional way of illustration was nowhere developed with such refinement as in Scotland and England. This vignette illustrates the value not only of the line but of the space around it.

2·2 Gaillard: Handle for a cabinet made in 1900, showing the interlaced and dynamic play of line usually adopted by French and Belgian designers.

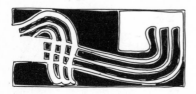

2·3 Hoffmann: Vignette for *Ver Sacrum*, 1898. Hoffmann shows a predilection for a more rectilinear and constructive play of line.

most important aspect is its ability to emphasise the structure of form and, next, to fuse the object and its ornament into an organic entity: the aim is unity and synthesis.

But the ornamental qualities of Art Nouveau can also be seen in a more directly symbolical context, and it is possible that this symbolical background has in fact played a more important role than we are apt to believe today. 'Pour bannir le symbole du décor, il faudrait chasser du firmament notre satellite' ('If we wanted to banish the symbol of the decoration we would have to drive our planet from the firmament'),[1] as Émile Gallé put it in 1900. The budding, growing ornamentation thus reflects essential elements of Art Nouveau – the very force and creative ability of the style. Various natural elements are selected: the sappy shoot, the young tree, and the bud being the most important. Within this ornamental world an entire iconography is developed, which we shall examine a little more closely in connection with Symbolism and the literary background.

Even though the style has its internationally common features, national variants gradually developed; but as these are only to a

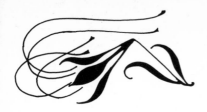

2·4 Eckmann: Vignette for *Pan*, 1896. Art Nouveau also had a floral aspect, which cultivated the stem as well as the flower.

2·5 De Bazel: Vignette, 1896, A spiky batik-inspired version of Art Nouveau was very prevalent in Holland.

2·6 Henrik Bull: Railing for the Government building in Oslo, 1901–6. Yet another aspect developed in the North, where Viking ornamentation fused with the tendrils of Art Nouveau.

certain extent conditioned by nationality, it might be better to consider the various aspects of form. Altogether we can distinguish four. First there is an abstract and structural, at times almost sculptural, conception, which is also strongly dynamic in character. Secondly we have a floral and markedly plant-inspired style in France, with great emphasis on the growing and organic. In the French-Belgian cultural-geographical sphere the structural tendency is generally speaking emphasised, with the main attention devoted to ornament as a structural symbol. In Italy, too, the style tends towards the floral, but without the same emphasis on structure. Thirdly we have a linear two-dimensional and literary-symbolical conception, notably in Scotland with the group round Mackintosh. In all these three versions of the style well-balanced asymmetry is an end in itself. The fourth conception which we shall come across is a constructive and geometrical one, which was developed especially in Germany and Austria. To these four main conceptions may be added an animal-inspired one, which was prevalent in Scandinavia and Scotland. It features the serpent and the snake, with generous use of *entrelac*.

18

2·7 *Right* Guimard: Entrance with iron
light fittings for the Paris Métro, 1899–1900.
These are among the most fascinating of
all Art Nouveau creations. They grasp the glass
as if to symbolise the relation between
ornamental structure and pure function.

Provided one realises the dangers of a generalisation of this
kind and is prepared to admit, for example, that Louis Sullivan's
symmetrical Art Nouveau patterns are not easily fitted into the
general picture, or that Germany too witnessed a vigorous floral
Jugend as well as highly abstract-structural tendencies, it may
perhaps be useful to investigate the different versions adopted by
the style, in order to penetrate to its true characteristics.

Abstract and structural-symbolical Art Nouveau flourished most
vigorously in the French-Belgian cultural sphere. In this version of
Art Nouveau natural shapes are transformed beyond recognition,
or the decorative motifs are turned into an entirely abstract form-
language, as a rule highly plastic and dynamic in character. Which-
ever of these two starting points is taken, the typical feature of this
style is that the actual material and its qualities are secondary, the
structure and main form of the object being emphasised by means
of 'power lines', often running from central points like nerves in an
organic system. As a rule, too, this form-language emphasises the
construction of the object or the structural importance of a
particular feature – the prehensile shape of a stretcher in a piece of
furniture or the relationship of a light-fitting to the actual source of
light. Guimard's *Métro* décor and his design of certain constructive
parts are in this respect highly characteristic (figure 2·7). The orna-
ment may also emphasise or symbolise this structure, so that we
can actually speak about ornament as a symbol of structure.

Floral and organic Art Nouveau flourished particularly in Nancy,
under the hand of its great master, Émile Gallé. For the Paris Exhi-
bition of 1900 Gallé made a work table with marquetry of various
woods (figure 2·8). Between the legs we can observe the floral motifs
flowing and undulating rhythmically in a linear interplay. The
actual table-top bears the inscription 'Travail est Joie'. The inscrip-
tion in itself and the use of literary quotations are typical of Gallé,
reflecting the symbolical and literary tendency to be found in his
work. The aim is not only to express its function through the

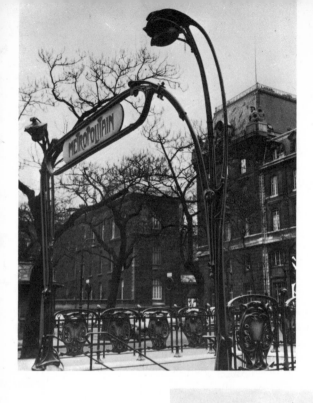

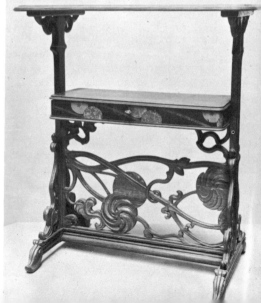

2·8 Gallé: work table with marquetry in various woods, 1900. Nowhere was the floral aspect of Art Nouveau cultivated with such delicacy and truth to nature as at Nancy.

construction, but through its decoration, a conception with roots far back in the nineteenth century. Nature – its plants and flowers – provided the great source of inspiration, but only by recreating the organic, in terms of various symbols, can this source be used and acquire its own value. Nowhere was the flower so lavishly recreated as in his studio. Above the door hung his slogan: 'Our roots are in the depth of the woods – on the banks of streams, in mosses'.[2]

3

The linear two-dimensional and symbolical conception of Art Nouveau reached its apex of elegance in the Glasgow School. One of the School's fundamental decorative principles, in fact what might be called its artistic starting point, was the decorative value of line. Just as important, however, was its striving for a taut and at the same time elegant form. Mackintosh's design for a Tea Room, 1903–4, (figure 2·9a), is a consummate example of the highly sophisticated interior design of this school. The decorations are linear, and entirely two-dimensional; the ornamental details recall stylised buds, or beans. The introduction of lanky female figures, draped in the outlines of falling teardrops or enclosed in linear patterns, is also characteristic (figure 2·9b). But everything is subordinate to clear, definite decorative principles; there is no striving for an effect of depth or illusion.

In the Glasgow School a symbolical ornamentation developed, independent of the object, its structure, or its function, and consisting essentially of stylised and markedly abstract hearts, buds, sprouting bulbs and egg-shaped forms. These ornaments can best be understood if we consider them as symbols associated with life and growth.

A distinction between the Scottish and the abstract-structural and floral-organic aspects of the style, is the rhythm of the line and the tense form of the curves. The French rhythm is a whiplash one, a powerful shape producing abruptly contrasted and dynamic movements. Not so in Glasgow, where the curves flow smoothly, and where the line as a rule is less abruptly bent but by contrast longer – which helps to produce an effect of greater restfulness. For

this reason the tension factor in the line is reduced: the line does not fling its final rhythm into space, but instead recoils, enclosing the form and thus appearing more controlled, less dynamic and less temperamental than on the other side of the Channel.

The fourth conception of Art Nouveau is the *constructive and geometrical*. It is to be found in the work of Serrurier-Bovy and Mackintosh, and also in Germany and Austria. Van de Velde in particular developed an Art Nouveau-like constructivism, with ample use of arched struts and rectilinear components. Unlike abstract and structural Art Nouveau, the ornament is securely anchored in the surface. In Austria, proceeding still further in constructivism and rectilinearism, the geometrical ornament – the square and the circle – became an end in itself; in fact the extremes of what we call Art Nouveau were reached. Nowhere is the symbolic meaning so much reduced in status as here: the plant no longer grows, the flower has replaced the bud. In 1898 Hoffmann designed an interior (figure 2·10) where we notice above all the additive principle which is characteristic of Austrian interior décor in this period. The tendency to achieve a cohesive fusion, with each feature blending with the next, is non-existent. While every individual piece of furniture forms part of the whole, it is nevertheless an entirely independent object in the spatial composition. In addition, we encounter the square as the most common decorative motif, and at the same time we note an unerring appraisal of the ornament in relation to the undecorated surface.

If we draw definite formalistic boundaries, it might seem that the rectilinear and geometrically influenced *Wiener Sezession* style falls outside the Art Nouveau movement. Hans Curjel, however, was right when he declared in 1952:

If linear dynamics was one means of expression at the turn of the century, creation based on geometrical elements was equally important. At the beginning of the period, about 1900, the rectangular features exercised a power of attraction as great as the wavelike flowing dynamic forces. . . . In the use of the geometrical means there is no less artistic sensibility and no less considerable power of the imagination.[3]

2·9a and b *Below* Mackintosh: Door for the 'Room de Luxe' of the Willow Tea Rooms, Glasgow, 1903–4. *Right* Margaret Macdonald: Leaded glass panel for the Willow Tea Rooms, 1903. Both show the decorative play of the Scottish school at its best. The colour schemes and the undoubtedly symbolic egg- and bud-shaped forms are typical. Another favourite device was the rose-ball.

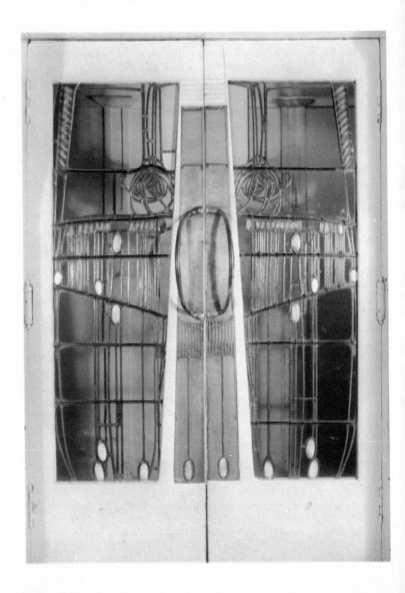

But what the geometrical trend lacks is the structural-symbolical and organic idea which is of such fundamental importance to the Art Nouveau style.

It may be asked whether this style-language should be labelled Art Nouveau at all. It is somewhat far removed from what is generally associated with the style. On the other hand it embodies the same basic ideas, viz. the desire to create a 'New Art'. As long as ornament and decoration constitute an essential part of form-conception, the Austrian style must be included in our survey.

The predilection for animal ornamentation hardly justifies a special label, since it is less important than the others and further-more is mainly confined to metalwork, silverware and jewellery. In Scandinavia, and to some extent in England, Norman style elements fused with Art Nouveau; the result was a stylistic sym-biosis, one component of which was Romanesque animal ornamen-tation, with serpents entwined in *entrelac*, and the other the elegant rhythmical line of German *Jugend*. Swans, octopuses, and jelly-fish are also to be found used as ornaments, owing to the gliding rhythm which these creatures enable the artist to reproduce. Another form of inspiration from the animal world is to be found in the work of René Lalique (figure 2·11), where Woman is often fused with other creatures of Nature. The jewel depicting the half-swallowed woman presents precisely the blend of the morbid and the sordid which flourished in the 1890s. It illustrates the complete transfor-mation of the female personality: Woman is now shown as one with the venomous and predatory creatures of the night. Frequently, too, she is associated with growing plants which cling caressingly about her; but this often expresses a profounder idea, Man's deep and intimate union with Nature.

But it is also important to single out those aspects that were *not* inherent in the origins or the development of Art Nouveau. The history of art reveals many cultural forms in which a swaying linear rhythm, energy-charged contours, and a graceful play of line have been cultivated. We can find Art Nouveau-like ornaments in Cretan and Mycenean culture; Dali claims to have found it in

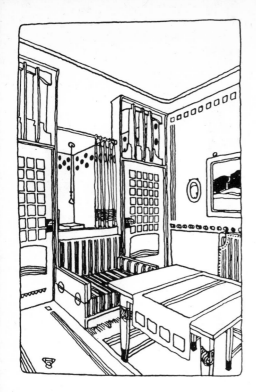

2·10 Hoffmann: Design for interior, 1898. Though there were fewer flowers and less play of line, Hoffmann's interior design is based on the same search for renewal as we find further West in Europe. His work showed a similar sense of unity, but the striving for simplicity soon led him and the rest of the Austrian school away from Art Nouveau.

Greek art; it is familiar to us from the ornamentation of Merovingian times, from the Viking period in the Jelling style and in the Urnes style, in Persian embroidery and glass, in Japanese culture, and in English seventeenth- and eighteenth-century embroidery. In all these art forms – and probably in a great many others – it is possible to find ornamental elements suggestive of Art Nouveau, even designs that are strikingly similar. Nevertheless, it is obvious that none of them has any connection with the Art Nouveau style. Similarity must not be confused with causality. Nor does a comparable analysis suggest that in these various cultures there exist common factors which, in given circumstances, produce a whole stylistic picture analogous to that of Art Nouveau.

The style is the product of nineteenth-century precursors: it was created in the last quarter of that century, flourishing in the period around the turn of the century, setting its hallmark on nearly every genre of art.

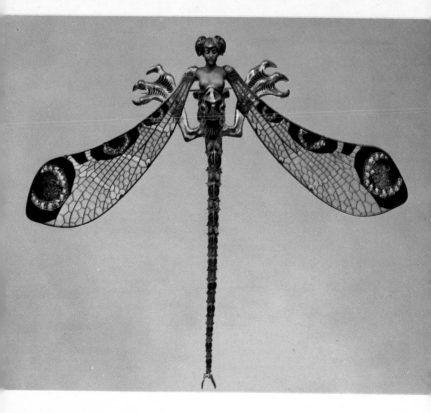

Terminology[4]

As Art Nouveau gradually spread and attained popularity, it was given a host of names and labels – a phenomenon which is symptomatic of the striving of the age for an acceptable stylistic conception. Among the more popular names are *Paling stijl* (*paling* = Flemish for *eel*), the name it quickly acquired in Belgium, as well as *Style Nouille* (spaghetti style), which was the *sobriquet* given it by Paul Morand. Names such as the *Mouvement belge* and *Ligne belge* are expressions rather of a national Belgian consciousness, and in addition we get names such as *Style 1900*, *Modern Style*, the latter alluding to its connection with England, while *Style Moderne* was also much in use in France.

In 1901 van de Velde mentions names such as *Veldescher Stil*, *Stil van de Velde*, but also notes that in Dresden and Berlin his

2·11 Lalique: Corsage ornament in the
form of a dragonfly with female bust;
gold and enamel, 1898. This corsage
which was lent to Sarah Bernhardt, a
great lover of jewellery – was exhibited
in Paris in 1900 and at Turin in 1902.

work was called *Schnörkelstil*, (scroll style) and *Bandwurmstil*
(tapeworm style), while the *Kölnischer Zeitung* called it the *Wellen-
stil* (wave style). Other German nicknames were *belgischer Band-
wurm* (Belgian tapeworm), *gereizter Regenwurm* (popping up
earthworm), and *moderne Strumpfbandlinien* (modern suspender
line), while the term *Jugendstil* (young style) soon replaced names
such as *Neu Stil* (new style) and *Neudeutsche Kunst* (new German
art). The German name is, as said, taken from the lively, ribald
periodical *Jugend*, the first copies of which circulated in Munich in
January 1896. Here we find Otto Eckmann delighting his readers
with his floral Art Nouveau vignettes, in company with a number
of other artists with definite Art Nouveau leanings; and three or four
years after the founding of this periodical the term *Jugendstil* had
taken root and was being used in applied art. It is hardly surprising
that the style should also have been named after certain artists, as
mentioned above in the case of van de Velde, and we do in fact
find names such as *Style Horta* and *Style Guimard*.

In Austria the corresponding stylistic phenomenon was covered
by the term *Sezessionstil* (secession style), a term which can be
traced back to the union of radical Viennese painters and Viennese
sculptors founded in 1897 under the name of *Wiener Sezession*.

In Italy the style was called the *Stile floreale* or *Stile Inglese*,
though the commonest designation was *Stile Liberty*, after Liberty
and Co. in London, one of the leading fashion stores in Europe and
a manufacturer of printed cotton cloth.

Edmond de Goncourt was responsible for the style being given
the celebrated name of *Yachting Style* as early as 1896. What he
actually said was that the furniture of the time had been 'em-
pruntées aux hublots d'un navire' ('borrowed from the portholes of
a ship'). In the early days the French called it *Modern Style*. 'One
says *Modern Style*,' a French connoisseur of applied-art problems
wrote in 1901, 'in order to remind oneself of its British origin.'
Émile Gallé, too, used this name, as did Émile Bayard in the last
volume of his series *L'Art de reconnaître les styles*. It is significant,
however, that in France there was a change in nomenclature after

Samuel Bing had opened his shop in Paris round about Christmas 1895, with the orange-coloured sign which Arsène Alexandre, editor of the *Revue des Arts Décoratifs*, described as follows:

Above the two enormous embossed sun orioles violently exaggerated, without taste or style, can be read these two words, with their delicious modesty: 'Art Nouveau'.

As the French came to fashion their own style out of Art Nouveau and Bing's shop gradually increased in popularity, the shop gave its name to the style in France. In this connection it may be of interest to hear what Bing himself has to say about the name:

At its birth Art Nouveau had no pretensions to being a generic term. It was simply the name of an establishment opened as a rallying point for youth keen to show their modern approach.

In the late 1890s the name Art Nouveau became the accepted one in France, apart from the more flippant names used by the man in the street, such as the *Style Métro*, a reference to Hector Guimard's iron railings designed for the Paris Underground stations (figure 2·7 and frontispiece) or the *Style rastaquouère* (foreign adventurer's style). Characteristically, the highly reputable periodical *L'Ameublement* no longer called Art Nouveau furniture *Genre Anglais*, but *Art Nouveau*.

It was, of course, natural that this name should establish itself, since the term so completely reflected the age and its strivings. For half a century people had searched for a new style. In 1849 John Ruskin had written:

A day never passes without our hearing our English architects called upon to be original and to invent a new style ...

and as early as 1836 Pugin had warned his readers of the danger of imitation. In cultural circles in France in the 1870s and 1880s the hope – and the demand – for a new art was constantly expressed. Van de Velde spoke in 1894 of an 'Art Nouveau' which was to come, by which he meant a complete artistic revival. This was the dominant mood in the 1890s; in the midst of *la décadence* and the

fin-de-siècle mood, people were striving energetically to attain a renaissance, a new form-language, an *Art Nouveau*, and a new *Jugend*, with all the wealth of symbolism contained in these words. The term *Arte Joven* (young art) is an indication of the same striving. It was used in Spain to describe the Catalan form of Art Nouveau, and the name was derived from the periodical with this very title, founded by Soler and Picasso in Madrid in 1901.

In England the term Art Nouveau was used to describe decorative art as early as 1896, though at that time it implied the Continental trend. In the same year Victor Champier wrote:

... is it not obvious that this expression *Art Nouveau* has only one thing against it: its unduly pretentious precision? It simply indicates an effort ... Should we not accept it, this expression *Art Nouveau*, and give it the right of entry from now on to our discussions?

This, in fact, is what happened, and after the Paris Exhibition of 1900 and the spread of the style the term became the usual one. German-speaking countries proved an exception, as here the name *Jugend* was used – and is still used – both in applied art and in the pictorial arts.

After the period became the subject of investigation by other art historians, especially English and American, the name *Art Nouveau* – confined essentially to applied art and architecture – appears to have been generally accepted, while the different national terms remain as labels for the various national forms that evolved.

3 The ideological background

As the nineteenth century drew to a close, the desire grew to liberate art from the academicism everywhere so firmly entrenched. The knowledge that a new century was approaching, and the feeling that a new era was at hand, encouraged the hope for a new art. Now at last was the chance to shake off the traditions of the past. Typical of this feeling is the following statement from 1894:

We are standing at the end of a century; we are at the conclusion of an historical period ... Mankind is in a state of sickness, now roused to feverish excitement, now inert, weary and discouraged. This is true of the civilised nations. Something is dying, something has long been dead. And the author adds, with a sidelong glance at Henrik Ibsen: We are sailing with a corpse in the hold.[1]

Weltschmertz, *décadence*, *fin-de-siècle*, and *nostalgie de la boue* were phrases bandied about in the 'Gay Nineties'. This strange mood of decline was intimately bound up with the Symbolist trend in literature in France and Belgium, and with the Aesthetic Movement in England. In 1893 Arthur Symons, the leading light of this movement, described it as follows:

This representative literature of today ... is really a new and beautiful and interesting disease.

These literary currents, which in other countries were capable of developing a neo-romantic, irrational or mystical side, were in conscious opposition to Naturalism and Positivism. Despite differences in national characteristics, these trends reflect certain common basic features, *inter alia* a marked sense of literary sophistication and a search for the exotic. They also reflect an intellectual resignation which is probably bound up with the psychological effect which a dying century was able to exercise on a young and critical generation. Positivism was unable to solve every problem with its scientific acumen. The more subtle sensibilities of the human mind escaped it. Positivism created museums of art, but not art, it has been said. The aim was now no longer to depict or describe Nature, but to evoke and convey sensual impressions in a subtle and obscure manner, as Verlaine, Rimbaud, and Mallarmé

did for example in their poetry. Symbolism made no attempt to convey its impressions through the medium of external, naturalistic means, or by an appeal to reason, but purely emotionally, through the use of such effects as musical rhythm, sounds, and suggestive associations.

An interesting feature of Symbolism was the intimate relationship between authors and other artists. In the Symbolist periodicals which had recently been founded – *La Plume*, 1889; *Le Mercure de France*, 1890; and *La Revue Blanche*, 1891 – Vallotton, Maillol, Bonnard, Denis, and Toulouse-Lautrec found an outlet for their talents, not to mention Prouvé and Gallé, who worked hand in glove. The entire artistic milieu was woven together and permeated by the same ideas. We find the same situation in England, where Swinburne, king of the Aesthetic poets, was intimately associated with the Pre-Raphaelites. He dedicated his drama *The Queen Mother* to the poet and painter Rossetti, and his *Laus Veneris* to Burne Jones, who in turn gave one of his pictures the self-same title.

The links with the world of music were even closer. Here, Claude Debussy occupies a central position. It was no coincidence that he should have played his *Quartet in G Minor* and *La demoiselle élue* – so called after one of Rossetti's poems, *The Blessed Damozel* – at the opening of the first exhibition of *La Libre Esthétique* in Brussels in 1894. He also recreated Mallarmé's *L'après-midi d'un faune* and Maeterlinck's *Pelléas et Mélisande* in music. He wrote *Images* for piano, and was an artist one would be fully justified in associating with the Art Nouveau style, even though it would be dangerous to press the parallel too closely. Debussy's work, on the other hand, certainly realises Wagner's ideal of the fusion of the arts, and Edward Lockspeiser points out that there is a great deal of evidence to show that his musical and artistic sensibility at this stage was a reflection of Art Nouveau. His conception of melody as an 'arabesque' was the direct musical counterpart of these theories. Debussy himself says in *La Revue Blanche* (May 1901) that 'the musical arabesque or rather the principle of the ornament is at

the basis of all forms of art.'[2] He is thinking particularly of the interlaced designs with strong counterpoints. The musician tried to achieve the ornamental rhythm of the pictorial artist, while the latter strove to attain the abstracted forms of music. The friendship which existed between Frederick Delius and Edvard Munch, and their common motifs, are another reflection of the close relationship between music and painting.

In pictorial art the same Symbolist ideas are reflected as in literature. The goal was no longer to achieve a faithful reproduction of the motif. Objective description gave way to subjective selection: the aim was to convey an 'after impression' of the essential impression, a synthesis of what had been experienced. Schopenhauer, too, undoubtedly contributed to the spread of this attitude to Nature: Émile Bernard carried a volume of the philosopher's works with him on his rambles through Brittany, and he was assiduously discussed at Pont-Aven by the group that gathered around Gauguin. It was precisely this reaction against Naturalism, and the conscious search for a synthesis – which in painting found expression in the bold, firm, encircling outline – that proved important to Art Nouveau. Literary trends, too, will help to explain the feeling for and use of the symbol in the Art Nouveau style. Hardly any style in recent times has been so 'musical' in its ornamental form, or possessed such a wide range of symbols in its cycle of ornaments. It may safely be said that Art Nouveau has its own very special iconography.

From the Aesthetic Movement the style inherited the lily, the peacock, and the sunflower. The significance of the lily as a symbol of purity was, perhaps, no longer so predominant but, to make up for this, greater emphasis than ever was placed on its formal qualities, its long stalk and the closed chalice. The water lily, too, joined the group of symbols, adding just the right touch of deep, profound mystery. In the peacock the feathers, rather than the bird itself, proved of paramount interest. The plumage represented the magnificence of vanity and, with its gorgeous colours and closed oval shapes, the bird was tailor-made for Art Nouveau

artists. The sunflower, on the other hand, with no exotic features and few sophisticated ones to commend it, gradually disappeared. The flowers and shrubs borrowed from the vegetable kingdom were not of the common or garden type. This would hardly be expected in the case of a style anxious to create something new. It was the exotic plant, with long stalks and pale blossoms, that inspired the imagination of the Art Nouveau artist, for these flowers were peculiar, unfamiliar, carrying a message of aesthetic delight, exoticism, and sophistication.

An aesthetic menu from 1893 in *L'Émulation* provides a sort of culinary picture of the age:

> Lis en branches au naturel
> Fleurs de Tournesol à l'oriflamme
> Poissons louches à la dado
> Cuisse de Cigogne tout au long
> Tête d'épouvantail à la Botticelli
> Compote de fruits défendus à la Baudelaire fortement sucré

Yet the tendency for the stalk to eclipse the flower persisted, and it was precisely all sorts of creepers, such as verbena, and snowdrops, and tall slim reeds and rushes, that retained their popularity. The preference for the stalk, with its powerful, elegant curves, reflects the interest in the structure of Nature rather than her external splendour. This approach is in complete harmony with Art Nouveau. In addition to these plants we have the entire range of submarine flora, with all sorts of waving, oscillating kinds of seaweed and wrack. Characteristically, too, the bud was used as a motif just as frequently as the flower itself. The bud, after all, symbolises the future, concealing within its closed form the promise of the growth and beauty that will unfold. Once again we see the profound symbolical meaning of Art Nouveau decoration.

Just as the artists regarded themselves as the fountainhead of a new age and a new style, a style that was to flourish in the future, it is natural to assume that they expressed this feeling in the symbols they chose. This general basic interpretation is supported

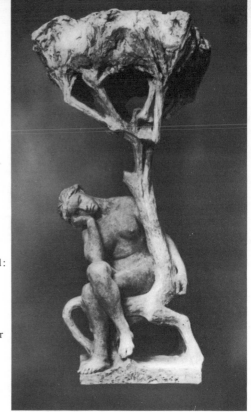

3·1a *Right* Gustav Vigeland:
Sitting Woman, modelled
1905, cast in bronze, 1907.
3·1b *Far right* Gilbert:
Nymph and two Cupids, no
date. The Art Nouveau
artists searched for a deeper
and more intimate relation
between Man and Nature.
The tree often symbolised
Nature itself, and could
also be interpreted as the
Tree of Life or Fertility.

by a remark by Meier-Graefe, a man well versed in Symbolism and one exceptionally alive to the feelings of his age. Of the decorations of the Glasgow School he said:

Artificial flowers of coloured paper with glass buds decorated the tables; the light bulbs were suspended from long, parallel connecting wires, and as a mural ornament inflated coloured eggs, large and small, had been hung up at regular intervals. The meaning of these eggs puzzled people, but to me they seemed quite understandable, indeed necessary symbols.[3]

The English art critic Christopher Dresser also spoke of 'the bursting buds of spring', and the symbolic force they conceal.[4] The attitude to Nature at this time was also to a certain extent inherited from the theoreticians of the Pre-Raphaelite Movement. John Ruskin and William Morris were both absorbed by the idea of

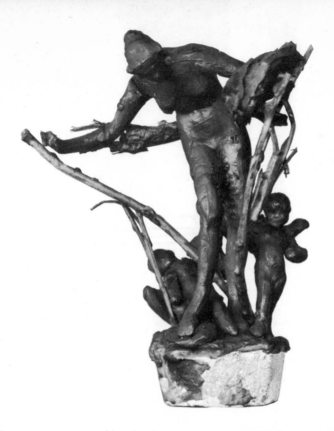

Nature as a source of inspiration, a source to which they constantly return. The one sees in Nature a divine miracle which is to serve as a direct model; the other regards it rather as a source of inspiration. As Morris's enthusiastic pupil John Sedding put it: 'Drop this wearisome translation of old styles and translate Nature instead.' Naturalism and its basic values should on the whole be regarded as a necessary background for the process of transformation that took place during the Art Nouveau period, although we have also noted a reaction against it.

But apart from the plants and flowers already mentioned, there was a deeper and more symbol-invested natural object to which the artists of the Art Nouveau period gravitated – the tree. They were attracted by the Paradise Tree, the Tree of Life, as well as by the tree as a symbol of fertility – and we should also remember that the

tree was the haunt of witches. Paul Klee's *Young Woman in a Tree*, Edvard Munch's numerous paintings showing young people grouped round a tree, Giovanni Segantini's *Child Murderess*, 1894, Antonio Gaudí's stone tree, Gustav Vigeland's and Alfred Gilbert's bronze and clay trees (figures 3·1a and b) reflect mankind's intimate links with Nature, and its oneness with it, both for good and for evil. Particularly as a fertility symbol and a life symbol the tree was excellently suited to the iconography of Art Nouveau.

The animal world of Art Nouveau is no less interesting. After a while the swan eclipsed the peacock in popularity. It symbolised beauty and pride no less effectively, and furthermore its long neck was perfectly adapted to reflect the rhythm of the Art Nouveau style. The gliding, graceful movements of the swan were equally a point in its favour. Finally it wore the colour of purity – white – one of the favourite colours of Art Nouveau. The swan became one of the most popular Art Nouveau animals: we find it rocking gently in numerous book illustrations and floating in many a stained-glass window.

In addition to this proud symbol the style appropriated a whole series of other animals, none of which were chosen for their generally recognised beauty. Characteristically, many of the fauna of Art Nouveau had their natural habitat in water: we find the octopus, the jellyfish, the eel and a great many others – all of them enlisted in the décor of the turn of the century purely for the undulating and sinuous movements of their bodies. Amongst insects the dragonfly proved particularly popular. In the 'citron wing of the pale butterfly, with its dainty spots of orange', as Whistler expressed it in 1888, the artist observed a special touch of aesthetic sophistication.[5] This penchant for marine creatures reflects the Art Nouveau delight in water and waves.

The flower was discarded and the stem and the bud were cultivated. The gay lines from a sunny and luxuriant floral world of the 1870s and 1880s gave way in the 1890s to the cool evening mood by the shores of a placid pool, where the lilies lie at rest, and the dragonfly glides softly by.[6]

There were also other trends, latent in the age, which contributed to the background of Art Nouveau. One of these may be traced to Nietzsche. In the Anglo-Saxon world of art and letters Nietzsche's influence appears to make itself felt relatively late, not until well into the 1890s, and without profound effect. In Germany he stood forth as the ardent champion of an artistic, aristocratic radicalism, cherishing the dream of an artistic renaissance. Van de Velde, who designed the title page for his *Dionysos Dithyramben*, was one of his friends, and Nietzsche also had a considerable influence on Edvard Munch.

Together with Maupassant, Strindberg and Schopenhauer, Nietzsche was a sturdy opponent of female emancipation. Woman was regarded by them as a dangerous, sensual creature, full of cunning and evil. 'This dangerous, beautiful cat', was Nietzsche's description. 'When you go to Woman, forget not the whip', we read in *Thus Spake Zarathustra*. This attitude to Woman entailed a marked emphasis on the erotic and the purely sensual. One of Nietzsche's admirers, Stanislav Przybyszewski – who belonged to the group around Munch – published his *Totenmesse* in 1893, which contains this passage:

In the beginning was Sex. Nothing was outside it, everything was in it. Sex is the basic substance of life, the inner being of evolution, and the essence of individuality.

In her main features the female Art Nouveau type was derived from the Pre-Raphaelites. We are familiar with her from William Morris's and Dante Gabriel Rossetti's depictions of their wives – melancholy women with heavy lidded half-closed eyes and sensual pouting lips. This narrow-shouldered female type was resurrected in the 1890s, with the addition of a morbid, demonic touch, as for example in Aubrey Beardsley's illustrations for *Morte d'Arthur*, 1892, and *Salome*, 1893 (figure 3·2). In Scotland she came into her own. She became still more sophisticated, though at the same time the melancholy of the *fin-de-siècle* mood was allowed free play in the linear streams of her tears. The black-stockinged can-can

3·2 Beardsley: Illustration for
Salome, 1893. The morbid and diabolical
interpretation of Woman was never
treated more convincingly, or with
greater refinement of line, than in
Beardsley's illustrations of the 1890s.

girls of Paris certainly had their sadder sisters in other countries.

Perhaps the underlying conception of this female type will also explain the sensual, at times almost erotically inspired, play with forms and caressing motifs in Art Nouveau.[7] The female idea, as well as the cult of the sophisticated as an aim in itself, should be seen against the background of the aesthetic and exotic tendencies of the age. The East played its part not only in pictorial composition and the placing of motifs, but also in introducing influences that are less easy to record, in conveying and emphasising a sense of quality and refined appreciation of form. The words of a critic, describing Ludwig Dill's pictures in 1905, can to some extent be said to cover the entire epoch:

> There is, despite their coolness, something voluptuous in these pictures, though without a hint of female nudity.[8]

A literary trend which should not be ignored for its importance as one of the precursors of Art Nouveau is the Celtic Revival,[9] which developed mainly in England, Scotland, Ireland, and Scandinavia. With the growing historical interest which developed in a great many countries under the stimulus of Romanticism, which often took a national turn, artists turned to the years of national greatness. In the Scandinavian countries the cult of the Viking Age goes back to the beginning of the nineteenth century, reaching a peak in the era of national Romanticism. William Morris's interest in old Nordic culture is familiar enough: he had already made two visits to Iceland when, in the autumn of 1872, he set to work to translate some of the Sagas.

The Celtic Revival was political, literary, and artistic in character, with Ireland as its natural centre. In the 1890s the Symbolist W. B. Yeats was its literary spokesman and it was not until he had written *Wanderings of Oisin and Other Poems*, 1889, that the real Celtic Revival began, to be followed by such works as *The Countess Kathleen* in 1892 and *Celtic Twilight* in 1893. In an article in *The Fortnightly Review*, 1891, Grant Allen gives the impression that the Celtic influence dominated artistic activity.

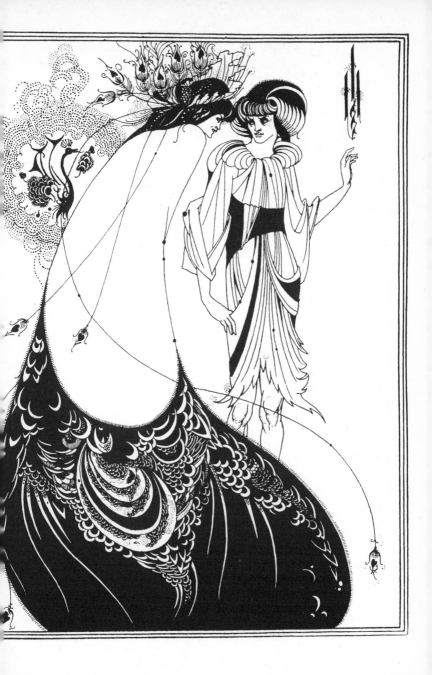

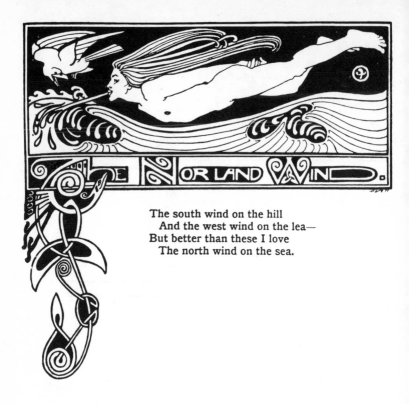

The south wind on the hill
 And the west wind on the lea—
But better than these I love
 The north wind on the sea.

The most typical feature of this revival in Scotland is the periodical *Evergreen* which appeared in the years 1895–7. The first number contained poems such as John Duncan's *Anima celtica*. It would be difficult for a larger measure of melancholy and yearning – a greater number of Celts, swords, and dragon-coils – to be contained within the narrow compass of a single page, than Duncan succeeded in including in his illustration to this poem. In the case of the Celtic Revival it would perhaps be no exaggeration to say that it made a direct contribution to Art Nouveau with its medieval *entrelac* motifs, which in certain cultural spheres blended so easily with the stylistic tendencies of Art Nouveau (figure 3·3).

If we turn to late German-Austrian rectilinear Art Nouveau, with its cult of the square and circle, we may assume that these

3·3 Illustration for the poem 'The
Norland Wind', in *Evergreen*, 1895.
The rhythmic line of the 1890s
fuses here with the Celtic inspired
ornamentation to produce a *vue d'ensemble*
which is typical of Art Nouveau.

ornamental forms, too, were a vehicle for a symbolic meaning.
One is tempted to see in this play with geometrical forms a reflection
of the contemporary search for a constructive and simple form-
language.

While it may not be possible to provide an explanation that
will cover the whole ornamental world and iconography of
Art Nouveau, its Symbolist and literary background neverthe-
less permits a deeper understanding of its ornamentation and form
of expression.

But in addition to the trends we have dealt with, there is an
undercurrent running throughout the 1890s, a yearning promoted
by the desire to get rid of all the old, outworn ideas of the century
now drawing to its close, an insatiable yearning for 'the new', to
which Holbrook Jackson draws attention in *The Eighteen-Nineties*.
This was reflected in movements such as New Paganism or New
Hedonism, while *The Picture of Dorian Grey* was characterised as
the New Voluptuousness. Oscar Wilde himself wrote about the
New Remorse in *The Spirit of the Lamp*. Turning the pages of
Punch and other contemporary magazines, one constantly comes
across allusions to 'new' movements and ideas – New Humour,
New Women, New Realism, New Drama – and we find periodicals
such as *The New Age* and *The New Review*. In common with all
these names, and expressing the same spirit and tendency of the
age, the New Art – *l'Art Nouveau* – comes into being.

4 Art theory of the time

The search for unity in the arts

One of the dominant ideas in circles where the artistic problems of the age were systematically tackled was the desire to renew decorative art by promoting closer cooperation between artist and artisan. As early as 1847 Henry Cole had founded *Summarly's Art Manufacture*, based on the principle of a direct association between leading painters and sculptors and applied art and industry. Though this venture lasted only three years, it provides evidence of a trend already at work, as well as foreshadowing developments to come in the later years of the nineteenth century.

As we have seen, the bonds linking pictorial art, literature, music, and decorative art were many and inextricable. The Pre-Raphaelite periodical *The Germ*, which appeared in 1850, aimed to combine arts and letters, and its sub-title characteristically enough was *Thoughts towards Nature in Poetry, Literature and Art*. But how were these literary trends expressed both in terms of art theory *and* in practice? William Morris, who wielded the pen as unerringly as the brush, once declared:

If a chap can't compose an epic poem while he's weaving tapestry, he had better shut up, he'll never do any good at all.[1]

Dante Gabriel Rossetti's famous dictum propounds the same view:

The man who has any poetry in him ought to be a painter; the next Keats ought to be a painter.

All the Pre-Raphaelites – Rossetti, Hunt, Burne Jones, and Madox Brown – designed furniture and textiles, or contributed in some other way to design. The later Pre-Raphaelites passed on this heritage, and men such as Walter Crane, George Heywood Sumner, Herbert P. Horne, and Selwyn Image all made their contribution to the renewal of English design. Oscar Wilde, too, was intensely interested in decorative art, and his lectures on *Art and the Handicraftsman* and *Art Decoration*, 1882, should not be forgotten, not least for their importance in the United States. The idea of

enriching the various artistic genres through cooperation between artist and artisan was the inspiration of Morris's firm, *Morris, Marshall, Faulkner and Co., Fine Art Workmen in Painting, Carving, Furniture and the Metals*, founded in 1861. It was also the dominant idea behind *La Libre Esthétique* in Brussels. In *Les XX*, the group which produced *La Libre Esthétique* in 1894, Gauguin had already exhibited his vases in 1891. Delaherche showed his pottery, and van de Velde his embroidery designs in 1892. In 1893 there were two rooms filled with decorative art objects, and from 1894 the decorative arts comprised a permanent section of this exhibition. In the same year van de Velde also delivered his lecture on Camille Lemonnier's thesis *L'Égalité de tous les arts, décoratifs et autres*, and in 1895 he wrote his *Aperçus en vue d'une synthèse d'art*.[2]

In France the position was the same: many of the artists who subsequently became leaders of Art Nouveau, such as de Feure, Grasset, and Majorelle, had started life as painters, while Charpentier and Dampt were originally sculptors. The painters, for their part, were highly interested in applied art, and Gauguin was one of those who really believed in the new style in the decorative arts.[3] One of Gallé's most important artistic principles was likewise based on equality between the arts; and with the exhibition of pottery, side by side with painting and sculpture, in 1891, at the *Salon du Champs de Mars*, this new idea may be said to have been officially established in France. Gradually this idea of equality spread and in 1895 the painter Henri Rivière declared 'a nice table is just as interesting as a piece of sculpture or a painting'.

In Germany and Austria the relationship between the arts, particularly painting and the decorative arts, was striking. The special attention paid to the framing of a painting, with the canvas and the carved decoration blending imperceptibly with one another, as for example in the work of Max Klinger and Ludwig von Hofmann, is typical of the age. Still more significant, however, was the new approach adopted by many leading architects and theorists. In the first volume of *Deutsche Kunst und Dekoration*, 1897, the architect Alexander Koch writes about the need for a complete

integration of all artists, sculptors, painters, and technical artists ... each thinking individually, yet working hand in hand for a larger whole. *Gesamtkunstwerk* (uniting of the arts) was now the slogan in Germany. This principle, which we find gathering strength from the middle of the nineteenth right up to the beginning of the twentieth century, and which was based on the belief in the supreme mission of art and the conviction that the fine arts should be mobilised to enrich the decorative arts, was to prove of fundamental importance to Art Nouveau. In England and many Continental countries the style appears virtually to spring from painters' illustrations and the vignettes of black-and-white artists. Not surprisingly many of its leading executants came from the ranks of the pictorial artists. As a result, it became in some respects an 'artist's style', and the tendency for products of applied art to be signed is a visible token of the position of equality accorded the decorative arts. Never since the Renaissance had artistic talent been so versatile, nor the genres so fruitfully wedded to one another. The idea of a renaissance – or in Otto Wagner's word, a 'naissance' – provided the very inspiration of the new movement. Furthermore, few styles have been so squarely based on theory. Artists poured out an incredible stream of theoretical writings and observations, which clearly reflect the earnest endeavours of this generation to solve its artistic problems.

Handicrafts versus the machine

It was natural that the artist's aid should be enlisted in solving the problems of applied art, but although he might have possessed every qualification for solving the problems of *art*, the question arises whether he was by nature fitted to solve those of *industry*. The whole idea and practice of equality among the arts was in turn based on *handicraft* and as long as this doctrine held sway all was well. The whole teaching of Ruskin and Morris was founded on the idea of a rebirth of art through the renewal of handicraft. The machine and industry represented a great danger. Ruskin heartily

detested both iron and the machine, and in Morris's eyes the belief in the Middle Ages and the struggle against the machine – not the machine *per se*, but the enervating mechanical product – were equally important:

That thing which I understand by real art is the expression by man of his pleasure in labour.[4]

The new century, however, was to be not the golden age of handicrafts but the era of industry and industrial design and here, not surprisingly, the artist was at a loss, faced as he was with the dualism inherent in the theory of Art Nouveau in its attempt to reconcile art and industry. On the one hand there was the desire to renew handicraft through art. On the other, through the process of renewal, a handicraft was created which, in its very nature, in its special approach to decoration and not least in its individuality, was hostile to the machine. The theory, once launched, was doomed to failure, since the art which the artist created was transient by its very nature and therefore incompatible with mass production.

In the latter half of the nineteenth century, however, other tendencies appeared which were not based on a renewal of handicraft and the principle of equality between art and applied art. This new approach gave full scope to the machine. As early as 1888 the English architect John Sedding had mooted this problem in his lecture *Our Arts and Industries*.[5] Sedding, who in many ways is associated with the Ruskin-Morris tradition, expressed himself, clearly and concisely, in favour of the machine and its relationship to the applied arts. Charles Robert Ashbee, who had wrestled with this problem from as far back as the 1890s, proclaimed with great vigour axiom no. 1, namely:

Modern civilisation rests on machinery, and no system for the endowment, or the encouragement, or the teaching of art can be sound that does not recognise this.[6]

In 1901 Frank Lloyd Wright declared: 'The machine is here to stay. It is the forerunner of the democracy that is our dearest hope.'

He describes the machine as 'this normal tool of civilisation' and adds that 'the old structural forms which up to the present time have spelled "architecture" are decayed.'[7]

This relationship between the artist and handicraft on the one hand and the advanced architect and the machine on the other, reflects the profound difference that existed in the approach to the industrial, stylistic and social aspects of applied art. In the artist's intimate links with the style are also to be found the seeds of decay that were to attack Art Nouveau. All too quickly the social idea which had, for instance, inspired the thinking of Morris and van de Velde was abandoned. Its form-language appealed to a small, exclusive group, while its expensive design and its reliance on the handmade product rendered it incapable of satisfying the social needs of the new age. The twentieth century needed technically inspired and trained designers capable of tackling mass production and the problems posed by new materials – not painters and sculptors.

The Reform movement

The artistic theory concerned with the renewal of decorative art had a strong social leaning. On the Continent, too, William Morris's heritage is clearly in evidence. In 1890 van de Velde wrote:

> What is of benefit only to the few is already nearly useless, and in the society of the future only what is beneficial to all will be valued.[8]

These ideas are in complete harmony with those of William Morris, as expressed in his articles in *Hopes and Fears for Art*, 1882. His

4·1a and b Vignettes from *The Art Journal*, 1851, *left* and *Ver Sacrum*, 1899, *right*. Art Nouveau artists were consistent in their unified conception of form, which extended to each single ornament. Naturalism gave way to a stylised, simplified shape. The pliant, round and enclosed form contrasts sharply with the gristly, angular and open form of the 1850s and 1860s.

aim was to reform not only art but the whole of society. The aim was to make a clean sweep, a fresh start; at the same time there were high hopes of what might be achieved with the new materials.

All artefacts must reveal the new materials, and the needs of the times, if they are going to fit the modern world ...

Otto Wagner wrote in his significant article *Moderne Architektur*, 1895; and he continued:

So great will be the revolution that we can hardly speak of a renaissance of the Renaissance. A completely new birth, a *naissance*, will develop from this movement.

Not surprisingly the attitude to the preceding period was neither sympathetic nor respectful: Morris spoke scornfully of the 'imitation of an imitation of an imitation'; Voysey of 'the tyranny of styles'; Hankar of 'la sacrosainte Renaissance', while Horta referred to a stylistic 'cacophony'. Today we are in a position to realise that 'Historicism' possesses its own form-language, based on a number of special features, from the ornamental *horror vacui* principle to decorative symbolism; but the Art Nouveau generation were capable of seeing only a degenerate imitation of styles, which had to be abandoned at all costs. This attitude is reflected in a reaction which was only to be expected: Art Nouveau became an anti-movement, both in its ideas and in its form. It rejected, lock, stock and barrel, the interior design of the late nineteenth century. The dark, over-furnished rooms, with their lavish use of textiles and upholstered furniture, were to be replaced by a bright, simple interior, where stylistic unity of the details and of the whole

comprised an essential element. Furniture was carefully adapted to the interior, as we see in the work of Mackintosh, van de Velde and Hoffmann. This striving for synthesis and fusion was so fundamental that its effects can be traced right down to the smallest ornamentation (figures 4·1a and b). The pliant, round and closed form contrasts sharply with the gristly, angular and open. Three-dimensional and illusionary shape has given way to a stylised and simplified two-dimensional conception.

But the question of the justification of ornament for its own sake was never really broached by the Art Nouveau artists. There is, of course, no question of doing without ornamentation. There is a clear line running all the way from Ruskin's statement in *Architecture and Painting*, 1853, that 'ornamentation is the principle of architecture' to Grasset's dictum in 1905:

> The aim of ornamental art, as its name suggests, is to *ornament* artefacts ... devoid as they are of pure construction, they may become clothed for the delight of the eye.[9]

The ornament had its own intrinsic value; for Art Nouveau it was *l'ornement pour l'ornement*.

This is the basic ornamental principle of Art Nouveau, but there were other forces wrestling with ornament. Adolph Loos is reported to have exclaimed to Behrens: 'Ornament is a crime',[10] and Louis Sullivan stated as far back as 1892 that

> ornament is mentally a luxury, not a necessity ... it would be greatly for our aesthetic good if we could refrain entirely from the use of ornament for a period of years ...[11]

We are faced here with a similar dualism, reflecting the same tendencies as we observed in the conflict of handicraft versus the machine – and in the same way the anti-ornamental trend was to make its contribution to the decline of Art Nouveau.

What, then, were the basic theories behind Art Nouveau and its principles of ornamentation? Many of the artists have written about this problem, and it seems possible to extract three main

ideas which together form the basis of Art Nouveau's ornamental theory: the principle of the intrinsic value of line, the organic power of plants, and the structure-symbol.

The cult of line[12]

The theoretical basis for the cult of line was a revulsion against 'the demoralising influence of imitating nature so directly',[13] as Owen Jones expressed it in 1863. New values were sought in nature, and in the work of Jones we also find the psychological factor playing an important role, particularly in his doctrine of colour. He also emphasised that junctions of curved lines with curved, or of curved with straight, should be, as in nature, tangential to each other. Owen Jones is one of the most interesting personalities of this period, and his views on the relationship between construction and ornamentation, also elaborated in 1863, are far in advance of his time.

With the designer and writer Christopher Dresser we move further from the imitative attitude to Nature and approach the symbolical. His conception of Nature was formulated with all the systematic and intellectual circumspection of a trained botanist. It was not until about 1860 that he first started work as an industrial designer and writer on art theory. All his studies were based on a botanical *vue d'ensemble* and were supported by botanical examples. The interesting point, however, is that he warned his readers against undue accuracy in the imitation of Nature in the ornament itself. His curvilinear aesthetics were logically and geometrically based. 'Curves,' he said, 'will be found to be more beautiful as they are subtle in character.' Consequently, the arc was the least beautiful of curves, because its origin was instantly detected, while an egg-shaped curve was more subtle, because it related to three centres. In other words, the beauty of a curve increased with the complexity of its origin. But he also pointed out that 'there must be a graceful flow from one line to the next'. Dresser sought the beautiful line in what he called pliant and energetic curvature.

The aesthetic outlook, however, in all its mathematical logic, was intimately bound up with his views of Nature. He rediscovered the *line of life* in Nature, best expressed in young palms and tropical vegetation, where he found the energetic curve and the linear rhythm he sought. Of proportions he said: 'Proportions, like curves, must be subtle.' Dresser's views on decorative design can be summed up in his three conditions of beauty – of which his curvilinear aesthetic is one, power and utility the others.

If we turn now to the theories of the designer and book illustrator Walter Crane, which he formulated in the years 1888–93, we shall find that he, too, was concerned with line and its emotional powers of expression. It was the most essential factor in his art, and the most important point in his aesthetics (figure 4·2).

Hence LINE is all-important. Let the designer, therefore, in the adaptation of his art, lean upon the staff of *line* – line determinative, line emphatic, line delicate, line expressive, line controlling, and uniting.

It was no coincidence that he opened his book *Ideals in Art* with a tribute to William Blake and his expressive linear rhythm. Furthermore, Crane said of the innate aesthetic value of line:

It does not require use to stop and think . . . to appreciate the rhythmic silent music which the more formalised and abstract decorative design may contain, quite apart from the forms it actually represents.

The French engraver and potter Félix Bracquemond stated in *Du dessin et de la couleur*, 1885:

. . . everything that in art is gesture, movement, character, expression and disposition, becomes *lines* in the work of art.

4·2 Crane: Illustration for his book *Line and Form*, 1900. The wave-line, indeed, may be said not only to suggest movement, but also to describe its direction and force. It is, in fact, the line of movement.

51

Eugène Grasset emphasised the symbolical context when he declared:

> Every curve gives the idea of movement and life . . . the line of the curve should be full, rounded, closed and harmonious like a stalk full of young sap.[14]

And van de Velde, the great theoretician of the Art Nouveau movement, was no less precise:

> When I now say that a line is a force, I maintain something very real. It derives its form and energy from the person who has drawn it. This force and this energy affect the mechanism of the eye in such a way that they extend one's range of sight.[15]

The organic force of the plant

It is not always either easy or necessary to separate individual theoretical principles from one another: they merge, and so we find ideas about the organic force of plants inseparably bound up with their linear qualities. Dresser was among the first to realise the organic forces symbolised by plants. His demand for power in design can best be illustrated by his own drawing (figure 4·3) and his caption for it:

> . . . I have sought to embody chiefly the one idea of power energy, force, or vigour, as a dominant idea; and in order to do this, I have employed such lines as we see in the bursting buds of spring, when the energy of growth is at its maximum . . . and I have also availed myself of those forms which we see in certain bones of birds which are associated with the organs of flight, and which give us an impression of great power . . .

With regard to utility his doctrine is developed largely on the basis of his botanical views: 'In vegetable Nature the utmost regard to fitness is manifested.' He is constantly repeating that 'an object must aptly answer the purpose for which it has been originated.' This is concisely expressed in his sentence 'Utility must precede beauty.' In this connection he refers to Pugin. To a certain extent Art Nouveau and the rational attitude of the Modern

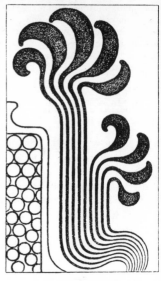

4·3 *Left* Dresser: Illustration for *The Technical Educator*, 1870. Dresser was trained as a botanist and his work is rooted in the study of Nature: 'If a week is not too long to spend in the consideration of a single leaf, how long should we meditate upon a flower? Say a month.'

Movement both had their points of origin in an attitude to Nature: one trend developing the flower, the stem and the rhythm, i.e. the ornament; the other the fitness, the logic and the structure, i.e. the construction.

Walter Crane also dwells on the effect of the ornament as a symbol of force. He is selective in his attitude towards the lines offered by Nature and – as we might expect – is constantly on the look-out for lines which 'are essential to character and structure. They are organic lines, in short. They mean life and growth.' Eugène Grasset has a highly illuminating example of the ornamental application of this organic force – but it has passed through the process which Jean Dampt points out is necessary: it has been transformed, stylised and synthesised. Grasset himself says of his examples (figure 4·4):

4·4 Grasset: Illustration for *Méthode de composition ornementale*, 1905. 53
Grasset, one of the leading French Art Nouveau artists, was like most
designers of the time greatly interested in art theory. In this piece of
ornamentation, the roots and stalks fill a definite ornamental role.

The illustration shows two clusters each gathered together in its root.
One is rectilinear, while the other is portrayed with harmonious curves. It
can be seen here that the movement of the roots can play an important orna-
mental role and that each cluster becomes a decoration at the end of a stalk.

In France as well as in Great Britain we have seen how this
interest in plants made its contribution to the theoretical back-
ground of Art Nouveau. In addition, in the last quarter of the
nineteenth century a whole flood of pattern books appeared, with
plants as the principal motif, culminating in the 1890s with a
complete series, from A. Seder's *Die Pflanze in Kunst und Gewerbe*,
1886, and M. Meurer's *Pflanzenformen*, 1895, to M. P. Verneuil's
Étude de la plante, son application aux industries d'art in 1900, to
mention only a few.

Ornament as structural symbol

The starting point for ornament as a structural symbol seems to be
on the one hand the growing force of the plant motif and on the
other the constructive and decorative qualities of iron. Viollet-le-
Duc's theories and his interest in structure as an architectural
expression in itself proved of fundamental significance to con-
temporary architects: Horta, who regarded Viollet-le-Duc's
writings as his bible, gives iron a decorative form that emphasises
its structural effect. Louis Sullivan singles out precisely the same
phenomenon when he points out that

there exists a peculiar sympathy between ornament and structure. Both
structure and ornament obviously benefit by this sympathy, each enhancing
the value of the other. And this, I take it, is the preparatory basis of what may
be called an organic system of ornamentation.[16]

Nevertheless, the most important champion of this principal was
Henry van de Velde. Van de Velde has been regarded as more or
less the creator and theoretical founder of Art Nouveau, and he
was probably the most committed writer on Art Nouveau at the
turn of the century. He was at the same time the most theoretical

of all theorists and the most vociferous propagandist of the ideas latent in the age. If, however, we examine his direct contribution to the development of art theory, we shall find that the result is somewhat more meagre than his numerous and forceful writings might lead us to believe. Van de Velde must, in fact, be considered in relation to the English art theorists and the Arts and Crafts Movement if we are to see him in the right historical light. In his first publication, *Déblaiement d'art*, *1894*,[17] and his articles in *l'Art Moderne*, he also reveals an excellent knowledge of contemporary English art and theory, and agrees entirely with the younger generation of English art theorists in their attitude to the machine and their social conception of art. But, even more than they, he emphasised that 'l'utilité seul peut régénérer la beauté'.

Van de Velde's spiritual predecessors are obvious enough, and he states as much on several subsequent occasions. And yet he deviates from the general conception of his age in three essential points. The first point lies in his views on the relation of ornament to construction. Unlike the French, he maintains that the function of ornament is not to decorate but

> to structure: The relationships between this 'structural and dynamographic' ornamentation and the form or the surfaces, should appear so intimate that the ornamentation seems to have 'determined' the form.

Secondly, he has a markedly anti-Naturalistic attitude:

> The least sentimental weakness, the least Naturalistic association, is a threat to the timelessness of the ornament.

He could hardly have put it more clearly: the ornament should be abstract, and his attitude is in every way the complete opposite of the English attitude, and also of the French with its 'exécuter *pour servir*, et orner *pour plaire*'. Thirdly, with van de Velde symbolism in decorative art took an entirely new turn. In common with the preceding generation, he too wanted objects to express something beyond themselves and the ornament to act as a symbol – but not as a symbol of any literary idea and certainly not of nature. He

maintained that ornament plus the shape of the object, should express and symbolise the object's function. Through ornament, the aim of the object should be clarified; it should allude to its function and should always be based on reason.[18]

Even though he differed markedly from his contemporaries on these points, van de Velde was, as we have seen, very much in accord with the most essential trend of his time: the cult of line. With van de Velde the role of nature had been played out; line was now all, worshipped in its every aspect – abstract, symbolical, ornamental, and structural.

The contemporary striving for the functional should not be forgotten: it was one of the fundamental ideas among later Art Nouveau artists, an idea that takes us straight to the Modern Movement. We find this striving, which in England goes back to Pugin, clearly expressed on the other side of the Channel, by men such as Gaillard, Guimard, and Gallé. But, unlike the three principles we have already mentioned, we do not find it realised so convincingly. It was to remain a profound undertone, whose full strength only emerged later on. Once again we seem to sense a certain inconsistency in the ranks of the theorists and to note the wide gulf between an idea and its realisation.

Instead of the motto 'Useful and if need be beautiful', the real motto of Art Nouveau was: 'I believe in everything being beautiful, pleasant, and if need be, useful.'[19]

5 Trends leading up to Art Nouveau

Influence of William Blake and the Pre-Raphaelites

It is no easy task to distinguish between consciously formulated theories and trends that were in the air between 1870 and 1900. Yet many of these trends contributed to the development of Art Nouveau almost as much as the theories which we have just discussed.

The earliest 'ancestor' is the English poet and artist William Blake (1757–1827). Robert Schmutzler has made a convincing analysis of his influence on the Pre-Raphaelite Brotherhood and certain artists around the Century Guild, and has established a direct link with English Art Nouveau. Blake's outstanding characteristic as a book illustrator was his ability to create unity between text and illustrations (figure 5·1). His visionary and symbolical poems are woven into their décor, and the lettering has been hand-drawn as part of the picture. As one leafs through his books, flames flicker along each side, enclosing figures and letters, which seem to grow with fierce energy, recalling the poet's own words, 'Energy is eternal delight'.

It was only natural that Dante Gabriel Rossetti (1828–82), leader of the Pre-Raphaelite Brotherhood, should be attracted to Blake, who like himself was both a poet and a painter. In his late teens he became absorbed by the work of Blake, and in 1847 he secured possession of Blake's notebook, which is consequently now often referred to as the *Rossetti Manuscript*. Interest in Blake quickly spread from Rossetti to the other Pre-Raphaelites. Burne Jones would insist on having passages of Blake read to him while he painted, and Selwyn Image lectured on Blake and required several of his drawings for the *Book of Job*, 1826. The illustrator Charles Ricketts was also familiar with Blake, as was Walter Crane.

Blake's art was unique in its time, but viewed in a wider art-historical context his unique qualities can be more easily understood. His flame-like motifs seem to derive from plant studies and the *rocaille*, a motif which had been highly popular during his youth. In the work of the German artist Philip Otto Runge (1777–1810) we find the same fluent, linear rhythm, which at times is

5·1 Blake: Illustration for *Songs of Innocence*, 1789. Blake not only fore-shadowed Art Nouveau, but inspired the Pre-Raphaelites. The cover for Swinburne's book on Blake, 1868, was directly inspired by Blake's own drawings. The first Blake exhibition was in 1876.

charged with growth. A similar linear tendency is apparent also in the work of Ingres (1780–1867), but perhaps the appearance of it in the work of the Swiss artist Johann Heinrich Fuseli (Füssli) (1741–1825) is of still greater interest. Fuseli lived for most of his life in England, and we can see in his drawings particularly an expressive and wave-like rhythm similar to that of Blake. Generally speaking, the period around 1800 reveals a certain linear refinement which anticipates Art Nouveau without having any apparent connection with it. Only in England – and there only in the work of William Blake – is it possible to trace a direct connection right through to early Art Nouveau. We may speak of an uninterrupted sequence, running from the Pre-Raphaelites' enthusiasm for Botticelli and Blake, to Crane's linear aesthetics and Beardsley's elegant play with lines and curves. For the earliest Art Nouveau style was to evolve in a circle of late Pre-Raphaelites, comprising

artists such as Walter Crane, George Heywood Sumner, Herbert P. Horne, Selwyn Image, Aubrey Beardsley, Charles Ricketts and the architect Arthur Mackmurdo (who was not exactly a Pre-Raphaelite, but considered himself the bearer of Pre-Raphaelite principles). The importance of late Pre-Raphaelitism can hardly be over-estimated, as far as the development of early Art Nouveau is concerned. The late Pre-Raphaelites' sense of the intrinsic value of line, their female type and their preoccupation with floral rhythms, such as we find especially in the work of Crane, together with the elongated proportions and tendencies to symbolism in their paintings – all these factors provide clues to an understanding of Art Nouveau, particularly in England and Scotland, but also in Holland and Belgium.

Japanese and oriental influence

During the early 1860s an Oriental influence suddenly became apparent in Western art. In 1862 amateurs in London and Paris were at last able to buy specimens of Japanese art, for this year Japan appeared for the first time as an exhibitor at the World Exhibition in London, and allowed the firm of *Farmer and Rogers* to sell off its exhibits at the close. The manager of this firm was none other than the young Arthur Lasenby Liberty, who in 1875 established a firm of his own called East India House in Regent Street, London, which was later to turn into the celebrated house of Liberty & Co. Ltd. In 1862, too, Madame de Soye opened her shop *La Porte Chinoise* in the Rue de Rivoli in Paris, where Japanese prints and other Far Eastern wares were on sale. In 1862 the English architect Edward William Godwin furnished his house in a simple Japanese style, with plain colours and Japanese prints on the walls. In his reminiscences William Rossetti relates that 'the "Japanese mania" began in our quarters towards the middle of 1863', and he also tells us that 'it was Mr Whistler who first called my brother's attention to Japanese art'. Whistler undoubtedly played a decisive role in introducing 'the blue and white' from Paris to London.

In Whistler's pictures from the 1860s Japanese figures and objects introduced without any obvious specific purpose, are of frequent occurrence, as in *The Golden Screen* and *La Princesse du Pays de la Porcelaine*. Subsequently he abandoned this rather superficial approach, and began to look more deeply into the underlying pictorial values of Japanese art. This was also true of a great many others, as familiarity with Japanese art increased through the medium of publications.

In 1867 appeared Owen Jones's *Examples of Chinese Ornaments*, in 1878 R. Alcock's *Art and Industries in Japan* and two years later both O. H. Moser and T. W. Cutler published books on Japanese design and ornamentation. In 1882 came Dresser's *Japan, its Architecture, Art and Art Manufactures*, followed in 1883 by L. Gonse's *L'Art japonais*. These represent only a selection. It is also worth noting that Bing, Tiffany and Liberty all collected oriental art, while among the creative artists Beardsley, Eckmann and Toulouse-Lautrec cultivated a vein of Japonaiserie.

The Japanese influence came later in France, even though Bracquemond's chance discovery of Japanese prints used as wrapping-papers occurred in 1856. Not until the 1870s did designs appear on the Continent that could be compared with the English.[1] As far as the Nancy School was concerned, it might be interesting to mention the special way in which Japanese influence was introduced. In 1885 a Japanese botanist called Takasima went to Nancy to study at the *École Forestière*. He happened also to be a *savant-artiste* and made friends with Vallin and Gallé, so that we have good reason to believe that the presence of Takasima helped to increase the interest in Japan and Japanese art.[2] After the exhibition in 1889 E. de Vogue, writing about Gallé, said: 'Bénissons le caprice du sort qui a fait naître un Japonais à Nancy.'[3] ('Let us be grateful for the quirk of fate which caused a Japanese to be born in Nancy.')

Practically all artistic genres were influenced by Japanese art; painters particularly were concerned with two-dimensional problems. By abandoning a fixed background plane the artist could place his figures more freely in space, while the absence of

5·2 Godwin: Design for Anglo-Japanese furniture, 1877. The Japanese sense of simplicity in construction, recti-linearism in design and delicately placed ornamentation were among the basic principles adopted by European artists – as can be seen in the work of Godwin.

central perspective was another step in the same direction. Another feature that produced a new spatial effect was recourse to a high horizon line. Tall forms were much cultivated and great use was made of an elegant – almost haphazard – placing of the human figure. A refined and sophisticated use of line was naturally insisted on. The use of vertical lettering on the picture-surface, equally a Japanese device, was to prove of the greatest significance in poster art, book illustration, and lettering. The Japanese influence on Art Nouveau involved, in these artistic genres, a radical break with traditional nineteenth-century European design, so that text and image now fused together to form an artistic whole as formerly seen only in Blake's books and in medieval illuminated manuscripts.

In applied art the Japanese influence likewise left abiding traces (figure 5·2). The conception of asymmetry also affected furniture, which now became liberated from the previously inescapable principle of symmetry. Still more important was the actual conception of furniture as a refined 'creation' with a simple and occasionally almost fragile construction. The *horror vacui* of Historicism was replaced by an *amor vacui*. The bare, unadorned surface attracted renewed interest, and it was discovered that a sparing use and careful placing of ornament increased its effect and value. Japanese rectilinearism in furniture design was an important influence in certain parts of Europe, particularly in Scotland, England, and Austria, while an appreciation of dark woods and of black painted furniture became more general. Last but not least, people's eyes were opened to an interior as a whole, to a simple but elegant approach to furnishing, placing and grouping.

The Japanese contribution was the most important exotic element and its bearing on Art Nouveau was considerable in a great many sectors. But there were trends, too, from other parts of the world, which caught the imagination of western Europe in the closing decades of the nineteenth century: orientalism, exoticism, primitivism and even influences from Egypt all played their part. None of these trends, however, is comparable with the Japanese influence. But in some countries orientalism could be reconciled with national

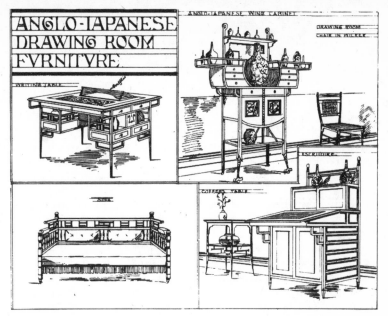

ANGLO-JAPANESE DRAWING ROOM FURNITURE

tradition and at the same time serve colonialism. As Clay Lancaster has pointed out, European countries undoubtedly considered 'orientalism a by-product of the new imperialistic pride in territorial possessions, particularly England that of India, France that of Indo-China and the Netherlands that of Java.'[4]

In Belgium the jeweller Wolfers introduced ivory from the Belgian Congo as a fashionable material, and in Holland T.A.C. Colenbrander introduced the Javanese batik pattern, both in ceramics and in textiles. His colleague Willem Dijsselhof, as was noted even at the time, showed signs of oriental influence.[5]

Marcel Bing's final pronouncement (1901) in his chapter on Japan in Richard Grant's book *Die Krisis im Kunstgewerbe* may well serve as a fitting conclusion:

Thus some artists believed they could find a new source of ornamentation, or even the lost principles of modern style in various linear combinations.

These attempts seem to have been inspired to a certain extent by the graceful wavy movement of Japanese line, which has so happily influenced linear ornament. Without a doubt drawing has in the decorative arts experienced an enrichment in new kinds of linear coils and developed a manner in which can be found something of the charming pliancy and sound decorative understanding of oriental motifs.

The Gothic Revival

Is Historicism a style, or is it many different kinds of style? It might even be described as all styles in one. A feature common to the development from about 1820–90 is an historical interest in the styles of past periods, a retrospective view which in many ways is rooted in the interest in the Middle Ages promoted by the Romantic Movement. The *Einlebung* (empathy) and enthusiasm of Historicism is also a trait inherited from Romanticism, but as the development proceeded the Romantic *point de départ* was gradually lost sight of. It was not only the Middle Ages that were 'revived', but – one by one – the Renaissance, the Baroque, the Rococo, and the Classical, though not necessarily in this historical sequence. Then, in about 1890, one gets the impression that chunks of period style are being served up afresh! At any rate, they became indiscriminately mixed. The Romantic approach was abandoned, giving way to a more scientific view, with empathy yielding to the interests of archaeological and art-historical research. Nevertheless, the whole of this period possesses a form-language, a mode of expression, which has only recently engaged the serious attention of scholars, among them Nikolaus Pevsner and Karl Scheffler.[6] Yet how could this period, against which Art Nouveau reacted so violently, significantly influence the shape of the style?

The importance of Historicism to Art Nouveau, apart from the purely negative and formal reaction, is to be found on two levels: one indirect and preparatory (here the Gothic Revival comes in), the other formal (here the Neo-Baroque and Neo-Rococo formal conceptions come in). The prophets and champions of Neo-Gothic, such as Pugin, Viollet-le-Duc, Ruskin and William Morris, modelled themselves on medieval ideals of craftsmanship and the principles of Gothic architecture. William Morris developed an art which, in its form, is far removed from Art Nouveau, but in its striving for renewal, and in its entire approach as a reform movement, has a great deal in common with what subsequently occurred in the 1890s. The Gothic Revival, as developed by Morris, is the

forerunner and the basis of the Arts and Crafts Movement: without this foundation of knowledge and understanding of the Middle Ages the further development of the Movement would have been impossible, and it is in the ranks of the Arts and Crafts Movement that we find English proto-Art Nouveau. At the same time the interest in structure – visible structure – may be said to reflect the interest in the architecture and construction of the Middle Ages. Not only did honesty in the use of materials and a feeling for good craftsmanship provide inspiration, but an understanding of visible construction was perhaps an even more important factor where Art Nouveau architects were concerned. In the work of Victor Horta, for example, we find his Neo-Gothic form-language in iron entering into a sort of marriage of convenience, on a constructive basis, with Art Nouveau. Again, van de Velde maintained that his countrymen were caught by the 'pure reason' of the Gothic.[7]

Eugène Grasset reflects the French attitude and the heritage from Viollet-le-Duc when he declares that one ought to 'étudier le Moyen-Age pour en tirer le bon sens'.[8] The Spanish art historian Andrés Calzada mentions Ruskin's doctrine in connection with Gaudí's architecture, emphasising the constructional aspects and noting that Gaudí at times conforms closely to Viollet-le-Duc's intentions. No less interesting is Gaudí's own remark on the Gothic as 'sublime, but incomplete; it is only a beginning, stopped outright by the deplorable Renaissance . . . Today we must not imitate, or reproduce, but *continue* the Gothic, at the same time rescuing it from the flamboyant'.[9]

Morris's pupil John Sedding summed it all up:

Our Gothic Revival has been a solid, not a trifling transient piece of art history. It has enriched the crafts by impetus and initiation. It has imbued two generations of art-workers with passion. It has been the health-giving spark – the ozone of modern art.[10]

It would be wrong to over-estimate the importance of the Gothic Revival in connection with trends leading up to Art Nouveau but it is of fundamental importance in understanding the age, the Arts and Crafts Movement, the Modern Movement and Art Nouveau.

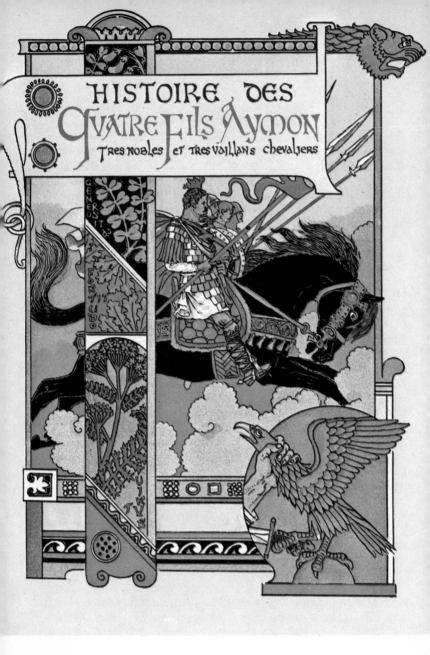

HISTOIRE DES
QVATRE FILS AYMON
TRES NOBLES ET TRES VAILLANS CHEVALIERS

5·3 Grasset: Cover for *Histoire des Quatre Fils Aymon*, 1879–83. In this fabulous tale from the time of Charlemagne, the design is naturally in harmony with the story, but among the Celtic details are also to be found traces of Japanese design.

Neo-Rococo[11]

Among the other period styles of Historicism, Neo-Rococo is the oldest. In its essence and expression it differs widely from the Gothic Revival. While the latter was a movement which arose in the same way as Neo-Classicism in the latter half of the eighteenth century, and like it became an expression of a deep-rooted movement and a fresh cultural outlook, Neo-Rococo was not a movement in that sense of the word. It was the stylistic expression of a search for something new – a fashion which flourished from approximately 1835–40 until superseded by Napoleon III's Classicism in the 1860s, to reappear a second time in a somewhat coarser and more violent form-language together with Neo-Baroque during the 1880s and 1890s.

Its appearance was neither entirely sudden nor entirely accidental. Just as in its origins Rococo is a French style, so likewise is Neo-Rococo. When Louis XVIII assumed power at the Restoration (1815–24) it was a true Bourbon who ascended the throne and, as though to emphasise that old traditions were being renewed, he re-introduced Rococo. Neo-Rococo contained form-elements far more favourable to a combination with Art Nouveau than the Neo-Gothic. It showed a plastic treatment of the whole as well as of the details and often a well-nigh bombastic fashioning of each separate element. Neo-Rococo lacked, somehow, the elegance of Rococo, but had the same asymmetrical sense, sometimes in the details and at times in the whole. Asymmetry was one of the essential features of Art Nouveau, and it is not unlikely that this may have been due in part to the influence of Neo-Rococo, although the Japanese influence must also be taken into consideration.

In as much as Rococo and Neo-Rococo both reached their finest flowering in France, it seems reasonable to trace the source of their influence on Art Nouveau to that country. It is in Nancy that we find the most intimate connection between Neo-Rococo and Art Nouveau.

It is hardly surprising that Neo-Rococo should have established

5·4 As jewellery designer, Alfred Gilbert was inspired by Mannerism – he was in a way the Cellini of Art Nouveau. In the centre of the badge of the *Preston Chain*, 1888–92, we find a peculiar blend of the style of past centuries and the passing fashion of a style not yet born.

itself in this Rococo city and it is easy to understand why the artists who lived and worked there should have carried on the proud traditions of their native town. Subsequently, when the artistic revival and flowering took place in the 1890s with the rise of the Nancy School, the motifs of Neo-Rococo in their turn made their appearance, fusing with the form-elements of the new style. Émile Gallé's earliest work reveals clear traces of Rococo, while Louis Majorelle worked both in a rich Rococo *à la Louis XV* and in an austere Classicism *à la Louis XVI* before his 'conversion' to Art Nouveau. Like Gallé, however, he always retained traces of Rococo in his Art Nouveau – the flame motif, the tapered legs, the *C* motif, and the use of brass. As we shall see later, Art Nouveau was merged completely with Rococo in the furniture designs of the Nancy School.

But it was not only in the Nancy School that this influence was noticeable. Already in 1899 K. Scheffler drew attention to Rococo's importance to Art Nouveau, and in the *Deutsches Wochenblatt* (p. 408) he wrote:

Sharp eyes are needed to see the Rococo behind the work of the moderns, and above all in the art of van de Velde. But once it has been spotted it is undeniable, and one is glad that tradition still plays a role in the art of modern architecture.

The influence of Rococo and Neo-Rococo on Art Nouveau is limited mainly to France and Belgium, and is especially dominant in Nancy. The elegant use of flowers and the naturalistic way in which they are arranged – not common to Art Nouveau in general – may have been stimulated by this trend and may partly explain how French Art Nouveau at times came close to a pure imitation of Nature. The sense of ornamental asymmetry may also derive from Rococo. Another major feature that Rococo has in common with Art Nouveau is the unified conception of the interior and there are good reasons for believing that this striving for a fusion of room and furniture, which is to be found in Art Nouveau, is in part at least inspired by Rococo.

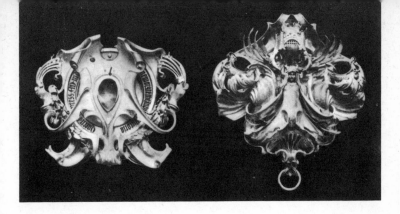

Neo-Baroque[12]

Neo-Rococo, which survived into the 1850s – and in the case of Germany into the 1860s – was succeeded by Neo-Renaissance, which flourished in Germany in the 1870s, stimulated by the wave of nationalism which followed the war of 1870–1, the Munich Exhibition of 1873 giving it an important start. Neo-Baroque then flourished in Europe during the 1880s and 1890s, though its origins in France can be traced back to the 1860s, while in Holland its influence was negligible, owing to the fact that the Dutch adhered more closely to Neo-Renaissance than most other countries because of their rich Renaissance traditions. There is something dramatic about the Neo-Baroque style in its violent light-and-shade contrasts, and something theatrical in its lavish use of architectural effects.[13] Bold cornices and deep incisions seem at times to transform the surface into a battlefield between light and shade. Not only do the details emphasise the vigorous treatment, but even the actual mass of a building can be subjected to the same plastic treatment.

The conception of form did not apply only to architecture, but can be encountered also in applied art. Again, with its markedly plastic effect the style was eminently suitable for sculpture, and it is in sculpture that Neo-Baroque first fuses with early Art Nouveau. Karl Scheffler has called it *Jugendstilbarock*, a term which indicates the fusion of styles that took place at this time.

In England we find that the Neo-Baroque conception of style exercised a fundamental influence in this respect; in particular it can be seen in the Mannerist form-language of Walter Crane, and to a special extent in that of Alfred Gilbert. In jewellery and ornamental work Gilbert developed a style which is patently

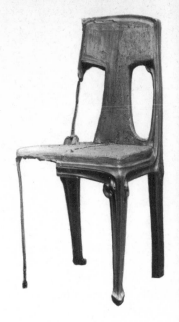

5·5 André: Modelled
prototype for chair, about
1901. The plastic concep-
tion of objects was so
important to some Art
Nouveau artists, that
almost everything they
made they modelled first
in clay.

inspired by Baroque (see Chapter 6), but which in an astonishing
way reveals features that herald the Art Nouveau style (figure 5·4).
It is strange that we should find in the work of an English artist of
all people – although trained in Paris and Rome – the form-
language of Baroque, with its gristle and crayfish-like ornaments,
transformed into Art Nouveau, foreshadowing Hector Guimard's
Métro fantasies thirteen years later.

In France the fluent form-language of Baroque and the pliant
fusing of one shape into another was especially developed, and
both here and in Belgium we find the same tendency to bend and
mould materials and forms ruthlessly to the new fluent design.
This particular aspect of Art Nouveau can no doubt best be
explained as the heritage of certain Baroque form-conceptions
which were well to the fore in this period. The fact that Horta
modelled his architectural details in clay – whether he was working
in iron, wood, or stone – is highly illuminating, as is also the fact
that the Nancy architect Émile André preferred to model than to
construct his chairs. So it is hardly surprising that the chair, the
ornament and the total effect were plastic (figure 5·5).

The Celtic Revival

This revival, as we have previously noted, was closely associated with a literary trend, and has a limited geographical distribution, in common, incidentally, with several of the trends we have already dealt with.

Hand in hand with enthusiasm for the Middle Ages and interest in historical research went an interest in Nordic archaeology, and in Great Britain people became alive to the remarkable art and ornamentation of the Celts. In the 1840s, 1850s, and 1860s George Petrie and Henry O'Neill published works on Irish archaeology, and in 1863 O'Neill stated that

among the branches of manufactures which have, within the last years, made great progress in Ireland, that of brooches and other personal ornaments in imitation of the old Irish models, holds an important place.[14]

Thomas Howarth has pointed out that this resurgence of national spirit also found expression in Scotland, and emphasises its influence on the Glasgow School. This is the stylistic trend which comprises the direct predecessor to Liberty's *cymric* silver, round about the turn of the century. In France Grasset was the foremost representative of this style, as can be seen in his early book illustrations (figure 5·3; see also chapter 6).

The influence of the Celtic Revival on Art Nouveau should not be over-estimated: geographically speaking it is a somewhat limited phenomenon, being mainly confined to Scandinavia, England, Scotland and Ireland, although a Merovingian influence is also visible in Tiffany's metalwork in the 1890s. The Neo-Celtic style was also quite naturally more confined to special fields: the art of the silversmith and of the book illustrator. Only in Scandinavia was it of any importance to furniture making, interior design or architecture. But the linear rhythm in the decorative works of the Celtic Revival may have helped to prepare the ground for Art Nouveau, and it may be assumed that the use of the *entrelac* motif in Art Nouveau is explained by the influence of the Celtic

Revival. The Celtic Revival thus contributed to the origin of Art Nouveau both directly, through form, and indirectly by the increasing interest in artistically decorated and illustrated books. When the two styles fused into an ornamental symbiosis in the hands of gifted artists, a new Nordic aspect of Art Nouveau emerged, the *Dragon Style* (figure 2·6).

The Arts and Crafts Movement[15]

In the last three decades of the nineteenth century powerful forces were at work in every country in Europe to renew the arts and crafts, initiated by a number of official organisations. But it was in England and France that the problems were first systematically tackled: both countries had rich artistic traditions, and it was in them that the development was to prove of more universal interest. On the whole it may be said that in England and France the pattern was set that was to be followed by the other European countries. For both of them the Great Exhibition in London in 1851 was the beginning. In France the designer Charles Clerget made an appeal in 1852 to the *Comité Central des Arts Appliqués à l'Industrie* to help put things right by setting up a museum of applied art. In the same year the sculptor Klagmann suggested that attempts should be made to improve the relationship between artist and artisan. In 1856 appeared *De l'Union des Arts et de l'Industrie*, the work of that tireless champion, the Comte de Laborde, and in 1858 there was established the *Société du Progrès de l'Art Industriel*. In 1864 came the *Union Centrale des Beaux-Arts Appliqués à l'Industrie*, an organisation which arranged exhibitions and was very active in the 1860s and 1870s. The *Société du Musée des Arts Décoratifs*, founded in 1877, worked hand in glove with this organisation, and in 1882 the two bodies effected a fusion, which resulted in the creation of the *Union Centrale des Arts Décoratifs*, with its own organ, the *Revue des Arts Décoratifs*, which was to play an important role in the 1890s. At the World Exhibition in 1889, where Gallé made his *début*, it became obvious that there existed a need

for a *salon* for decorative art. From 1891 annual exhibitions were held in the *Salon du Champs de Mars*. Here artists such as Chaplet, Cheret, Charpentier, Dampt, Delaherche and Gallé met and mingled with other artists and painters. In 1893 Chennevières started buying examples of modern applied art for the newly organised *Luxembourg Museum*.

Though the starting point in England was the same, the development nevertheless took a somewhat different turn. An important difference between the English Arts and Crafts movement and the French movement was that the former was more closely associated with the Middle Ages – not in form, but in spirit. Sporadic attempts at guiding the movement into proper channels had been made by various local organisations, while in 1835–6 a Parliamentary committee was appointed to look into art education. Its findings resulted in the setting up, in 1837, of the *Normal School of Design*, which in 1849 had as many as sixteen branches. The severe criticism and reaction which were a sequel to the Great Exhibition were also soon to bear fruit. In 1852 the *Department of Practical Art* was set up, though its name was changed after one year to the *Department of Science and Art*, and at the same time the *Victoria and Albert Museum* was founded, with the assumption that a great deal of its activity should be based on teaching. The most important single artist was William Morris. In 1860, a year after he had moved into the *Red House*, newly married and full of optimism, his firm was established, with offices in 8 Red Lion Square, close to the house where he and his companions had lived during their gay student days. The *Red House*, its architecture and interior fittings, as well as the men who worked there, are all important factors in the history of nineteenth-century art and of basic importance to the Arts and Crafts Movement. Here, in almost rural surroundings, William Morris worked with Philip Webb, Ford Madox Brown, Edward Burne Jones – and occasionally Dante Gabriel Rossetti – as well as the shrewd mathematician Charles J. Faulkner. The seventh member of the firm was Peter Paul Marshall, a friend of Madox Brown, originally an engineer but like the others

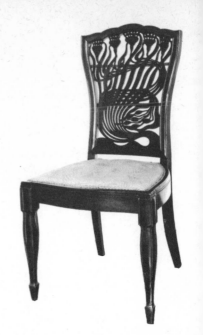

5·6 Mackmurdo: Chair, 1882. This piece of furniture is one of the very first examples of Art Nouveau in applied art. It is traditional in construction, but the back has seaweed-like stalks and flowers which undulate in a rhythm which is entirely Art Nouveau.

intensely interested in arts and crafts. From the 1870s Morris and his movement seemed to be having a clear influence on contemporary taste and trends, and by now the firm had taken part in international exhibitions, while its production comprised practically every branch of applied art.

The generation born around the year 1850 – Arthur Mackmurdo in 1851, Walter Crane and Lewis Day in 1845, Selwyn Image in 1849, C. F. Annesley Voysey in 1857, as well as the somewhat younger Herbert Horne, born 1864, and Charles R. Ashbee, 1863 – were all in one way or another associated with Ruskin and Morris or the Gothic Revival. It was this handful of enterprising men who were to start the Arts and Crafts Movement and become the leading lights in the various organisations which the Movement fostered.

Of these organisations, the oldest was *The Century Guild*, founded in 1882 with the object – as expressed in its statutes – 'to render all branches of art the sphere no longer of the tradesman, but of the artist'. In 1884 a number of artists, who since 1881 had been in the habit of meeting at the house of Crane, formed themselves into an organisation called *The Art Workers Guild*, with Crane and Day as

its leading originators. These last two were also actively engaged in the *Arts and Crafts Exhibition Society*, both at its inception in 1888 and its subsequent development. A smaller organisation, the *Home Arts and Industries Association*, was established in 1885, and here too Mackmurdo was actively engaged. In 1888 both the *Guild and School of Handicraft* and the *National Association for the Advancement of Art and its Application to Industry* were founded, the former on the initiative of Ashbee, while in the latter Mackmurdo and Crane were active members from the start. In this milieu of Gothic Revivalists, naturalists, and theoreticians – a milieu which was alive to the simple and the genuine, where a Ruskin or a Morris could be a source of inspiration – we shall find the first linear and floral English Art Nouveau, created by Crane, Dresser and Mackmurdo (figure 5·6).

The Arts and Crafts Movement is, in its widest sense, the most important contribution to the entirely new trend in applied art both in Great Britain and on the Continent – and yet at the same time a factor which must be taken into consideration in the purely formal development of Art Nouveau.

6 Early Art Nouveau

English proto-Art Nouveau

Among all the remarkable inventions and the astonishing wealth of goods of every kind shown to the public at the Great Exhibition of 1851, a group of earthenware by Grainger & Co. attracted attention and came to be described as 'curiosities'. These objects are of considerable interest to us because while their actual forms and purely naturalistic decoration – imitative and without abstraction – belong absolutely to the period around 1850, the graceful way in which the plants encircle the object, as well as the reed-shaped leaves with their willowy rhythm, anticipate the style of the 1890s. No less interesting is the functional role allotted to certain plant shapes. We can hardly call this collection Art Nouveau: it embodies certain individual phenomena which reveal what Naturalism in applied art can achieve, and yet it foreshadows to some extent the development which was to come some decades later.

One of the outstanding personalities in the ranks of English draughtsmen in the 1860s and 1870s was Walter Crane, who worked as painter, draughtsman, author of children's books, art critic and industrial art designer. As a young man he was attracted to woodcuts, and at this stage of his life he admired the Pre-Raphaelites. A visit to Florence in 1871 aroused his interest in Quatrocento, and characteristically he was attracted to Botticelli. During the 1870s he developed his own style as an illustrator and pattern designer, which involved a monochrome background, undifferentiated planes and a non-plastic treatment of the figures, although outlines were always clearly emphasised. In *Lines and Outlines*, 1875, whose title is revealing enough in itself, he achieved his own personal form-language with qualities which we find at about the same time in his pattern designs, as may be seen in *Bo-Peep*, *Boy Blue*, *Queen of Hearts*, *The Sleeping Beauty*, *Iris and the Kingfisher* and *The House that Jack Built* – all nursery wallpapers, many of them having the same title and subject-matter as we find in his children's books. A vignette for *The Baby's Bouquet*, 1878, reveals his knack of giving a floral motif an entirely new rhythm

6·1 Crane: Vignette for
Baby's Bouquet, 1878.
The stylised flower in
this modest vignette has
a graceful, rhythmic line
which is remote from
the naturalistic trend of
the time and points
towards Art Nouveau.

6·2 Crane: *The House
that Jack built*, 1875.
Crane's nursery wall-
papers often took their
motifs from his
children's books. The
tale was woven into a
charming world of coil-
ing tendrils and animals
at play, in which the
subtle rhythm of Art
Nouveau was never far
distant.

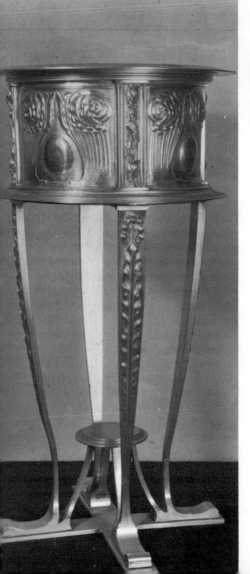

6·3 *Above* Dresser: Claret jug, glass mounted with silver, 1879. Dresser's ideas were expressed in a form language which showed intellectual clarity, simplicity of structure and truthfulness of material and construction. His actual designs, however, were not always so revolutionary.

6·4 Mackmurdo: Lamp stand in *repoussé* brass, 1884. With Mackmurdo English proto-Art Nouveau went beyond two-dimensional art. His lamp has the usual floral motifs, and the curvature of the simple construction adds to the advanced design.

and decorative force, thanks to the play of line (figure 6·1).

What strikes us in Crane's design is the growing force and great wealth of floral motifs. His figures are enclosed in this floral world, and become part of it, as in *The House that Jack Built* (figure 6·2). Here the stem of a plant sweeps along in a curve which ends in an energetic counter-movement. This curve, with its flowing lines and energetic termination, is one of the floral characteristics of the Art Nouveau style, and distinguishes Crane's patterns from those of his contemporaries. Unlike Morris's patterns, for example, which Crane said had started him off,[1] Crane's curves are asymmetrical. Morris's tendril compositions always remained symmetrical even when the pattern was composed of diagonal rhythmic stems. Crane developed a stylistic element based on floral principles – a linear form of expression – which was new and fundamental and was to prove one of the outstanding features of the Art Nouveau style.

A man of an entirely different cast of character was Christopher Dresser, whom we have already come across as a theorist (see chapter 4). This botanist was also a keen designer and writer. He was, among other things, art editor of the *Furniture Gazette* and one of the founders of the *Art Furniture's Alliance*. At the end of the 1870s he was associated with Linthorpe Pottery as art adviser, but he also worked in glass and metal. His claret jug from 1879 (figure 6·3) shows a revolutionary simplicity which places it apart from contemporary work – including the bulk of his own production. Not least striking is the graceful play of line, and the way in which the constructive elements enfold the glass, giving an impression of force and pliancy. Involuntarily one is reminded of the inspiration he sought 'in certain bones of birds which are associated with flight and strength'.[2]

Crane's and Dresser's work contain elements which became an essential part of the Art Nouveau style. It is no coincidence that it is precisely in the work of these theorists, both of them with a marked penchant for the linear, that we should first find those features which were to become so popular and fundamental in the later form-language.

We next come across clear Art Nouveau tendencies in the drawings and designs of one of the leaders of the Arts and Crafts Movement, Arthur H. Mackmurdo, a man trained in the Neo-Gothic tradition, who accompanied Ruskin to Italy in 1874. In 1878 and 1880, he was once again in Italy, and his sketchbooks from this period contain – apart from architectural studies – a whole series of naturalistic studies of flowers, tendrils, buds and stalks. Immediately after his return home he assisted in founding the *Century Guild*, 1882, and began to design textiles and furniture. In 1882 he designed two textile patterns as well as the chair decorated with an Art Nouveau-like motif on the back.[3] In the *Peacock* wallpaper, 1882, we find a floral motif with the same floating, seaweed-like character. That year Mackmurdo also designed a tapestry, with a floral motif whose restless rhythm and whirling movement repeat in more lively fashion the formal elements we have already noted. In 1884 he designed a printed cotton fabric, *The Cromer Bird* (figure 6·7), a design reminiscent of drifting seaweed where the birds look more like fish, and this floating stalk motif was to prove his favourite throughout the 1880s. It possesses moreover the characteristic counter-movement which gives it added power and an effect of suppleness. When Mackmurdo designed the cover for his book *Wren's City Churches*, 1883, he used the same floral motif, and while the three surrounding peacocks have little bearing on the plant stalks, it is still more difficult to find any association between cover and contents. Mackmurdo merely uses the cover to give expression to his decorative talent. But he did not confine himself to two-dimensional motifs: in 1884 he completed among other things a screen[4] and a lamp stand, of which the top part was in *repoussé* (figure 6·4). We recognise the stalk-like floral motif, while the supple rhythm of the legs with their energetic curves reminds us of Dresser. That other traditional elements are also to be found in this, as in so many of Mackmurdo's products, is a different matter. In the 1890s we find him adopting a far more traditional approach, and after the turn of the century he devoted his energy to other work.[5]

Another member of the Arts and Crafts Movement who designed in a similar style was Selwyn Image. His cover for *The Hobby Horse*, 1888, has the same stalk-like feature that we find in much of Mackmurdo's work. In other respects, too, he employed a style that was highly akin to Mackmurdo's.

Charles Annesley Voysey occupies a unique position. He designed his first wallpapers and textiles in 1883, under the direct influence of Mackmurdo. He used plants or animals as his motifs but Nature was stylised and subjected to the rhythm of a linear force entirely in the spirit of Art Nouveau, as for example in *Design for Printed Textile*, 1888 (figure 6·8), and *Water-snake*, from about 1890. In the later years of the decade his forms lost their frenzied movement, and his many birds began to settle peacefully among foliage and greenery. Even though Voysey took a firm stand against Art Nouveau, many of his designs in the early period were, in fact, very much Art Nouveau. His work proved popular and his influence on the Continent was considerable. Another designer associated with the Century Guild was Herbert P. Horne, joint editor with Mackmurdo of *The Hobby Horse*.

In *The Hobby Horse*, from the very first number in 1884, we find certain features that were to prove of fundamental significance to book illustration and the graphic arts in the 1880s and 1890s. Not only the page but the entire layout was treated as an artistic entity. The illustration was not merely a dependent narrative element, but an integral part of the whole. The flame-like, flowing movement in the illustrations was also in evidence, even though later in the 1890s floral motifs were to play a predominant part in this style. The two-dimensional effect of the woodcut, concise and artistic, was also fully developed with special emphasis on the innate value of line. A particularly important point is that *The Hobby Horse* abandoned the illusionistic three-dimensional art of illustration. Admittedly, complete understanding and exploitation of the two-dimensional effect, and of the ability of line to create two active surfaces – the enclosed and the unenclosed – had not been fully developed in the illustrative art of *The Hobby Horse*, nor had

6·5 Ricketts: Illustration for Oscar Wilde's *A House of Pomegranates*, 1891. Ricketts was one of the most gifted of the English illustrators at work around 1890. His drawings show the influence of the periodical *The Hobby Horse*, and at the same time point to the development of the later 1890s.

6·6 Robert Burns: *Natura Naturans*, 1891. This picture has all the swirls of English proto-Art Nouveau, but also portrays the female type of the period with drooping lids, long, wavy hair and expressive movement of the hand.

the free Japanese-inspired treatment of surface, even though there is a hint of this too in the placing and design of letters. But *The Hobby Horse* is the first periodical which expressly tackled the task of renewing typography and book illustration.

The Hobby Horse soon had a number of imitators: in 1889 the first number of *The Dial* appeared, edited by Charles Ricketts and his pupil Robert Shannon. As an illustrator Ricketts derived his style from *The Hobby Horse* and from the art of this group, while at the same time he foreshadowed the illustrations of the 1890s, changing his style in the early years of this decade and placing more emphasis on line. Among other things he illustrated Oscar Wilde's *A House of Pomegranates*, 1891 (figure 6·5), and *The Sphinx* in 1893. His book-binding technique followed the same principle as René Wiener's at Nancy, in that the entire cover was regarded as part of an artistic entity though there was far more emphasis on line than was the case with Wiener.

Another illustrator who should also be mentioned in this connection is Robert Burns, whose drawing *Natura Naturans*, 1891 (figure 6·6), published in *The Evergreen* in 1895, reveals all the qualities of Art Nouveau illustration in line, space and two-dimensional conception.

The leading English book illustrator was of course Aubrey Beardsley. At the age of twenty he had already interpreted – we might almost have said anticipated – the mood of the 1890s in a whole series of sophisticated and daring drawings. Beardsley was not a direct product of the late Pre-Raphealites, though at an early stage he had been in contact with Burne Jones and Morris. However, he slipped elegantly and with ease into the linear style of the

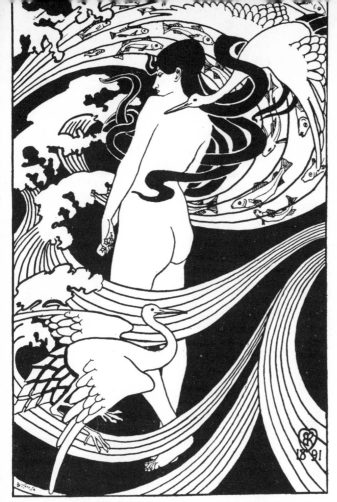

age and, with the emphasis on line, fused Japanese refinement and Pre-Raphaelite rhythm into a personal style, filled with the *New Voluptuousness* of the 1890s. A special feature of his style is his evenness of stroke: temperament is expressed not by varying thickness, but merely through linear development. Beardsley's most important contribution is undoubtedly to be found in the effects he evoked by allowing both the areas included, and excluded, by the line to be activated by the effect of the contour: the actual figure itself as well as the empty space around it. In 1892

6·7 *Below* Mackmurdo: *The Cromer Bird*, printed cotton, 1884. Mackmurdo created many textile designs in the 1880s. They all have the same whirling, flamelike movement, based on floral motifs. Often the colours are brown, shading into violet at one extreme and pale beige at the other, brightened with accents of blue.
6·8 *Right* Voysey: Design for printed textile, 1888. At an early stage Voysey was influenced by Mackmurdo and joined the English proto-Art Nouveau designers.

Beardsley completed the illustrations for *Morte d'Arthur*. In 1893 he was working on the illustrations for *Salome* (figure 3·2). In the same year appeared Ricketts's illustrations to Longus's *Daphnis and Chloe*. In 1896 Ricketts started his own printing press, *The Vale Press*.

Parallel with this development we have William Morris's contribution to book-printing, which is of fundamental importance. In 1890 *The Golden Type* was completed; in 1891 came *The Story of the Glittering Plain*; and in 1892 he founded the Kelmscott Press. Once again the Middle Ages and its approach to craftsmanship provided the inspiration, thus initiating new ideas about book production, which on the strength of Morris's name were to spread through Europe and the United States within a few years. Other periodicals which tackled typographical problems similar to those of *The Hobby Horse* and *The Dial*, were *The Yellow Book*, 1894, and *The Evergreen*, 1895; in Holland *Van nu en straks* appeared in 1892 and in Germany *Pan* in 1895, while Austria followed suit with *Ver Sacrum* in 1898.

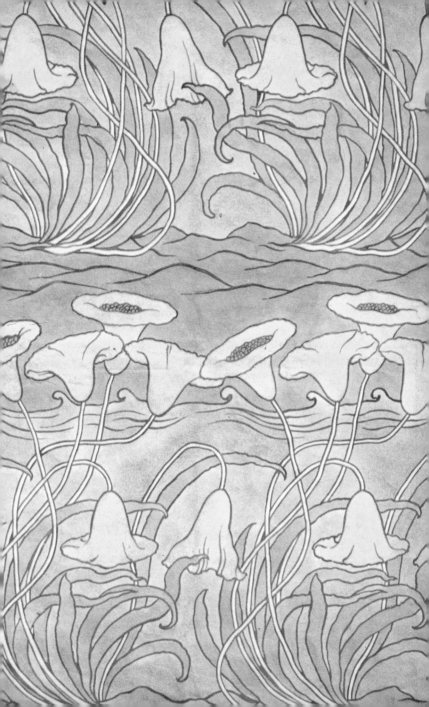

This early English Art Nouveau, which foreshadows the Continental movement, laid stress on linear decoration. For this reason it is largely two-dimensional in character and mainly confined to the surface. It was in the circle of the creative artists closely associated with the late Pre-Raphaelite movement that the striving for a renewal of book illustration and applied art took place, out of which grew early Art Nouveau. It had, however, another aspect, three-dimensional and dynamic, as we see in the work of the sculptor Alfred Gilbert.

Gilbert was trained on the Continent, at the *École des Beaux-Arts* from 1875–9 and in Rome from 1880–4. He concentrated his studies on Michelangelo and Cellini, but he was also attracted to Mannerism. Reviewing the ornamental problems he faced in 1884–5, he says:

Being unwilling to copy or steal the method of ornament I had so strongly neglected, I set myself a new task, the hardest of my life, which some day may bear fruit.[6]

Gilbert's source of inspiration seems clear enough: it is to be found in Italian sixteenth-century sculpture, with all its wealth of ornament, now gristle-like and fluent in its conception of form, now a melodious transfiguration of cassette and scroll-work ornamentation. In 1887 he executed a splendid *épergne* for Queen Victoria's jubilee. The crowned main figure stands aloof above the heads of hissing lizards, snorting monsters, crawling snakes and sprawling fishes.

With the ornamental sections of the *John Howard Memorial* in Bedford, 1892–3, and the *Shaftesbury Memorial Fountain* (Eros) in Piccadilly Circus, London, 1887–93 (figure 6·9), the symbiosis between Baroque and Art Nouveau is complete – a peculiar fusion of a style of past centuries and a style whose form-language was not yet born. It should be pointed out, however, that the principal shape of the fountain is rather traditional, and Neo-Baroque in spirit. The picture of early English Art Nouveau would not be complete without this Mannerist-inspired contribution, at once dynamic and

plastic. A style was developed in sculptural details which bore unmistakable traces of Art Nouveau.

It was in England too that the important steps were taken from the pages of books to applied art. While other countries produced now and again a vignette or an isolated ornament in a proto-Art Nouveau style, England in the 1870s and 1880s launched an all-embracing movement in the decorative and applied arts, illustration, painting and sculpture, which had roots going back to Blake.

The geographical limitation, the comparatively early date and the wide distribution of the early Art Nouveau in the various artistic genres suggest something more than a mere trend. In the 1870s and 1880s we are, in fact, faced with a genuinely English stylistic phenomenon which has tentatively been called English *proto-Art Nouveau,*[7] to distinguish it from the Continental style which emerged one or two decades later. This approach appears to be justified, since the English style remained a relatively isolated phenomenon – in time and place. English influence on the Continent was certainly considerable, but the special English stylistic expression does not appear to have been readily adaptable to the rest of Europe – the more so as England was not much influenced by Continental Art Nouveau.

Early Art Nouveau on the Continent and in the United States

In the rest of Europe, and also in the United States, we find similar preludes to Art Nouveau. A host of tendencies were in the air – we come across plant-inspired Art Nouveau-like motifs in France, Celtic-inspired details in Belgium, seaweed-like coils in Spain, an abstract play of line in the work of artists such as van de Velde, and even a curious tangle of tendrils in the work of Sullivan, the American. Yet all the time we are faced with individual phenomena which have no apparent connection, apart from the fact that the individual artists reflect various tendencies which all point or lead the way in the direction of Art Nouveau.

The earliest example – and one of the most striking – of Art Nouveau-like forms of expression is the French painter Felix Bracquemond's decorated plate from 1867 (figure 6·10). Bracquemond was trained as a painter and engraver, but devoted himself to

6·10 Bracquemond: Plate, earthenware. Manufactured by de Bailnet & Co., 1867. The flowers are painted more naturalistically, while the curling ribbons foreshadow the rhythm of Art Nouveau – as though to illustrate Bracquemond's saying: 'What in art is gesture, movement, feature, expression, and disposition of things, becomes lines in the work of art'.

6·11 Gauguin: Jug, in unglazed reddish-brown stoneware, 1886–7. In the 1880s Gauguin produced in his very personal and expressive style, both carvings and ceramics. This jug has a female with the bust of a woman in the style of Degas, and the handles emphasise the movement of the whole object.

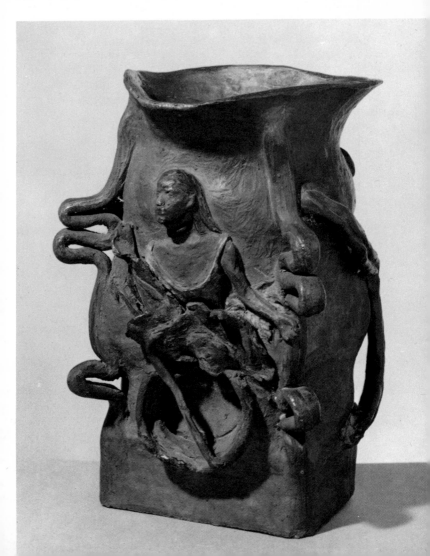

pottery from the 1860s, and his elegant play with semi-stylised plant-shapes – essentially linear in conception – illustrates his approach to nature as a source of inspiration. Something similar is to be found in the work of the goldsmith Henri Vever.[8]

Art Nouveau tendencies of an entirely different kind may be seen in the work of Viollet-le-Duc, one of the leading architectural theorists and historians of his age. His advanced theories sprang from the study of Romanesque as well as Gothic architecture. Unlike Ruskin, he championed the visible use of iron construction, as revealed in his famous *Entretiens sur l'architecture*, 1863–72. An enthusiastic supporter of the Gothic Revival, he invested iron with Neo-Gothic form, and at times with entirely new designs, Gothic foliage being transformed Art Nouveau-wise into a rhythmical, undulating stem-and-leaf decoration, as in his illustration to the chapter 'Sur la Construction' (figure 6·12). Viollet-le-Duc tried apparently to find a sort of 'padding', a form with a pliant rhythm representing the qualities of iron, and his decorative and fanciful forms may be regarded as a structural symbol on a par with Dresser's. But he also produced decorative sketches in an Art Nouveau spirit: for example, those for a small chapel in the *Rue Notre-Dames-des-Champs*, (1861–3), with stem-like, stylised plant ornamentation, where his point of departure was Norman. To his pupil Grasset his ideas on ornament were to prove more important than his theories. Grasset's early Art Nouveau work, however, was confined in the main to illustration, even though he also produced designs for wrought iron during this period.

Although it is impossible to point to a compact group of early Art Nouveau work in France, as one can in England, it is none the less possible to detect strong Art Nouveau tendencies, for example in the work of the glass-designer Eugène Rousseau. His work, from the middle of the 1880s, with its flowing, stylised flower motifs, is reminiscent of Voysey's contemporary designs. In his *Jardinière* of 1884–5 not only the decoration, but the actual form, has become Art Nouveau, the decoration and shape of the object blending to produce a single entity.

6·12 Viollet-le-Duc: Illustration for *Entretiens sur l'architecture*, 1872. By replacing the usual decorative Gothic foliage, with forms of his own imagination, Viollet-le-Duc created a 'padding' on a structural basis. In the text, however, Viollet-le-Duc is concerned merely with the construction.

Paul Gauguin represents yet another aspect of the French stylistic tendencies in the 1880s. He had already turned to applied art in 1881, when he executed two panels on the front of a cupboard in a flaming pattern full of movement. In 1886–7 he completed a jug, decorated with sculptural work (figure 6·11), and in 1888 a dish, both original in form and revealing some Art Nouveau traits in their stem-like forms. His vase with Breton motifs from 1888 has an entirely different and firmer ceramic pose, due possibly to his cooperation with Chaplet, who baked his pottery. The expressive form of Gauguin's decorative works in wood and ceramics of the mid-1880s are among the most interesting precursors of Art Nouveau.

In Belgium, too, we find early traces of Art Nouveau, for example Paul Hankar's design for wrought ironwork for *83 Chaussée le Charleroi*, Brussels, from 1889. His inspiration here is clearly Celtic, although the design already has an Art Nouveau rhythm.

It should also be added that he had Crane wallpaper in his studio,[9] and that Bonnat's pupil, the painter and poster artist Adolphe Crespin, was his friend. J.H.M.Schadde's roof design for the *Antwerp Stock Exchange*, from about 1868–72, contains an incredible wealth of foliage, immediately suggesting Art Nouveau, but it lacks the pliancy and reveals no abstraction of natural form.

In Spain we likewise find Art Nouveau tendencies in the 1880s. In the details of Antonio Gaudí's *Casa Vicens*, Barcelona, 1878–80,[10] we can find details pointing towards Art Nouveau. In the *Palau Güell*, which Gaudí built for the industrial tycoon Count Eusebio de Güell in Barcelona, 1885–9, we find an early Art Nouveau of an interesting and highly personal kind (figure 6·13). The wrought iron gates have a snake-like design; coiled beneath a parabolic arch, the metal is twisted in a whiplash rhythm. Other details reveal seaweed-like forms in an interlaced pattern. At this time, too, Gaudí's furniture design had also achieved an astonishingly mature Art Nouveau style.[11] Although it is not easy, in Gaudí's case, to find precursors for his form-language, we can learn something from a brief glance at his background. In the first place, following in the steps of his father, he had worked in his younger days as a blacksmith and was thus familiar with the Mudejar style and the many finesses and fanciful forms of Spanish

6·13 *Left* Gaudí: Palau Güell, Barcelona, 1885–9, with its magnificent
iron gates. The son of a blacksmith, Gaudí was versed in the Catalonian
art of metal-working, with all its ingenuity and richness of form.
6·14 *Below* Sullivan: The bar in the Auditorium Building, Chicago,
1887–9. Sullivan's ornamentation remained unique in American art.
His world of tendrils, scales and coral was too idiosyncratic for
imitation, but proves how style-tendencies can develop separately
and simultaneously when certain tendencies are common.

wrought iron. A deeply rooted sense of Catalan patriotism, difficult to explain in concrete terms, no doubt also stimulated his artistic individuality. Nature, too, provided him with a source of inspiration, not least through the plant forms of the Costa Brava and the Catalan countryside, with its strange, rounded stone formations.

Finally mention should be made of the Gothic Revival: in common with Horta, Gaudí was influenced by Viollet-le-Duc, and in the *Sagrada Familia*, of which the crypt and the first part were completed in the 1880s, the interest in structure is marked. Not until later do Neo-Baroque trends appear, for in the 1880s his architectural views were far more traditional. But Gaudí's outstanding contribution as an artist depends on his imagination and his knack of fusing different elements and of creating something new out of them.

The same may be said of the American Louis Sullivan. During the years 1887–9 Sullivan completed the *Auditorium Building* in Chicago, where both in the bar and in the banisters of the main staircase (figure 6·14), elements are to be found which point towards Art Nouveau and foreshadow a richer ornamental style. There are no Art Nouveau features to be found in the architecture as such: they are confined to the decoration. The starting point for his ornament appears to be Gothic foliage and naturalistic stem motifs, together with a certain Celtic interlacing of forms, as his sketchbooks reveal.[12] In tracing the origins of early American Art Nouveau, mention has been made both of Sullivan's teacher Frank Furness and of Frank Lloyd Wright, but it is also interesting to note that Owen Jones's *Grammar of Ornament* appeared in the United States in 1888. Sullivan's own comment on Nature as a source of inspiration in his article 'Ornament in Architecture', 1892, is probably the most illuminating on this question:

> . . . we must turn again to Nature, and hearkening to her melodious voice, learn as children learn the accent of its rhythmic cadences.[13]

However, what prevents Sullivan's ornament and likewise Healy's and Miller's stained-glass windows, shown at the Paris Exhibition

6·15 Grasset: Vignette from *Les Fêtes Chrétiennes*, 1880. Grasset was one of the leading French book illustrators of the late nineteenth century. Through Celtic inspiration he developed a style which in many ways foreshadowed the purer Art Nouveau of his later work.

in 1889, from ever quite becoming what we understand by Continental Art Nouveau, is the fact that asymmetry does not provide the motive force. Like Morris's tendrils, Sullivan's plant motifs are pregnant with growth and power, but the whiplash flick is missing. In refinement of line, however, Sullivan is not inferior to his European colleagues.

The desire to create something new, to find a new form-language, is at the root of all the various attempts and experiments we have briefly considered. But as in the case of Gaudí and Sullivan and the other pioneering artists of the 1880s, an investigation of the individual elements comprising their form-language provides no complete explanation of the phenomenon: there is always present a personal and artistic element which – fortunately – often defies analysis. But we have come a good deal closer to an understanding of it by identifying the precursors of this early Art Nouveau. At the same time we have come a great deal closer to identifying the origins of the Art Nouveau style. These scattered attempts to create a style all bear within themselves the essential elements of the fully developed Art Nouveau style, even though none of the artists succeeded in the 1870s or 1880s in fusing the various components together and creating a consistent stylistic expression.

Early Art Nouveau in posters

On the Continent, the development of the illustrator's art was very different from its development in England. The artists were more closely associated with painting, and it is no coincidence that France was the home of the poster. The two artists mainly responsible for developing both the art of illustration and poster art in France were Eugène Grasset and Jules Chéret.

Eugène Grasset was originally trained as an architect. After a visit to Egypt in 1869 he returned to Paris in 1871 and was soon

captivated by Viollet-le-Duc and his medievalism. At the same time he studied Japanese art with great interest. Both these influences were to affect his art profoundly. After a while he devoted his energies to working as an illustrator and typographical designer. In 1880 he illustrated Abbé Drioux's *Les Fêtes Chrétiennes*.[14] Here we find a highly personal style, a blend of medieval tendrils and foliage together with flowers and stalks in an Art Nouveau rhythm, occasionally all arranged *à la japonaise* (figure 6·15). In his illustrations to Renaud de Montauban's popular edition of the legendary story of Charlemagne, *Histoire des Quatre Fils Aymon*, published in 1883 (figure 5·3), we find this same medieval-inspired style, with clear traces of Japanese influence. Through his posters for the *Opéra National*, 1886, for *Sarah Bernhardt* (before 1890), *L'Encre Marquet*, 1892, and for his own exhibition in 1894,[15] we can follow his development from the early medieval and Japanese-inspired style to a calmer, more rhythmically flowing Art Nouveau style in the 1890s.

Eugène Grasset was in a sense France's Walter Crane – an enthusiastic art theorist, as we have seen, who like Crane made a considerable contribution to the art of book illustration and, like him, devoted himself to applied art.[16] Both of them found their source of inspiration in the Middle Ages – in Grasset's case, especially in Celtic *entrelacs* and in Japanese art,[17] though he also looked greatly to nature as a source of ornament. Both were however of greater importance as precursors of Art Nouveau than as exponents of the fully fledged style, from which they both dissociated themselves. Grasset's work also proved important beyond the borders of his own country, not least in the United States where – after France – his influence was greatest.[18]

Jules Chéret is the other poster artist whose work heralds the developments of the 1890s. His first poster was *Faust: Lydia Thompson*, 1869, with a rhythmical movement of the figures which many an artist in the 1890s might have envied. This is also evident in his poster series for the *Folies-Bergères*, *Les Girard*, which dates from 1877. It has been suggested that he was influenced by Crane

6·16 Mucha: Poster for *Job* cigarette papers, 1897.
'La Mucha', as this popular artist was called by Parisians,
often places a semi-circle around the head of his
girls, thus giving them an aureole effect. Here he has
cleverly used the letter O in Job as a nimbus, thus
emphasising the decorative effect of hair and profile.

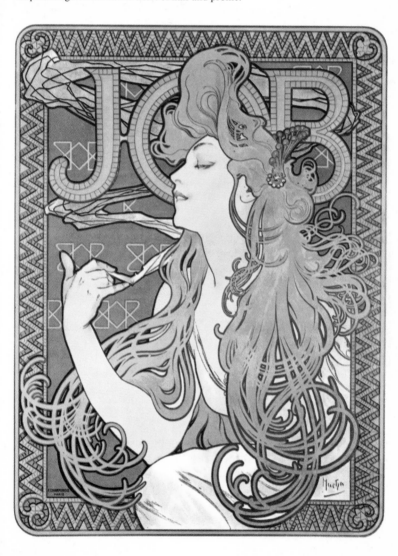

and William Morris.[19] Be that as it may, he certainly altered his style, loosened up his composition and made his contours more spiky; and the silhouettes of his figures also became more angular – almost more nervous – producing a sketchier effect. In about 1890 he changed his style once again, this time showing a fresh and more technical approach to his form of expression. We cannot, however, claim that this unrivalled master of the poster art made any direct attempt to seek the form of expression of Art Nouveau; but he approached it in the graceful rhythm of his figure-style.

Meanwhile, in about 1890–1, poster art had developed into an important factor in the creation of style, and Robert Koch goes so far as to talk of a Poster Movement. Chéret alone had created some thousand posters, and Bonnard, Ibels, Steinlein, Toulouse-Lautrec and Vallotton had already produced their first posters and discovered their own particular style. With the emphasis on the flat surface and its fixed encircling contour, it is quite natural to consider this artistic genre in connection with Synthetism, and yet poster art is also something more. A two-dimensional visual picture is created, built up of homogeneous, clearly delimited surfaces, based on an effect of distance. With this in mind a form of expression was evolved which covered the aim and intentions of the poster in an entirely satisfactory manner.

Henri de Toulouse-Lautrec continued where Chéret left off. He endowed the contours of figures with greater significance, had a firmer use of line and gave more emphasis to the surface, at the same time he restricted the range of his palette. His lettering and free placing of the text also add to the artistic value of his posters. Among his most famous posters are *Moulin Rouge*, 1891, *Les Ambassadeurs*, 1892, *Yvette Guilbert*, 1894, and *Jane Avril*, 1899.

Pierre Bonnard also turned his attention to poster art, with very charming results, as did most of the painters of the time. In common with Toulouse-Lautrec, Théophile Steinlen used Montmartre as his setting, and in his posters we frequently find a reflection of his social attitude and his struggle for the rights of the working class. One of the more important poster artists, who also made

designs for applied art, was Alphonse Mucha, a Czechoslovakian by birth who spent much of his early life in Paris. He worked in an Art Nouveau style, with a great deal of elegance, and created the buxom pin-up girl of the 1890s (figure 6·16). He had made a number of posters in 1891, but it was thanks to his acquaintance with Sarah Bernhardt, and the poster he designed for her – *Gismonda*, 1894 – that he achieved fame. In 1903 he made his way to the United States and subsequently devoted his talents mainly to painting.

France was the birthplace of the poster and the scene of its greatest triumphs, but outside France, too, there were poster artists who contributed to the special qualities of the new art.

While the Glasgow group created the first Art Nouveau posters in Great Britain in 1893–4, it was Will H. Bradley who completed the first one in the United States, the 'Twins' poster for *The Chap Book*, 1894.[20] Here Ricketts's and Beardsley's style can be clearly recognised. The Americans were well informed about stylistic trends in Europe. Oscar Wilde had lectured there in 1882. Walter Crane had been on a visit in 1890 and as far back as 1876 had won a prize in the United States for a wallpaper. Grasset had been commissioned to make posters for *Harper's Magazine* in 1889 and 1892, and Toulouse-Lautrec did the same for *The Chap Book* in 1896. On the other hand posters by Bradley had been exhibited in Bing's showrooms in 1895, and it may be said that on the artistic plane there were excellent stylistic links between England and the United States at this time. In the posters of Bradley and the British school – as also in Toorop's – we always feel a draughtsman behind the poster design, in those of Bonnard and Toulouse-Lautrec a painter.

Jan Toorop made posters in Holland, for instance the well-known *Delftsche Slaolie*, 1895, and *Het Hoogeland Beekbergen*, 1896. Henry van de Velde created his only poster for *Tropon* in Cologne, 1897. The Dane Thorvald Bindesbøll also made posters in a personal style remarkable for its curls and heavy forms. In Germany posters played a lesser role in the early 1890s, and

6·17a Khnopff: Cover for *Les XX*, 1890. The Japanese influence in the lettering is characteristic.

6·17b Lemmen: Cover for *Les XX*, 1891. Both Japanese influences and those of the Pont-Aven group are evident.

it was not until the arrival of artists such as Joseph Sattler, Thomas Th. Heine, Emil Rudolf Weis, and Edmund Edel that Germany had her own poster art, free of both English and French influence.

Early Art Nouveau in book illustration

In the art of book illustration, too, there is an essential difference between the English and French conceptions. In France content and illustration appeared to fuse in a visual symbolism. André Gide's dedication to Maurice Denis on the occasion of the illustration to *Le Voyage d'Urien* in 1893 is most significant: 'Ce voyage vraiment fait ensemble'.[21]

Maurice Denis had already illustrated Verlaine's *Sagesse* in 1889, and it is interesting to note that he mentions the Middle Ages as a source of inspiration. To at least as great an extent as the illustrations he carried out for Gide, this work reveals a complete empathy where content and picture go hand in hand, at the same time producing a visual experience of the poem. In 1890 Maurice Denis declared that

... the illustration is the decoration of a book, ... an embroidery of arabesques on the page, an accompaniment of expressive lines,

but he recommends a certain measure of freedom with regard to thematic material.[22] In Carlos Schwabe's ornamental illustrations

6·17c Van de Velde: Illustration from Elskamp's *Dominical*, 1892. Nature is partly abstracted into an expressive play of line.

6·17d Lemmen: Initial for the periodical *Van nu en Straks*, 1893. The floral influence is now predominant and the intricate loops and rhythmic ribbons show Art Nouveau fully fledged.

to *L'Évangile de l'enfance de notre Seigneur Jésus-Christ*, 1891, the artist has meticulously followed Denis's principles, and his floral motifs can only be described as Art Nouveau.

In common with Denis, Henry van de Velde was also an ardent admirer of Seurat and his theories, and in the *Les XX* circle we find a number of artists who at an early stage all made original contributions to the renewal of book art: for example Ferdinand Khnopff with his orientally-inspired cover to the catalogue for *Les XX* in 1890 (figure 6·17a). In 1891 George Lemmen executed a more Mackmurdo-like cover for *Les XX* (figure 6·17b) where we note traces not only of Japanese influence – especially in the lettering – but also of an expressive linear rhythm such as we associate with the Synthetists. Van de Velde's illustrations for Max Elskamp's *Dominical*, 1892 (figure 6·17c), are more abstract, with natural forms distorted almost out of recognition in a rhythmic play of line. In the illustrations for the periodical *Van nu en straks*, 1893 (figure 6·17d), Lemmen comes very close to Horta's contemporary style. In the vignettes for *Déblaiement d'Art*, 1894, van de Velde proceeded still further and evolved an entirely abstract form.

While English illustration art retains as a general rule a traditional conception of the page, developing linear elegance with all the sensual features of the *décadence*, on the other side of the Channel and in the same years – 1890–3 – a more abstract play of

line was evolved, with a heavier design, a freer treatment of the page and – at times – a deeper visual symbolism. In Holland, too, an independent school of graphic design developed very early, with artists such as Jan Toorop, Johan Thorn Prikker, Anton Kinderen, Roland Holst, and Theodor Nieuwenhuis. The main influence was English; Walter Crane was well known there, and in Anton Kinderen's illustrations for Joost van den Vondel's *Gijsbrecht van Amstel*, which occupies in Dutch book art a position similar to that of the *Histoire des Quatre Fils Aymon* in French, we find a remarkable similarity to Walter Crane's style, as well as to certain Celtic style-elements.

During the early 1890s, the English and Continental streams – as we have seen them in the various fields of art – came together to fertilise the questing, artistic milieu in Brussels and, in 1892–3, the style attained its most complete form in the hands of a thirty-two-year-old architect, Victor Horta.

7 Art Nouveau in architecture

The native soil

The break-through of Art Nouveau as architecture, in fact the
international début of the style itself, took place in Brussels. It
might therefore be useful to analyse the artistic milieu in the
Belgian capital, in order to get to the heart of the actual problem
of genesis.

In the early 1890s artistic life in Brussels reached a fresh peak of
intensity. *L'Art Moderne*, which helped to prepare the way, had
been appearing since 1881; and in 1891 *Le Réveil, Revue Mensuelle
de Littérature et d'Art*, (a symptomatic title), was founded. In the
same year the *Section d'Art* was formed, and in the following year,
when the English organisation, the *Arts and Crafts Exhibition
Society* made its first appearance in Brussels, the Belgians founded
a corresponding organisation, *L'Association pour l'Art*. In 1893
the periodical *Van nu en Straks* made its appearance, and a young
architect Paul Hankar joined the editorial board of *L'Émulation*,
bringing to it a more radical tone. In 1894 *Pour l'Art* was launched
to promote the applied arts. In the same year *Les XX* was re-
organised as *La Libre Esthétique*, and the *Association pour les
Progrès des Arts Décoratifs* was set up.

While the activity promoted by *Les XX* in Brussels and the
links forged with *avant-garde* trends in France started fresh impulses
(see chapter 9), contact with English art circles was no less
lively. The internationally minded Whistler exhibited with *Les XX*
every year from 1884, and Octave Maus records that the contact
with Anglo-Saxon artists, and Whistler's influence, found expres-
sion not only in art but in interior decoration and even in dress.
In 1892 the English exhibited in Brussels for the first time; in
1893 Ford Madox Brown was represented there, and in 1894
Charles Ashbee, Selwyn Image, Heywood Sumner, William Morris,
and Aubrey Beardsley – the latter with twelve drawings from
Salome and *Morte d'Arthur*. In 1894, Walter Crane exhibited in the
Cercle Artistique, and next year we find all these artists, with the
addition of Charles F. Annesley Voysey, exhibiting with *La Libre*

7·1 Gaudí: Güell Park, Barcelona, 1900–14.
Architecture and landscaping are here fused
as they were in the eighteenth century.
But the serpentine benches, 'Doric' columns
and pillars in the form of stone trees
give the park a prehistoric air.

Esthétique. The Glasgow School also exhibited at Liège at this time. In 1897 we once more find Voysey, Fisher and Morris's furniture designer George Jack exhibiting at *La Libre Esthétique*, together with the potter William de Morgan. Artists who belonged to the Arts and Crafts Movement contributed regularly, as well as others who had helped to create the photo-Art Nouveau style. In 1896 van de Velde exhibited what he called 'une salle de five o'clock'.

English modern art had already been made available since 1881 through Paul Dietrich's and Joseph Schwarzenberg's book shop *Librairie d'Art*. The proprietors frequently visited England and arranged sales for belated Pre-Raphaelites, such as Heywood Sumner, Walter Crane and Frank Brangwyn.[1] The interest in William Morris and the Pre-Raphaelite movement was very strong in Belgium in the 1880s and early 1890s, and a number of articles appeared on this and related subjects. In 1893 'G.M.' writes in *L'Émulation*:

> Of all outside influences which we have received during the last twenty-five years, the influence of England seems the strongest.[2]

That English wallpapers – possibly by Heywood Sumner – should have been selected for Horta's *Tassel House*, 6 Rue Paul-Émile Janson, Brussels, 1892–3, the first example of the mature Art Nouveau style, is in itself symptomatic enough.[3] Finch, Toorop, and Khnopff were, each in his own way, closely associated with England, which they visited at regular intervals. Van de Velde, too, followed English developments with the greatest interest and wrote several articles on English wallpapers in *L'Art Moderne* in 1893 and 1894. In his work, moreover, we find repeated recognition of the importance of Ruskin and Morris.

It was in this fruitful milieu, fertilised by a criss-cross of influences, that in 1892–3 the first example of Art Nouveau was born – a milieu in which literary ideas were marked by symbolism, and artistic ideas by a burning desire for renewal through the medium of and elevated union of all branches of art – a milieu in which French Symbolism and French rationalist theories were to blend with late

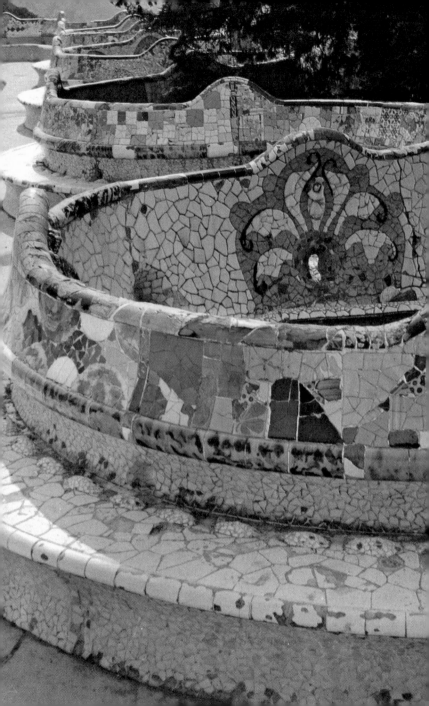

Pre-Raphaelite tendencies and English decorative styles. Strange as it may seem, the result was to prove a viable and fully fledged expression of style. Moreover, this birth occurred in a genre in which the style only seldom achieved full mastery, viz. in architecture.

Is there an Art Nouveau architecture?

If an architect decorates his building with some details which are unmistakably Art Nouveau in style, does this automatically make the whole edifice a piece of Art Nouveau architecture? One is tempted to answer 'No'. There must however be certain features which justify the term Art Nouveau architecture as a distinct entity. Fortunately, there are features enough to justify such an attitude.

One of the predominant qualities of Art Nouveau architecture is an ability to put the theory of structure into practice by 'exposing' the constructive elements of a building, particularly iron, so that they become visible, often decorative, parts of the façade. Ornament serves to symbolise and emphasise this structural approach. In France we find the basis of this exposure of the structural materials in the school of Viollet-le-Duc and in many of the outstanding cast-iron constructions erected in the latter half of the nineteenth century. Yet the particular manner in which the decorative form of iron emphasises and highlights construction and structure is peculiar to Art Nouveau architecture. We might, in fact, call it an architectural symbolism of structure.

Glass had for long been used in association with iron, but from the 1890s it was developed as a separate architectural medium of expression. The glass wall – combined with other architectural materials and media – enjoyed under Art Nouveau a rich and independent development. Simultaneously a new emphasis was given to staircases in glass and iron, as in Horta's *Maison du Peuple*. Furthermore we find a dynamic plastic treatment of the body of the building, which far exceeds what might have been expected in the heritage of Neo-Baroque: modelling now became an aim in

itself. Closely associated with this was the gliding rhythm of the various parts of the building, executed often with a firm, austere outline, such as we find in the work of Horta, Gaudí, or Mackintosh, and even including landscaping (figure 7·1). The smooth rounding-off of corners, bays, and so on reveals another aspect of this search. We are faced, in fact, with a striving for a closed silhouette and a synthetic effect, for which contemporary tendencies in painting and sculpture provide a close parallel.

Another essential feature was the Art Nouveau predilection for asymmetry, whether in the distribution of building masses or in minor details such as the siting of windows and doors. These features were undoubtedly closely associated with the passion for the Middle Ages, while the use of the large asymmetrically sited arch – especially in commercial architecture – was probably due, in part at least, to the influence of the American architect Richard-son. On the other hand, the gently flattened arch, slightly rounded at its base, was an architectural feature of Art Nouveau which probably derived from the structural requirements of large buildings, such as factories, railway stations and the like. Dutert and Contamin's *Halle des Machines*, erected at the International Exhibition in Paris of 1889, was one of the largest and earliest examples. This shape, which was originally introduced for technical reasons, was eventually developed for purely aesthetic ends, a development that was to prove one of the special features of Art Nouveau architecture.

Yet another feature of Art Nouveau architecture was the sense of space, whereby one room merged into and blended imperceptibly with its neighbours. The classic example is Gaudí's *Casa Milá*, 1905–7. Not only does this building display the gliding, rhyth-mical treatment of the mass in its exterior treatment, but the various parts are also linked organically together in the ground plan. There was also the relation of a building to the ground, which was often stressed by the architect: the lower part of the building would give the impression of rising from it. Similar tendencies are to be found in sculpture, in the treatment of bases (see chapter 10).

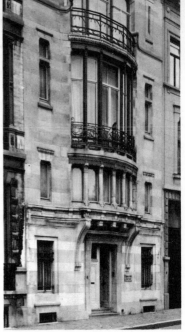

7·2 Horta: Tassel House, 6 Rue Paul-Émile Janson, Brussels, 1892–3. This house is the first fully developed architectural essay produced in the style. The interiors are in thrall to the pliant rhythm of Art Nouveau, while the exterior is more conventional. Here medievalism and neo-Rococo features are seen side by side with pure Art Nouveau details.

Knowing the predilection of Art Nouveau for symbolism, it is natural to regard this as an expression of the close relationship between architecture and Nature.

Finally, mention should be made of the Art Nouveau architect's attempt to treat the façade as a decorative entity, as we see for example in Hankar's work in Brussels. Ceramic tiles, then in fashion, were much used for this purpose – by Wagner in the *Majolika Haus* in Vienna, by Olbrich in Darmstadt and by Bigot and Lavirotte in Paris.

Art Nouveau architecture, as we can now see it, is not only conventional architecture with various ornaments stuck on, but also – whenever we find it – something far more. On the other hand, we cannot overlook the claims of conventional architecture, of which only the ornaments have an Art Nouveau character because it reveals the externals of the style and its predilection for ornament. Yet if the architecture is undecorated or consists of a series of cubic masses, or is composed of rectilinear elements without any striving for fluent rhythm and without understanding of the symbolical value of ornament – then we are dealing with things

7·3 Horta: 22–3 Rue Américaine, Brussels, 1898. Note the freely exposed iron constructions. Horta was not only a great ornamental designer, but also tackled problems of construction.

structural – symbolical(?)

which are outside the Art Nouveau style in architecture.

Generally speaking, Art Nouveau architecture represents a dichotomy which is reflected stylistically, chronologically and geographically. The markedly plastic, at times medievally inspired and often abstract structural-symbolical architecture, exploiting iron and glass, belongs to the earlier phase. This was widespread in Belgium and France. A more austere, rectilinear and two-dimensional conception – with no interest in wavy lines but with a preference for geometrical ornament – emerged in a second phase and spread widely through Germany and Austria. This style, looking beyond Art Nouveau, ushers in a counter movement.

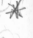

Belgium

Anyone entering today the house that Baron Victor Horta built for Professor Tassel in 1892–3, at what is now *6 Rue Paul-Émile Janson* in Brussels, will find much of the atmosphere gone. The interiors have in part been altered, but beneath a coat of paint Horta's bold innovations can still be glimpsed: the elegant play of

line in the full-bodied murals, the plastic dynamic effect of the balustrade and iron grilles, the polychrome interplay of the glass doors and mosaics and, last but not least, the free architectural conception of space (figure 7·2).

Victor Horta was the son of a cobbler. After making his way to Paris at the age of seventeen in defiance of his parents, he started his training at the *Académie des Beaux-Arts*. In 1881 he became a pupil of the classicist Alphonse Balat. He built a number of houses in the traditional Neo-Renaissance style around 1885,[4] but little is known of him after that until he was called on to design Professor Tassel's house in 1892.[5] The ground-plan of this house differs from the traditional Belgian scheme in the greater space allotted to the staircase and the varying shapes and sizes of the rooms, which open into one another. The various planes, too, emphasise precisely this impression of freedom and spaciousness. The façade displays the iron structure clearly, as an element in the composition, while the columns in the first-floor bay reflect not only Neo-Rococo but also a symbolical conception, their bases gripping the horizontal beam. The windows on the top floor are reduced like medieval openings to mere slits. The house, in fact, is not particularly unusual in its exterior except for ornamental details. The interior, on the other hand, is an ample expression of the new style, all the materials being subordinated to the ornamental presentation – iron, stone, glass, mosaics and wood, all of them conforming to the interlaced linear rhythm. On the walls formalised plant tendrils literally sprout forth, taking possession of the entire staircase. More than anything else this decoration recalls George Lemmen's linear fantasy from the same year (figure 6·17d).[6] The generous dimensions and scale employed by Horta in this staircase immediately raise the decorations to a more significant level. Horta's pupil, J. J. Eggericx, has provided an apt formula to describe his teacher's masterly attitude to materials:

When everything is simple and easy he creates difficulty in order to overcome it and solve it. He makes the material groan and howl. Conclusion: He is a Titan.[7]

The next house Horta built (1893–4) was for M. Frison, at *37 Rue Lebeau*, in two-toned bluish sandstone. The façade is less decorated, but his knack of fusing materials into a style of his own remains as lively as ever. In the years that followed he produced a great deal of work in Brussels, such as the *Hôtel van Eetvelde*, at 2 Avenue Palmerstone, 1895–6, with an asymmetrical treatment of the façade which is handled in a markedly plastic manner. The surface is practically devoid of ornament except around the windows; wherever ornament occurs independently it creeps discreetly and quickly into the walls as soon as it deviates from its fixed position.

Three of Horta's buildings from the 1890s deserve special mention: *22* and *23 Rue Américaine* and the *Hôtel Solvay*, at 224 Avenue Louise. The first two (figure 7·3) were designed in 1898 for his own use – today, one houses the Musée Horta – and their outstanding characteristic is the complete asymmetry of the façades. In both buildings the iron construction is freely exposed, and exploited as a decorative element, the style being more Gothic in one and in the other livelier and more Art Nouveau. Common to both of them is the flattened arch and the discreetness of the Art Nouveau ornament, which is confined to decorative elements on the façade which emphasise the structure. The *Hôtel Solvay* was built for the industrial magnate and chemist Ernest Solvay, in 1895–1900,[8] and remains Horta's most magnificent contribution to Art Nouveau. The plastic elaboration of the façade through the vertical elements distinguishes it from contemporary architecture. The unity of style in the interior – including the furniture and fittings – places it in a class of its own within the Art Nouveau style.

Horta continued throughout the 1890s to pursue his dual task – the creation of a new idiom of form and the search for a logical and clearly expressed architectural solution to constructional problems. The first task, achieved in Tassel's house, reached its culminating solution in the *Hôtel Solvay*; the second was fulfilled in the *Maison du Peuple*, Place Émile van de Velde, in Brussels, 1896–9 (figure 7·4), a building which was demolished in 1965–6. This

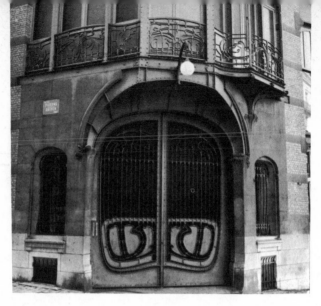

had the first façade of iron and glass in Belgium. The staircase and construction are freely exposed, with Art Nouveau ornaments which throughout happily stress the structure, at the same time softening the effect of the glass and metal. The supple plan of the building itself also reflects its curvilinear aesthetics. Not least important is the auditorium, with its open construction. Among Horta's other major works with iron and glass façades – executed in an Art Nouveau-Gothic disguise – may be mentioned the *Grand Bazaar*, Anspack, 1895, *A l'Innovation*, 1901, and *Gros Waucquez*, Rue du Sable, 1903–5, all of them in Brussels.

Around the turn of the century a simplification can already be noticed in Horta's form-language: his exteriors are calmer, clearer, while his interiors have a touch of Louis XV, with only an occasional Gothic note, as for example in the *Hôtel Aubecq*, 520 Avenue Louise, Brussels, of 1900. Horta's simplification of style, however, was to proceed still further; for example, in *85 Rue Washington*, Brussels, 1906, which has great simplicity. In time, his striving for a constructive and rational architecture became far more important than the decorative elements. In the large building designed for Philippe Wolfers, *11–13 Rue d'Arenberg*, Brussels, of 1906, there are no longer any traces of Art Nouveau. His youthful aim – to create a personal form-language, and to cast off the shackles of Historicism – had long been achieved, and

7·4 Horta: Maison du Peuple, Brussels, 1896–9, now pulled down. 111
This was Horta's most important contribution to the development of iron
and glass architecture. A clear distinction is made between the
firm major constructive elements and the decorative play of secondary
parts, such as railings. In the auditorium, the iron supports of the
galleries are both structurally expressive and gracefully decorative.

his pliant, abstract and dynamic décor, created without much
regard for the actual construction and qualities of the material,
had become an international style. Just after the turn of the
century he abandoned it, leaving it for others to vulgarise.

Paul Saintenoy, who built *Old England House*, Rue Montagne de
la Cour, in 1899–1902,[9] in a remarkably un-English style, may be
classed with the architects who continued to tackle the problems of
glass and iron façades without arriving at any further solution or
contributing anything particularly original to the Gothic-inspired,
and at times Art Nouveau-like, form-language

Paul Hankar was a far more gifted architect who had been
trained under Henri Beyaert, whose 'amour de la forge' he speedily
adopted. Other influences, however, were to prove more formative
and important. First and foremost, there was his interest in Viollet-
le-Duc: according to his friend Adolphe Crespin, with whom he
collaborated from 1888, Viollet-le-Duc's *Dictionnaire* and *Entretiens*
were his bedside reading.[10] Then there was Orientalism, which was
to set its mark both on his architecture and on his interior decora-
tion. Finally there was the English influence, as evidenced by his
interest in the English Arts and Crafts Movement and the wall-
paper by Walter Crane which graced his new studio when it was
completed in 1893.[11] Like Horta, Hankar started in a Neo-
Renaissance style, with *83 Chaussée de Charleroi*, of 1889, but by
1893 he had completed his own house, *71 Rue Defacqz*, and
by 1897 had gone on to design the house for the painter Ciamber-
lani at *48 Rue Defacqz* (figure 7·5). These two last houses are
remarkable for the striving for originality, not only in the iron
grille work and the large, almost horseshoe-shaped arches, but in
the use of painted decorations on the wall, which were executed by
Adolphe Crespin. In the *Barber's Shop*, Ixelles, however, as well as
in other shop-entrances, we find him working in a full-blooded
Art Nouveau style.[12] His furniture is of special interest: for
example a black table from 1893,[13] which is very Japanese in style.

The strongest Art Nouveau feature in Hankar's work is his
striving to treat the façade as a cohesive decorative whole, while his

7·5 Hankar: 48 Rue Defacqz, Brussels, 1897, made for the painter Ciamberlani. The house is richly decorated in polychrome sgraffito. The attempt to treat the whole façade as a decorative unity is typical of the time.

bid for austerity prevented a too lavish use of Art Nouveau form-language. Furthermore, he appears to have grasped the essential spirit of Orientalism, and his work illustrates admirably how this trend could be one of the sources of the rectilinear and plain form-elements that were to become such an essential part of the new trends that eventually replaced Art Nouveau. Horta and Hankar were the two leading Belgian architects of the 1890s – one acting as a sort of midwife to the style, the other assisting at its demise.

The Art Nouveau style quickly attracted a large number of adherents in Belgium, with Brussels as the centre of the school. A stroll round the streets of this city will still reveal a great many houses designed by architects whose names are now forgotten – Blérot, with his floral and French influences; F. Seeldrayers, with his imitations of Horta; Rysselberghe, who was associated for a short while with van de Velde; Macqs, who fused Neo-Gothic and Art Nouveau; Morichor, Peerboom, Roosenboom, and many others. None of these, however, reached Horta's eminence, nor influenced in any way the style and its development.

France

Hector Guimard was the leading French exponent of Art Nouveau architecture. His earliest work in Art Nouveau was the *Castel Béranger*, 16 Rue la Fontaine, Paris, of 1894–8, a block of flats with a rather conventional exterior. The main entrance, however, and the interior decorations are carried out in a rich Art Nouveau highly reminiscent of Horta. The style is abstract, asymmetrical and dynamic, though somewhat lighter and more elegant than that of the Belgians. The iron construction, the polychrome faience tiles, the ceiling decorations – everything is subjected to a sophisticated interplay of line and a wanton use of material (figure 7·6). There is no doubt that Guimard was heavily indebted to Horta, whom he considered one of the creators of Art Nouveau.

In the *Villa Flore* apartment house in Paris, we find an Art Nouveau feature in the exterior which is peculiar to Guimard –

rib-like ornaments (we might almost call them structural symbols) running along the surface of the walls. The same feature is repeated in his furniture design.

Among Guimard's masterpieces we must include the *École Humbert de Romans*, 60 Rue St Didier, completed in 1902 (but now demolished); here, his structural symbolism was allowed full scope, on a large scale, in iron and glass (figure 7·7). But it was the *Métro* stations in Paris, 1899–1900 (figure 2·7) which really made Guimard famous. In these charming buildings – a cross between pagoda and pavilion, and executed in glass and iron – he gave full rein to his imagination. Light bulbs appear to sprout from their holders like buds in spring; crustaceans from the ocean depths seem to have scattered their spiky shields along the balustrades. And yet every detail is subordinate to a stylistic common denominator – Art Nouveau. The horseshoe-shaped arch which we encounter in the main entrances may either derive from an oriental source, like Hankar's horseshoe arch, or it may equally well be a

7·6 *Left* Guimard: Castel Béranger, 16 Rue de la Fontaine, Paris, 1894–8. This was the first important work of the leading French Art Nouveau architect. The vivid interplay of line in the main entrance is markedly asymmetrical, and yet so beautifully balanced that the total effect is one of harmony.

7·7 *Right* Guimard: École Humbert de Romans, 1902, now pulled down. In this great piece of Art Nouveau architecture some of the constructive elements were decorated so as to symbolise the structure and express the function. The floral-inspired school of Nancy produced architecture as well as glassware, furniture and porcelain – one of the fundamental ideas of Art Nouveau architecture.

decorative symbol of the *Métro*'s tunnel shape. Dare we regard it as an example of structural symbolism?

Guimard continued to work in the Art Nouveau style right up to 1911, when he completed *17–21 Rue la Fontaine*, whereas an architect like Frantz Jourdain abandoned the style after he had completed his masterpiece in the Art Nouveau shop *La Samaritaine*, Rue de la Monnaie, in 1905, a synthesis of iron and glass and Art Nouveau. H-B. Gutton's *Magasins Réunis*, 134–6 Rue de Rennes, of a few years earlier, ought also to be mentioned as an outstanding example of a French blend of glass and iron in the spirit of Art Nouveau. No one else, apart from Guimard, succeeded in fusing the various stylistic tendencies in France into an architectural expression. Xavier Schollkopf was responsible for unique architecture, such as the house, now demolished, which he designed in 1900 for Yvette Guilbert, at *23 bis Boulevard Berthier*, Paris,[14] in a cross between Neo-Rococo and Art Nouveau. Louis Bonnier redecorated *Bing's House* in 1895 in Art Nouveau; Jules Lavirotte

7·8 *Below* Lavirotte: Lycée Leonardo da Vinci, 12 Rue Sédillot, Paris, 1899. The house is traditional on the whole, but in bays and balconies neo-Baroque and Art Nouveau fuse, especially in the floral details. 'Un peu sage' is one description which has been given of this house.

built several houses in the vicinity of the Champs de Mars, *12 Rue Sédillot* (Lycée Leonardo da Vinci) (figure 7·8), 1899, *3 Square Rapp*, 1899, and *29 Avenue Rapp*, 1901, in full-bodied Art Nouveau – sometimes influenced by Neo-Rococo, sometimes by Neo-Baroque, and sometimes floral. These, too, are remarkable for the lavish use of tiles in the façade, the work of the ceramic artist Alexandre Bigot, who established his reputation with the decoration of the main gateway to the Paris Exhibition of 1900, designed by René Binet. Binet's main work, however, is the *Magasins du Printemps*, of 1891–5. Among other architects working in an Art Nouveau-influenced style for a brief period was Henry Sauvage, who completed the house for Majorelle in Nancy, 1902; and Charles Plumet, who worked with the interior architect Tony Selmersheim. They were responsible for the house in *67 Avenue Malakoff* 1898 (now demolished), which was more or less a blend of Neo-Gothic and Art Nouveau. Charles Plumet is considered by Gloton the more important; he designed a number of houses in the Avenue du Bois, the Boulevard Montmorency, and the Boulevard Richard-Wallace, in Neuilly. Another architect was August Perret, who completed *119 Avenue de Wagram*, in 1902, where the floral motifs are

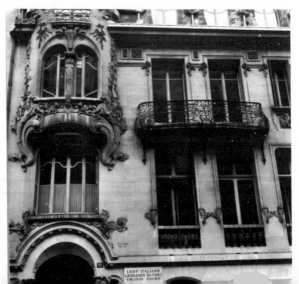

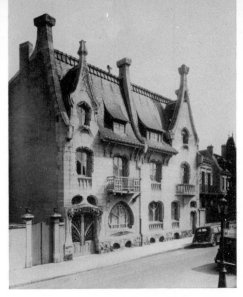

7·9 André: Maison Huot,
92–3 bis Quai Claude
Lorrain, 1902–3. This house
gives a medieval impression,
but the floral decoration
instead of being spread
across the façade is confined
to the doors and windows,
where stalks, leaves and
flowers have taken complete
possession of the actual
structure.

developed in a limited area. Quite apart stands Anatole de Baudot, a follower of Viollet-le-Duc, who in *St Jean-de-Montmartre*, 1894–1904, gave Neo-Gothic forms the structural force of Art Nouveau. In Gustave Rive's *Magasin Dufayl* (before 1902), it is not so much the details which are Art Nouveau, as the conception of the staircase. Probably the most famous interior in Art Nouveau, was the restaurant *Maxim*, 1899, by Louis Marnez (and the painter Léon Sonnier) possessing all the charm and atmosphere of the period.

Once we reach Nancy, however, we find a more Gothic-inspired approach, as in the work of the leading architect of the Nancy School, Émile André. Floral décor is particularly dominant, as for example in *92–3 bis Quai Claude Lorrain*, of 1902–3 (figure 7·9). Here stretchers in windows and doors appear to sprout like trees and gables terminate in Gothic buds – and naturally all corners and edges are rounded off.[15]

In French architecture, especially in Paris, Art Nouveau was mixed at an early stage with various other stylistic elements and the style was soon reduced to a decorative architectural mask. It was in glass and iron – particularly in the hands of Guimard – that Art Nouveau, with its strongly emphasised structural symbolism, achieved its most vigorous expression. It was an expression which was both homogeneous and independent.

7·10 Gaudí took over the construction of La Sagrada Familia
in 1884 and devoted the rest of his life to the erection of
this expiatory temple – the *chef d'œuvre* of ecclesiastical
Art Nouveau architecture. In La Sagrada Familia both structure
and decoration are subordinate to the softly rounded forms,
with long undulating lines and flowing planes.

Spain

In Spain Art Nouveau appeared in an entirely different guise. Here,
however, it was not a trend, but rather the personal and imaginative
architectural expression of a single man, Antonio y Cornet Gaudí,
operating in a clearly defined geographical area, in Barcelona, the
capital of Catalonia. Gaudí's youthful work the *Casa Vicens*,
1878–80, and the *Palau Güell*, 1885–8, have already been mentioned
(see chapter 6). At the start of the 1890s he was already established
as a mature architect with a developed form-language and for the
next twenty years, right up to 1910, he went on creating master-
pieces in Art Nouveau, ecclesiastical and profane.

The first building Gaudí completed after the *Palau Güell* was the
Colegio de Santa Teresa de Jesús, 1889–94, where he again demon-
strated his mastery of an austere form-language. He continued to
use the parabola-like arch and his interiors in particular were
designed with an architectural austerity which is just as impressive
as much of his more lavishly decorated work. During the 1890s
he was mainly engaged on another ecclesiastical task, the design
of an Expiatory Temple for the Holy Family, *La Sagrada Familia*,
which he took over from the architect Villar in 1884. The plans at
that time envisaged a Neo-Gothic cruciform church, and the
crypt was duly completed in 1891 according to Villar's original
plans. In the same year, however, Gaudí started work on the
façade, and in 1903 he was ready to begin the sculptural treatment.
The towers were completed in 1906, and from 1909 right up to the
time of his death he devoted himself to this building, though he
was never able to complete the nave (figure 7·10).

Directly, as well as indirectly, Gaudí's *point de départ* was Neo-
Gothic, but the sculpture becomes an integral part of the archi-
tecture in a way never previously or subsequently achieved – the
very architecture, in fact, *becomes* sculpture, a plastic mass, at
times naturalistic, at others demonic and weird. Here and there the
stonework seems to dissolve in Baroque-like gristle and in lava
masses, but at times, too, it reveals touches of floral inspiration or

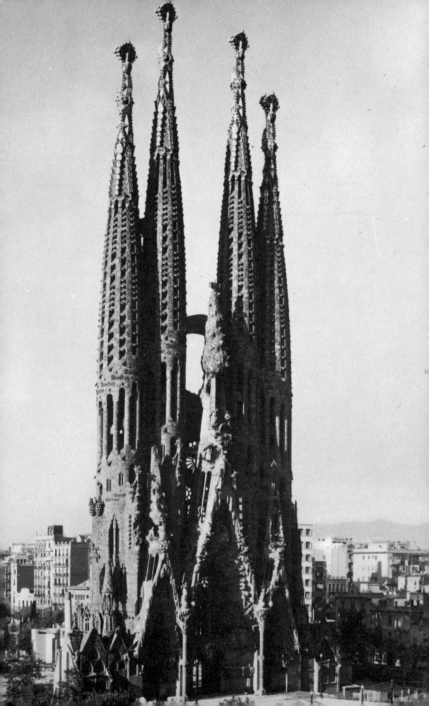

7·11 Gaudí: Casa Batlló, Barcelona, 1905–7. The lower storeys are openly and plastically treated with Gaudí's characteristic use of bony articulation, while the upper part of the façade glitters with coloured glass. The roof is dominated by a dragon-like construction and the sculpturally treated chimney-pots covered with polychrome tiles resemble the raised heads of monsters or snakes.

intimate religious motifs. The towers are crowned with elaborate finials, whose facetted surfaces are adorned with mosaic-work. In the model for this church, however, we can observe his predilection for structure, in the bone-like struts and supports; occasionally, too, Gothic constructive tendencies are in evidence.

In the *Sagrada Familia*, Neo-Gothic and Art Nouveau achieve a perfect fusion, and it can be regarded as the most important ecclesiastical work in the style. Yet, with all its sculptural achievements, it remains a mere torso: the transept with the cluster of towers over-crossing, which were originally designed to be a third higher than the present ones, is incomplete. The same fate befell his other church building, the *Santa Coloma de Cervello*, 1898–1914, whose crypt reminds one of 'cave architecture', both refined and primitive at the same time. With this highly original work we are a good way beyond the medieval – almost in the Stone Age.

Among his profane buildings three are outstanding: the *Casa Batlló*, 43 Paseo de Gracia, of 1905–7, the *Casa Milá*, 92 Paseo de Gracia, of 1905–7, both in Barcelona, and the entire *Güell Park* layout, of 1900–14, now the Barcelona Municipal Park. In the *Casa Batlló* (figure 7·11) the upper part is relatively moderate. The lower storeys, on the other hand, possess all the plastic originality one might expect: they are more open, with egg-shaped windows and twisted, flowing stone shapes.

In his interiors Gaudí achieved the full effect of flowing movement and spaciousness; one has the impression that details and even whole rooms have been hollowed out by the waves of the sea.

Casa Milá (figures 7·12a and b), built for Roger Segimon de Milá, is an apartment house in which the body of the building is grouped round two more or less circular courts. Thanks to the constructive skeleton, Gaudí was able to operate freely, without taking bearer-walls into consideration. The façade contains no features borrowed from period styles, such as the Neo-Baroque which is to be found in the *Casa Calvet*, 1898–1904, or the almost Neo-Gothic features of the *Bell-Esquard*, 1900–2. There is complete agreement between plan and façade, in so much as the free, undulating

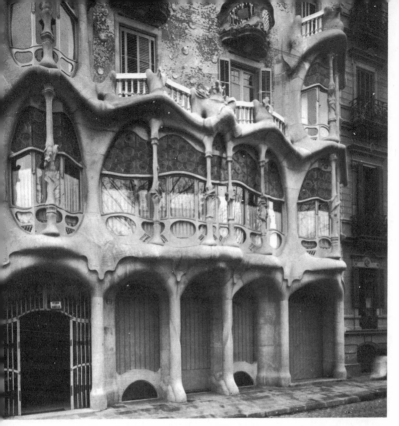

rhythm – without any straight plane – reflects a completely free use of space in the interior, where no corners are rectangular and no rooms are alike. The actual façade is executed in cut stone, with a hammered surface which gives an impression of the wear and tear of time. In this house every detail, from the iron railings, which remind one of enormous marine plants, to the heavy stone pillars, is entirely subordinate to the striving for plastic effect. But side by side with this plastic, robust conception of form, we find a more brittle, more delicate tone, a whisper from the sand dunes and of wavelets lapping the shore. Ceilings are like sandy beaches after the tide has receded, the gates to the inner courts have coral forms . . .[16] *Casa Milá* – in fact, the whole of Gaudí's architecture – is difficult to describe in mere words, whether we label it 'sculptural-architecture', 'architectural Impressionism', – though 'architectural

7·12a Gaudí: Casa Milá, Barcelona, 1905–7. Pillars, balconies and window-openings seem to have been washed eternally by the waves, while seaweed creeps and undulates around the balconies. The entire façade is in motion, mastered more by a sculptor than by an architect.

Expressionism' would seem more suitable – or a 'ten-course dinner taken in one gulp'. His architecture simply has to be *experienced*; it makes a tremendous impact.

In attempting to place this work historically, it must be recognised that it was the most original contribution to Art Nouveau architecture. Nowhere does the architectural conception of the style receive such a consummate expression as here. What is more, Gaudí succeeded where so many before him in the history of architecture had failed, viz. in abandoning stability and shaking the static foundations of architecture itself, without actually bursting its bounds.

Güell Park, 1900–14 (figure 7·1), on Monte Carmelo occupies a special place in the history of landscape gardening and architecture. By now the waves are subsiding. We find ponderous stone shapes, sometimes in the form of trees, sometimes as Doric columns, sometimes as mysterious stalactites. What gives the Park its picturesqueness is that the actual buildings – hitherto encountered in huge dimensions – are here reduced to something more tangible. The

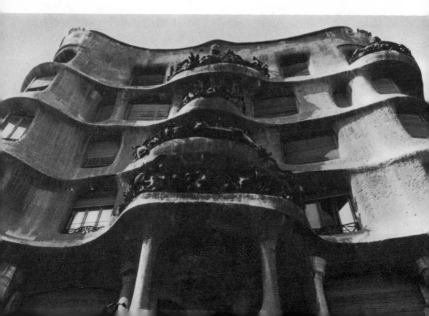

7·12b Gaudí: Ground plan for Casa Milá, Barcelona, 1905–7. Gaudí constructed the house with an internal skeleton such that no rooms were alike and none of the angles right angles. This gives the asymmetrical plan a special feeling of airiness and space: room flows into room. In this way a relation is established between the movements of the exterior and the interior.

gatehouse, symbolising St George and the Dragon and the gate lodge, grottoes and other sections of the construction recall the mood of an eighteenth-century park – an air, in fact, of intimacy. Seen in a larger context this reflects the most profound idea of Art Nouveau – Nature associated with Art in an elevated unity.

Gaudí's style was too personal for him to have followers. But there were other architects working in the Art Nouveau style: J.F. Granell, with his more floral design, as we see in the house in *La Gran Vía*, 1903, and J.M. Jugol Gibert in *335 Diagonal*, both in Barcelona: also Francisco Berenguer, who was associated with Gaudí in his work on the *Sagrada Familia*.

The other leading architects at the end of the century – José Puig y Cadafalch and Lluís Domenech y Montaner – remained on the whole aloof from the style, continuing in the often rather violent style-language of late Historicism, as was the case in the *Palau de la Música Catalana*, 1891–8, which has been described as 'historistisch gestörten "unreinen" Art Nouveau' ('overturned historicity, "impure" Art Nouveau').[17]

Scotland

It is a far cry from Barcelona to Glasgow, and no less from a man of Gaudí's personality to a Mackintosh; yet, both of them are unique style-creators, each in his own way, and both are to be reckoned among the most significant architects of Art Nouveau.

Charles Rennie Mackintosh worked as an architect from 1889, but his style attained its maturity in the elegant and sophisticated atmosphere of the Scottish Tearooms (figure 2·9a) which he designed in

7·13 Mackintosh: Haus eines Kunstfreundes, 1901. In this project Mackintosh operates with an additive system of blocks. The total impression, however, is softened by gently rounded projections, bays and corners. The somewhat closed appearance of the building is emphasised by the large, bare surfaces and by the windows formed without any architectural decoration at all.

about 1900 – or perhaps it would be more correct to say that he personally created this atmosphere! Among the four tearooms, designed for a Miss Cranston, the one in *Buchanan Street*, 1897, was the earliest. Here for the first time we come across the slim female figure characteristic of the Glasgow School, rhythmically repeated and entwined in an *entrelac* scroll-work reminiscent of Celtic décor.

In the following years Mackintosh carried out three more decorative *chefs d'œuvre*, the *Argyle Street Tearoom* in 1897, together with Walton; the *Ingram Street Tearoom*, 1901, and the *Willow Tearoom* in Sauchiehall Street, 1903–4, which were entirely his own work, as were the designs for the *Haus eines Kunstfreundes* in 1901, and the *Music Room* designed for Wärndorfer in Vienna in the late 1890s. His main architectural achievements are the *Glasgow School of Art*, Glasgow, 1897–9 and 1907–9, *Windy Hill*, Kilmacolm, 1899–1901, and *Hill House*, Helensburgh, 1902–3. In these works a stylistic dualism seems to exist: Mackintosh moved with ease and confidence from the then most delicate rhythm, which hovers in a world of olive-green and ivory-white harmonies, to the most ponderous cubes, which constitute integral elements in a system of rectilinear surfaces of dark-green and black.

The sprightly linear style appears, fully fledged, in his own flat at *120 Main Street*, Glasgow, 1900. The general impression is one of light and airiness: pale grey and white walls. The decorative accent was provided by small square panels of rose-coloured gesso. The Scottish School never allows decoration to overflow and take possession of the object, as it did in Continental Art Nouveau. This is one of their foremost decorative principles, which they share with English artists, and is a natural result of the relentless struggle of the Arts and Crafts Movement to achieve simple, austere decoration. Once victory had been won and furniture had been pruned of the extravagances of Historicism, ornament was used sparingly and with deliberation.

In *Haus eines Kunstfreundes* (figure 7·13), Mackintosh operates with masses and blocks just as freely as he composes in two

dimensions with flat surfaces and lines. An important feature of this building is the way it terminates without a cornice, a feature which makes greater demands on a firm, clear contour and thus helps to create a closed architectural effect. A special architectural effect is achieved by the functionally conditioned and asymmetrical placing of the windows. This asymmetry can be traced from the smallest decorative detail to the positioning of the surfaces and the distribution of the masses. In *Haus eines Kunstfreundes*, each architectural element in itself acts as an ornament where it stands against the plane surface, acquiring its own aesthetic value from the contrast between broken and unbroken surface. These ideas, however, were never fully expressed in architectural work, even though we find them partly represented by *Windy Hill* and *Hill House*. The first section of *Glasgow School of Art*, 1897–9, undoubtedly occupies an important place in the Modern Movement, perhaps more than in Art Nouveau architecture, even though the main entrance strikes obvious Art Nouveau notes, not least in the iron decoration and the lively asymmetry.

The importance of Mackintosh and the group gradually declined for a great many reasons. The decorative play of the Glasgow School was soon *passé* among those in the forefront of battle, and the advanced ideas of the School were generally adopted. By 1903, when Mackintosh's work had practically come to a stop, he had already made his own particular contribution to the development, and the dualism we have noticed in his work reflects the further development of the Art Nouveau style in its entirety. His personal

7·14 Townsend: Horniman Museum, London, 1900–2. Townsend's feeling for form, as well as over-emphasis of certain architectural elements, is wholly neo-Baroque. In the details, however, we find the typical features of English Art Nouveau.

versions bear the seeds of a counter-movement – a reaction against the curvilinear and ornamental sophistication, a search for geometrical clarity and decorative austerity. This counter-movement was to prove strongest in Austria and Germany.

England

The Glasgow School aroused nothing like the same interest in England as it did in the rest of Europe, and the three or four English architects who worked in an Art Nouveau style are far removed from the general development, dominated by Richard Norman Shaw and the new architectural expression of Charles Francis Annesley Voysey. Nevertheless, there is some connection with the Glasgow School. George Walton was trained in Glasgow and worked with Mackintosh, though when he arrived in London in 1897 he was already more influenced by the simpler style-language of the Arts and Crafts Movement.

Charles Harrison Townsend is the architect who can really be said to represent English Art Nouveau. Among his masterpieces in London are the *Bishopsgate Institute*, 1892–4, the *Whitechapel Art Gallery*, designed in 1895 and built between 1897 and 1899, and *The Horniman Museum*, 1900–2. The first of these can hardly be called Art Nouveau, but the other two reveal a style which is as close to Art Nouveau as the English managed to get.

The *Whitechapel Art Gallery* reveals the influence of Voysey in the low windows and ornamentation and of Richardson in the large, heavy arch. What is undoubtedly Art Nouveau, however, is the rounded modelling of the building and the markedly plastic treatment and asymmetrical placing of the main entrance. *The Horniman Museum* (figure 7·14), a detached building at Forest Hill, on the outskirts of London, is an important monument in English Art Nouveau architecture. The free, asymmetrical disposition has here acquired greater significance and Anning Bell's polychrome mosaics emphasise the faintly classical spirit which pervades the main building. The tower, too, with its rounded

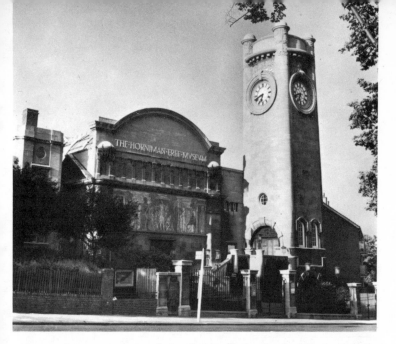

corners, shows a touch of the full-bodied, plastic effect of Continental Neo-Baroque, but the floral ornamentation, flush with the surface, clearly reveals its English origins. With its well-balanced distribution of mass, its soft lines and aptly placed floral ornaments, *The Horniman Museum* is a worthy though somewhat isolated example of English Art Nouveau architecture.

Together with William Reynolds-Stephens, Townsend completed the *Church and Garden of Rest* at Great Warley, Brentwood, Essex, 1897–1904. The more traditional exterior was designed by Townsend, while Reynolds-Stephens was responsible for the fully contrived Art Nouveau interior (figure 7·15). Here all the details and materials blend superbly to produce a decorative whole. The screen dividing nave from chancel consists of bronze trees, whose claw-like leaves grip the low wall. The crowns of the trees consist of compactly interlaced foliage, with angels in oxidised silver, red glass pomegranates and flowers in mother-of-pearl. The nave vaulting is decorated with rose trees and completely covered with aluminium leaf, while panels of lilies, rising from their bulbs, also in aluminium, run round the top of the wall. We are familiar with Gaudí's stone trees and the bronze and clay trees of Vigeland and

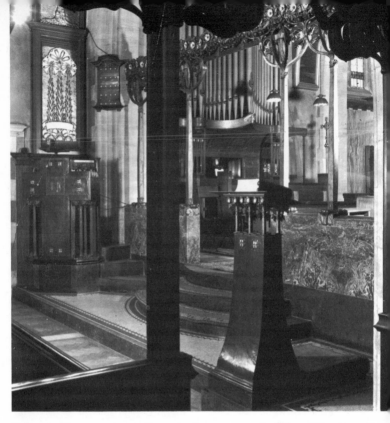

Gilbert. Here we meet them in brass – symbolising life. A contemporary writer describes the idea behind this ecclesiastical ornamentation as follows:

He has made free use of floral forms throughout the decoration, emblematic of progressive growth in the earthly life, but still more of glorious hope which year by year is emphasised at Easter-tide, the time of floral recrudescence.[18]

This interior occupies a unique position in English ecclesiastical art. Art Nouveau-like tendencies may be encountered elsewhere, though in the form-language of the Gothic Revival, as is the case with John Nimian Camper's *St Cyprian*, Gloucester Gate, approx. 1905, or J.D. Sedding's *Holy Trinity*, Sloane Street, 1888, both in London. Another example on more traditional lines is *St Cuthbert*, Philbeach Gardens, 1887–93, designed by W. Bainbridge Reynolds.

Throughout the nineteenth century English ecclesiastical architecture
was strongly influenced by the Gothic Revival. In the latter part of
the century the Arts and Crafts Movement renewed ecclesiastical art
generally, but only very rarely can traces of Art Nouveau be found.
This church therefore holds a unique position in English architecture.

The actual church is entirely Neo-Gothic, but in the choir rails and
lectern the architect has imbued the metal with a peculiar and
special rhythm. From a Continental point of view one would hardly
call this Art Nouveau, and yet it is in metalwork of this nature that
– within the limits of national tradition – the English approached
the style.

Yet another English architect deserves to be mentioned, Mackay
Hugh Baillie Scott, not least because he was one of the architects
most closely in touch with the Continent. Although of Scottish de-
scent, as his name indicates, his working life was spent in England
and he is therefore best classified among English architects. Baillie
Scott designed furniture for the Grand Duke of Hesse, at
Darmstadt, in 1898, and built a number of houses in Germany,
Poland, Russia and Switzerland, winning into the bargain the
competition sponsored by the Darmstadt art promoter, Alexander
Koch, in 1900, for a design for a *Haus eines Kunstfreundes*.
(Mackintosh won second prize on this occasion.) His architecture
is traditional English, often with a cosy touch of 'cottage' or Tudor.
The same applies to the interiors, where he makes lavish use of all
sorts of flower-covered textiles in the nineteenth-century manner,
all enclosed in a traditionally romantic English setting. But in the
eyes of Continental artists still dedicated to period styles, this
interior decoration and architecture was completely new and
inspiring – and it was English!

Austria

German and Austrian Art Nouveau architecture differ considerably
from the architecture we have so far dealt with. Even though several
of the architects published their *Jugendstil* ornaments at an early
date in various art periodicals, it took a considerable time, relatively
speaking, before Art Nouveau architecture got beyond the design
stage. Once it arrived it was of short duration, because it carried
within itself essential elements which the German and Austrian
architects were to transform into a different and a more important

7·16 Hoffmann: Sketch for entrance, 1898, showing the combination of a plastic conception with Art Nouveau rhythms. While Gaudí realised his project in the same spirit, Hoffmann's remained in the pages of *Ver Sacrum*.

phase of architectural development. As architects they belong rather to the next phase of the history of modern architecture.

The general stylistic development of Austrian architecture in the 1890s is entirely tradition-bound; and yet beneath the classical surface a radical architecture was developing, which was to prove of European importance. What corresponds to the Art Nouveau style merely became an interlude on a two-dimensional plane. In the early 1890s Otto Wagner was working in an idiom which varied from Florentine Neo-Renaissance to Neo-Rococo. Towards the end of the century he began to show a classical tendency, with simple, strictly architectural expressions and a certain elegant Louis XVI touch. Only occasionally did Wagner adopt Art Nouveau motifs, as in the *Nussdorfer Nadelwehr*, 1897, or in the *Karlsplatz Stadtbahn Station*, Vienna, of approx. 1897, where he adopted a more floral geometrical approach, or in the *Majolika Haus*, Vienna, of about 1898, which has more flame-like motifs. But in neither case does the architectural conception have much in common with the Art Nouveau architecture we have hitherto discussed. The essential difference is that the decorative play of Art Nouveau does not envelope the whole façade. In this case, it would be easy to imagine the decoration removed – as finally occurred – and then the building no longer has any trace of Art Nouveau.

Two of the younger Austrian architects, Wagner's pupils Josef Hoffmann and Joseph Maria Olbrich, were prominent in the 1890s as book illustrators, a field in which their architectural fantasies

7·17 Olbrich: Haus der Wiener Sezession, 1898–9. The strong classical heritage is obvious in the firm, simple treatment of the masses, while the cupola in the form of a tree reflects Art Nouveau ideas.

were given free rein. In this connection it is interesting to observe the attempt to fuse architecture and nature, with trees introduced as an essential decorative element in the ground floor of the building. Another feature, which is undoubtedly bound up with this and the organic theories of Art Nouveau, is the way in which the building rises organically from the ground, the plinth being given a pronounced outward curve near the ground.

Once we get to the completed buildings, however, the imagination is rather more restrained. This also applies to the ornaments – in design as well as in placing. It was in the columns of *Ver Sacrum* that they developed their ornamental style: Hoffmann his squares and rectangles, Olbrich his endless variations of circles and combinations of circles. From the pages of the book the two artists transferred their motifs to other surfaces, to walls, to interior decoration and occasionally to furniture design – but hardly ever to architecture. Art Nouveau architecture remained in the pages of periodicals (figure 7·16).

The *Haus der Wiener Sezession*, Vienna, 1898–9 (figure 7·17), however, with its rigid classicism and sparing use of ornament, remains one of Olbrich's masterpieces. The tree-shaped cupola, which has now been restored, reflects the relationship between architecture and nature. It also has a deeper meaning: let the arts flourish, it seems to say, beneath this sheltering foliage. The same qualities are a feature of the houses Olbrich built in Darmstadt after the Grand Duke of Hesse had invited him to join the artists' colony at

Mathildenhöhe in 1899. He designed practically all the buildings there, and his sober style has some of the same elegant Louis XVI touch that we find in Wagner's work, but at the same time a touch of something English – or perhaps Scottish.

That both Mackintosh and Hoffmann in 1897–8 should have used the square and the same colours – black and white – does not necessarily mean that one influenced the other. Two of the most advanced architects of the time may well have arrived at the same solution. Such influence as the Glasgow School may have had on the Viennese School, was probably more in the nature of a stimulus than of a purely direct kind. On the other hand, the development in graphic art and design suggests that the impulses originated in Great Britain, and it is possible that it was in Scotland that the actual seed of the architectural form of expression which was later to come to flower in Austria, is in fact to be found (see also p. 185). A certain English undercurrent, which is often noticeable, is undoubtedly bound up with the general influence exercised by England in the 1890s, reinforced by *The Studio*.[19] When we come to Hoffmann's later buildings in Darmstadt, such as the *Hochzeitsturm*, 1907, we are already past the Art Nouveau period and entering on the first phase of the Modern Movement.

Hoffmann, for his part, executed work such as the *Purkersdorf Sanatorium*, 1903–4, and the *Palais Stoclet*, 1904–11, the latter in Brussels. To what extent a masterpiece such as the *Palais Stoclet* can be labelled Art Nouveau architecture is disputable. In its clear additive effect and its sober surfaces, it has nothing in common with the Art Nouveau architecture we have dealt with so far. On the other hand, in its interior the brittle, sophisticated version of Art Nouveau of the *Wiener Sezession* is unmistakable. Already by 1900 Hoffmann had created an interior for the Paris Exhibition which was devoid of any trace of Art Nouveau. When he started on the *Palais Stoclet* he was really through with the form-problems of Art Nouveau, and this fine piece of architecture ought really to be classed with the next phase of the history of architecture, side by side with Wagner's *Postsparkasse*, Vienna, 1904–6.

The fourth leading architect in Austria, Adolph Loos, who also helped to found the *Wiener Sezession* in 1897, had produced designs far simpler than Olbrich and Hoffmann as far back as 1898, and was never involved in the Art Nouveau style, as these two were. Loos was – and remained – primarily an architect occupied with architectural problems and was by nature hostile to ornament.

In this way Art Nouveau in Austria proved a relatively unimportant deviation from the development in architecture: its essential nature was not given expression.

Germany

Germany too proved a relatively late starter. Soon after the turn of the century her leading architects were pursuing the same goal as Perret and Garnier in France and Wagner and Loos in Austria.

The chief centre of *Jugendstil* in Germany was Munich. But of the seven artists generally referred to as the Munich Group – Behrens, Endell, Eckmann, Riemerschmid, Obrist, Pankok, Paul – only the first three really devoted themselves to architecture. Riemerschmid was a painter before 1898, and as an architect is linked with the traditions of the Neo-Baroque, for example in the *Münchener Schauspielhaus*, 1900–1, though this building contains certain Art Nouveau features. Peter Behrens, too, was originally a painter – one of the founders in fact of the *Münchener Sezession* in 1903 – and it was only after he had joined the Darmstadt Group in 1899, and taken part in the group known as *Die Sieben* there – in company with Bosselt, Bürck, Christiansen, Habich, Huber and Olbrich – that he started working as an architect, building his own house. Here he already began to turn away from the curvilinear features and the general tendency to decorative effusion, and strove to achieve a more rectilinear and simpler architectural expression. In 1907 he took up an appointment as director of design with the electrical firm AEG, and became what might be called Germany's first industrial designer. In 1909 he designed a *Turbinhalle* for AEG – the first important iron and glass construction in Germany,

7·18 Endell: Atelier Elvira, 1897–8. The enlarged Art
Nouveau motif has no real connection with the building
itself which, in the architectural treatment of the block,
is more conventional. But the size of the motif – which
could equally well have been designed for embroidery – gives
the house its special place in Art Nouveau architecture.

apart from Alfred Messel's partly Art Nouveau-styled *Wertheim
Department Store* in Berlin, begun in 1896. In Behrens's important
building we once again meet the large gently curving arch, serving
an entirely constructive purpose. Yet this is not Art Nouveau
architecture: in the company of Behrens and his pupils, Le
Corbusier, Gropius and van der Rohe, we are well launched into
the Modern Movement.

It only remains for us to deal with two persons who are really
Art Nouveau architects – August Endell, and the Belgian van de
Velde. The latter came to Germany in 1899, after building his own
house, *Bloemenwerf*, in Uccle near Brussels, 1895–6. The praise of
contemporary critics has invested this building with a significance
to which it is hardly entitled, certainly not from the point of view
of architectural history. The visits received from Maurice Joyant,
Julius Meier-Graefe, Samuel Bing and Toulouse-Lautrec, made his
name famous beyond the borders of Belgium. Up to the turn of the
century he was predominantly concerned with interior design and
artistic craftsmanship. *Haus Esche*, Chemnitz, and *Haus Leuring*,
Scheveningen, both 1902, were his first major architectural efforts
after his own house. In their heavy granite style, however, they
have little to do with Art Nouveau, any more than *Villa Hohenhof*,
Hagen, 1904. His theatre for the *Deutscher Werkbund Exhibition*
in Cologne, on the other hand, contains many Art Nouveau features,
both in the distribution of masses and in the placing of ornament,
but it was built as late as 1914. As an architect van de Velde fell
short of his trained colleagues: the buildings he designed are in no
way revolutionary and bear no comparison with the work of men
such as Gaudí, Mackintosh, Horta or Endell, not to mention
Voysey, Perret, Garnier and Behrens.

August Endell's first important work was the *Elvira* photography
studio, 1897–8 (figure 7·18). The building's main conception is
simple and austere, foreshadowing trends that were to develop in
the twentieth century. But the large asymmetrical Art Nouveau
motif on the façade and the fantastic decoration of the staircase,
place it in a special position not only in German architecture but in

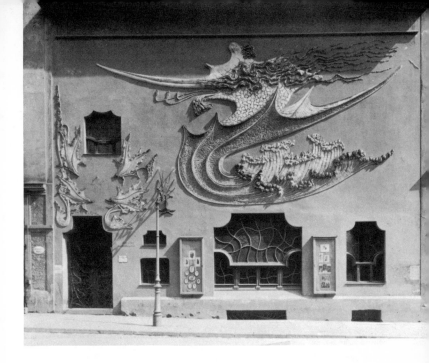

Art Nouveau architecture as a whole, even though it is only its size that justifies describing it as architecture. It might equally well have been the central motif of an embroidered cushion. There can be little doubt that Endell was influenced by Obrist, but the stimulus of Japanese art is also quite clear. Nikolaus Pevsner has also discovered other features:

> In its frantic outbreak of ornamental fury, the unbounded exuberance of German patterns of the Migration period re-emerged.[20]

Apart from the undulating, fluent play of line, it is the unerring sense of the placing of the ornament against a neutral background – a sort of Oriental refinement – which manages somehow to make this fluid, spiky, straggly ornament part and parcel of the façade. In its asymmetry it reflects the unreasonable and self-contradictory striving of speed and movement to achieve architectural stability. Endell's next building was the *Sanatorium in Föhr*, 1901, which reveals nothing like the same decorative excesses. In the *Bundes Theater*, Berlin, 1901, a similar form-language to the *Elvira* studio crops up again, though this time in a more muted form.

German architects abandoned Art Nouveau as rapidly as their colleagues in Austria. In fact, Vienna, Munich and Darmstadt became the main centres of the counter-movement that now set in, which rapidly reduced the Art Nouveau style to a commercialised stylistic disguise for second-class architects. In Germany and Austria, where the style was so emphatically two-dimensional, we do not encounter architectural forms of expression with the same content as in France, Belgium, and Spain.

Holland, Scandinavia, Italy and America

Art Nouveau proved a less significant phase in Dutch architecture, although several examples are known,[21] and it made its impact relatively late. Dutch Art Nouveau is characterised by bourgeois simplicity devoid of the excesses and opulent luxury that are to be found elsewhere. Furthermore the traditional element, brick, is copiously used and, when glazed, gives this architecture its special stamp. Among the architects who made particular use of this style for varying periods was Herman Pieter Mutters, who built the *Wassenaarseweg*, The Hague, 1898, in the best floral style. Mutters and Karel Shuyterman also built the Dutch pavilion for the World Exhibition in Paris in 1900. Mention should also be made of Willem Kromhout, who built the *American Hotel*, Amsterdam, 1900.

In Scandinavia, too, the style never really took root in architecture, though in Sweden both Ferdinand Boberg and Carl Westman designed buildings influenced by the style: Boberg's *Centralposten* in Stockholm, 1902–4, with its ponderous, somewhat American-influenced main outlines and Swedish national details – with a touch from the great forests – being the most representative building. In Finland, Lars Sonck is the most important architect, his *Tampere Cathedral* (designed 1899–1902 and completed 1902–7), being one of the greatest masterpieces of ecclesiastical architecture in the entire Art Nouveau period. In Denmark architecture on the whole remained outside Art Nouveau influences in the 1890s,

except for some of Bindesböll's decorative architectural fantasies. Norwegian architecture in wood, on the other hand, made a contribution with its national Romantic school where style elements from the Viking period and Art Nouveau fused together, as in Holm Munthe's masterpiece the *Frognerseteren Restaurant*, 1890–5, and the *Imperial Hunting Lodge* at Rominten in East Prussia, 1891. We can also find the same national elements in the work of Henrik Bull: for instance in his major buildings, the *Historical Museum*, 1897–1902, and the *Government Administrative Building*, 1901–6, both in Oslo.

In Italian architecture, too, Art Nouveau appeared in a national guise, and we find numerous reminiscences of traditional Italian architecture. As has been observed, 'the *floreale* was a style of decorative eclectic architecture which flourished most particularly in the residences being built for the prosperous bourgeoisie. . . .'[22] The Italian version had its first exponent in Giuseppe Sommaruga, but as a true-born Italian – and a pupil of Wagner – he always retained a classical grip on the building, as in his masterpiece the *Palazzo Castiglioni* in Milan, 1901–3. The most lavish user of ornament, however, was Gino Coppede, whose style achieved a peculiar massiveness from his full-bodied use of Neo-Baroque. Raymondo D'Aranco had something of the same Baroque heaviness in the rotunda for the exhibition in Turin in 1902, which, together with the exhibition building in Udine the following year, was his *magnum opus* in this style. The Italian who came nearest to the sculptural and gliding form-language of Art Nouveau architecture was Antonio Sant' Elia. At times he also achieved an airy elegance which was not really typical of Italian Art Nouveau.

In American architecture Art Nouveau was developed mostly as ornament. In Louis H. Sullivan's buildings from the 1890s we find the decoration used in the genuine Art Nouveau manner, unerringly placed on the surface, not structural-symbolical as in the work of Guimard or Horta, nor embracing the building with a wealth of floral details, but precisely placed with a sure sense of ornament. At times the ornamentation of these buildings possesses marked

7·19 Sullivan: Carson, Pirie, Scott & Co., Chicago, 1903–4. Detail. One must look back to the time of Louis XIV to find tendrils flowering so richly; and as in the seventeenth century the composition is symmetrical What makes Sullivan's fantasies Art Nouveau is the linear treatment and the tension in the curves.

intensity and violence, for instance in the *Carson, Pirie, Scott & Co. Department Store*, Chicago, 1899–1901, especially in the main entrance, 1903–4 (figure 7·19). It is also found in the frieze on the *Wainwright Building*, St Louis, 1890–1. Sullivan's ability to treat the façade as a decorative entity is in evidence in the *Guaranty Building*, Buffalo, 1894–5, where the ornamentation in the frieze seems to blend with the architectural elements. Sullivan's profound importance in the history of architecture is by no means on the level of the ornamental: what he created in this sector remains a fascinating but isolated phenomenon – the most important contribution to what we might call the architectural ornamentation of American Art Nouveau.

Conclusion

We have seen how Art Nouveau, from the early 1890s, created its own form-language, a form-language which, though varying markedly from country to country and from architect to architect, can nevertheless be labelled Art Nouveau architecture. It justifies us in speaking of a stylistic phase, even though it was of short duration and cannot be counted among the most significant eras of architectural history. Already by the end of the 1890s – at some time around 1898–9 – a counter-movement had set in in Germany and Austria, with a parallel movement in Scotland. First came a tendency to abandon the original Art Nouveau ornamentation and to develop instead a geometrical play of similar elegance and of the same artistic quality but with the square installed as the main embellishment. Subsequently, with the eclipse of the ornamentation as such, there was a strong movement away from Art Nouveau and all that it stood for. As early as 1902–3 these trends had found adequate expression and Mackintosh, Hoffmann, Wagner, Olbrich and Behrens had turned their backs on the style. By 1903 Horta had achieved an extreme simplification, Hankar was dead and Mackintosh was no longer undertaking major architectural work. In Paris the style had been abandoned shortly after 1900, with

Guimard alone continuing till 1911, while André in Nancy had given it up in 1908. In Spain, where Gaudí continued unperturbed throughout the first decade of the new century, Art Nouveau finally ceased when the master devoted himself to the planning of the *Sagrada Familia* in 1909–10.

Briefly, we may say that Art Nouveau architecture flourished in the years 1892–1900; the counter-movement set in in 1898–9; and in 1902–3 the style had been given up, even though its most ardent champions continued on for a few more years, up to 1910. With the outbreak of war in 1914 it was finally played out, although its influence was felt strongly in the sculptural Expressionism of Erich Mendelsohn, *The Einstein Tower*, Neubabelsberg, 1919–21, and Rudolf Steiner, *Goetheanevm*, Dornach, begun in 1923.

To sum up, what can the style be said to have achieved in architecture? It developed and applied the architectural stylistic

expressions we dealt with in the introduction. But the search for ornamental treatment of the façade as a whole, the dynamic and plastic treatment of the mass of the building, came for the time being to a dead end. Nor can widespread progress be said to have been made in planning. The exposure of the structure and its decorative and symbolical treatment, together with the unerring sense of the intrinsic value of ornamentation, its placing and its masterly organic design – these are probably the outstanding contributions of the style, beside the impulses given by the plastic treatment of the building. Art Nouveau was also the first style which succeeded in blending glass and iron to form an architectural and stylistically aesthetic expression. The search for a closed architectural form of expression should also be mentioned as one of the major and more lasting features of the style. Historically its architectural achievements belong rather to the final phase of the style-creating forces of the nineteenth century than to the first phase of the Modern Movement. And yet Art Nouveau prepared the way for this first phase, and in a large context constitutes the transition between Historicism and the Modern Movement. But the style never had time to establish itself sufficiently for the different tendencies to be fused in a lasting architectural form of expression.

8 Art Nouveau in applied art

It was within the applied arts that Art Nouveau was most prolific and proved to be most significant in the history of art, flourishing as it did in all areas and achieving a quality that places its products on a par with those of the greatest periods. Yet it was, of course, within the applied arts that a need for renewal had been greatest, and it was among the *avant-garde* artists of this medium that the style originated. As we saw in chapter 2, the style revealed a number of aspects which to some extent coincided with its cultural-geographical distribution. Within the various branches of applied art the form of expression which the style developed proved relatively homogeneous. The reason for this was partly that the Art Nouveau artist worked in many branches of applied art, and in this way any conscious creation of style was expressed in several fields.

France–Art Nouveau

France was undoubtedly the country where the style flourished most in the applied arts. Certain economic and social preconditions are necessary if a stylistic phenomenon of this kind is to achieve a breakthrough, and it is clear that these were to be found in France. The old traditions of handicraft were by no means dead, and a broad social basis existed in a prosperous and enlightened bourgeoisie. Not only were the people of Paris remarkably susceptible to trends in fashion, but Art Nouveau satisfied all their demands: it was elegant; it maintained high standards of quality, in everything from jewellery to furniture; it quickly acquired a fashionable international flavour, without really departing from French tradition; and finally – most important of all – it was new.

The exhibition at the *Union Centrale des Arts Décoratifs* in 1884 had seen a real revival of floral ornamentation, and this continued in the 1880s. The great Paris Exhibition of 1889 presented a broad view of French applied art, revealing Neo-Rococo as the dominant stylistic trend, though with a markedly floral character which was apparent in both Gallé and Delaherche. While touches of other styles were also apparent, the spirit of Historicism dominated.

This development continued throughout the 1890s, but at the same time potent forces, which were about to change the course of events, had already made their influence felt (see chapter 5). These forces were seen to be at work not only in Paris, but also in the provinces; and in fact French Art Nouveau acquired two centres, Paris and Nancy. They were very different in character, the first being international and fashionable, the second national and traditional. Paris was characterised by the abstract and structural-symbolical aspect of the style, Nancy by the floral. Both, however, shared a markedly plastic conception.

Paris

As a result of attempts in the 1880s to renew the applied arts, it was decided in 1891 to exhibit products of 'art industry' together with pictorial art at the *Salon du Champs de Mars*, thus implementing the idea of *Gesamtkunstwerk* (uniting of the arts). In 1892 Octave Uzanne had launched his periodical *L'Art et l'Idée*, in which a great deal of attention was devoted to applied art. In the same year five artists joined hands in the *Les Cinq* group: the sculptor Alexandre Charpentier, the sculptor and furniture designer Jean Dampt, the designer and decorator Félix Aubert, the architect Tony Selmersheim and the potter Étienne Moureau-Nélaton. In 1895 they held their first exhibition. In the following year they were joined by Charles Plumet, whereupon the group changed its name to *Les Six*. In 1896 a new exhibition was held, this time in the *Galérie des Artistes Modernes*. In 1897, with the accession of the sculptor Henri Nocq and the architect Henri Sauvage (known among other things for the house he designed for Majorelle), the group adopted the name *L'Art dans Tout* as a label for their joint exhibitions.

Among this group, Charpentier was a particularly ardent exponent of Art Nouveau. In the early 1890s he was still working along the lines of the somewhat austere Arts and Crafts style, but at the end of the decade he was attracted to Art Nouveau and subsequently designed several pieces of furniture in a markedly

plastic and rhythmic style. He was also active as an interior decorator and architect. Auguste Delaherche, probably the most outstanding potter working in the style, occupied a more isolated position. His major contribution was his masterly *coulée* of glazing, a technique which allowed the surface layer of paint to flow down over the object during the process of firing – clothing it, as it were, in the rich sumptuousness of deep enamels. The form of the object was always clear, and by 1897–8 he had already developed the particular Art Nouveau feature consisting of handles springing out of the vase like flower stems. We get an excellent impression of *Les Six* – not least of Aubert and Plumet – from a laudatory criticism of their work which appeared in *The Studio* in 1898.

In the preceding year, the German art critic Julius Meier-Graefe opened his shop *Maison Moderne*, which together with the *Galéries des Artistes Modernes* and Bing's *L'Art Nouveau* was to prove a forum for new trends. He was joined by other art critics, while leading writers of the age such as Gabriel Mourey, Jean Schopfer, Gustave Soulier, and Charles Genuys championed the style. However, the real breakthrough in Paris had already come with the opening of Samuel Bing's *Maison Bing, L'Art Nouveau*, in December 1895.[1] Though the art critic Arsène Alexander wrote disparagingly in *Le Figaro* 'Tout cela sent l'anglais vicieux, la Juive morphinomane ou le Belge roublard, ou une agréable salade de ces trois poisons' ('It all smacks of the vicious Englishman, the Jewess addicted to morphine, or the Belgian spiv, or a good mixture of these three poisons'), the opening was a sensation, and success was soon assured. Among the French artists who exhibited were Anquetin, Bernard, Bonnard, Carrière, Denis, Pissarro, Seurat, Signac, Toulouse-Lautrec, and Vuillard; among the British were Beardsley, Brangwyn, Crane, and Mackintosh; Whistler was also represented. Sculptors included Bourdelle, Meunier, Rodin, and Vallgren. Scandinavia was represented by the Swede Zorn, and America by Bradley's posters and Tiffany's glass (twenty pieces), while Gallé and Lalique represented French glass and jewellery respectively. Interiors were by van de Velde and Lemmen. Bing's

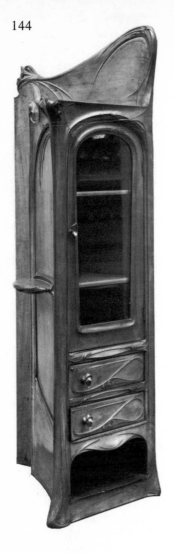

8·1 Guimard: Cabinet, 1900, and chair. Guimard's furniture is often original in shape. Sometimes it is as though the entire piece is enveloped in a mysterious veil – a feature also to be found in the sculpture of the period.

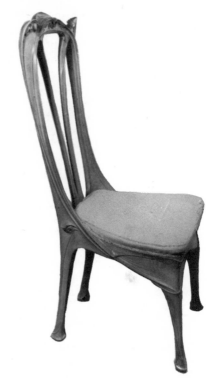

closest associates, however, were the painter and draughtsman Georges de Feure, the furniture designer Eugène Gaillard, and the potter Eugène Colonna. Mention should also be made of Dela-herche, who was associated with Bing at various times.

Apart from these two main groups of artists, one centred on

Bing, and the other composing the *L'Art dans Tout* circle, a great many others joined the movement during the closing years of the 1890s. These included architects like Louis Sorel, Louis Bigaux, Louis Bonnier (who also worked for Bing), George Hoentschel and – indisputably the leading figure – Hector Guimard. A leading Parisian potter was Ernest Chaplet who sold his workshop to Delaherche. It was after the exhibition of 1889 and 1900 that Chaplet's name became particularly well known abroad. Other artists included the sculptor-potter Albert Dammouse and the enamelist Émile Decoeur.

The leading Parisian Art Nouveau furniture designers were Guimard, de Feure and Gaillard. Guimard's furniture design displays the structural symbolism which we have already encountered in his architecture. He is not only adept at the architectural detail which creeps caressingly along a wall, eventually melting into its actual surface: in his furniture one has the impression that the structural lines vanish in the surface as though beneath a veil of cascading silk (figure 8·1). The entire piece appears to be enveloped in a mysterious veil which blurs the contours, seeming to hint at buds about to burst forth from beneath it. First and foremost, however, his furniture represents a search for cohesive unity of form, enhanced by a gliding rhythm between the various elements. His own conception of harmony, as he expressed it himself,[2] clearly reflects various features of structural symbolism, as in the decorations for the Paris *Métro* stations (frontispiece). The panels, which suggest the scales of fantastic sea-monsters, show how the decoration, through its clawlike settings, symbolises the construction. Apart from this, they are among the most imaginative forms of ornamentation ever created in abstract Art Nouveau.

Georges de Feure was an artist in an entirely different mould. In his work the graceful, fastidious, and almost feminine provides the *leit-motif*. He started as a draughtsman in *Le Courrier Français* and *Le Boulevard*, where he drew a great many posters. His posters and screens are filled with graceful female forms and his small objects designed with such grace and airiness that they might have

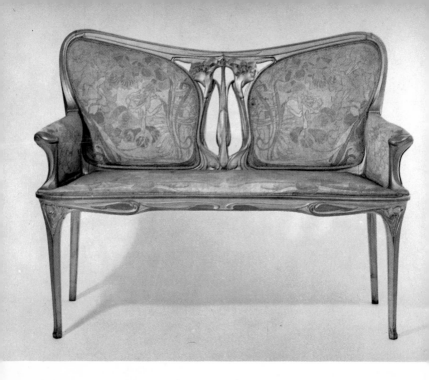

been intended for a female hand. He used pale, pastel-like colours, showing a special penchant for the more delicate shades of grey. Up to 1900 his form-language was derived from plants and flowers, with the stalks – always elegantly and delicately executed – providing the constructive elements. But beside his stylised plant shapes, there was a more traditional element: his furniture is certainly Art Nouveau, but it takes on a traditional French character, due largely to the gilding which he so often applies (figure 8·2). A Louis XVI chair would blend perfectly with any of his interiors.

Eugène Gaillard was a writer as well as a furniture designer, his *A propos du mobilier* appearing in 1906. As an artist he was far more virile than de Feure. Where de Feure exploited the refined effect of the *cannelure*, Gaillard used a plastic and dynamic form-language (figure 8·3). De Feure represented the French Louis XVI tradition and Gaillard Louis XV. Both brass and wood conformed to the curvetting and capering lines; the entire outline of a piece of furniture was enclosed in a rhythm, as in Guimard,

8·2 de Feure: Sofa, 1900, made for Bing. All the woodwork is gilt in conformity with the best traditions of the eighteenth century, but the decorations have the grace of the 1890s. In the abstract plant shapes and the fancy flowers, such as the water lily, one sees the search for germinating motifs.

though Gaillard was less preoccupied with structural symbolism.

As a designer Eugène Colonna was midway between de Feure and Gaillard: he had de Feure's elegance and something of Gaillard's play of line, though he was less dynamic than Gaillard and calmer and more austere in his decoration than either of them. In his pottery he achieved a pleasing harmony between form and ornament (figure 8·5).

It was the work of these three – de Feure, Gaillard and Colonna – which dominated Art Nouveau furniture at the Paris Exhibition of 1900, where they represented the firm *La Maison Bing*, *l'Art Nouveau*: *décoration et l'ameublement*. There were six rooms, de Feure being responsible for the dressing-room and boudoir, Gaillard for the vestibule, bedroom and dining-room, and Colonna for the drawing-room.

Bing's exhibition proved a brilliant success, arousing the enthusiasm of the critics, particularly Gabriel Mourey who wrote a glowing tribute in *The Studio*.[3] At the 1900 Paris Exhibition the style was entirely dominated by French contributors. Neither van de Velde nor the Scots were represented. England's stand with the furniture of Jean-Walters Gilbert was hardly calculated to arouse much enthusiasm, while the German stand, with Obrist, Pankok and Riemerschmid failed to reveal what these artists were capable of. Apart from the Frenchmen already mentioned, talented decorators and designers such as Charpentier (figure 8·4), Perol Frères and Louis Bigaux also contributed. Majorelle, from Nancy, also showed a notable collection. It was hardly surprising, then, that Art Nouveau should have been regarded as a French phenomenon.

In these circumstances the marked naturalism of the *Union Centrale des Arts Décoratifs* was hopelessly out of place. In the design of the potter and architect Georges Hoentschel there was not the slightest attempt at stylisation, and the experiment launched under the auspices of that venerable institution may be regarded as the last frenzied attempt to apply Nature pure and simple as a solution to the style problems of the nineteenth century.

8·3 *Below* Gaillard: Buffet, wood with bronze fittings, 1900. Gaillard's
decorations are always subject to an abstract and plastic conception of form,
characterised by a dynamic and forceful counter-movement in the play of line.

8·4 *Right* Charpentier: Music cabinet, 1900. In the 1890s Charpentier's style was
more rectilinear, but around 1900 he adopted the whole gamut of abstract form-
language characteristic of Art Nouveau. As a sculptor he frequently added
naked women to his low-relief whatever the piece of furniture
might be – whether music cabinet or sideboard.

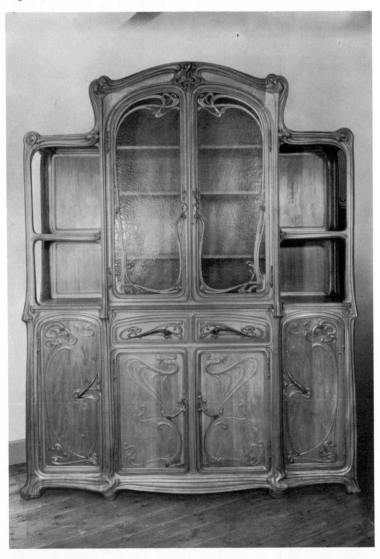

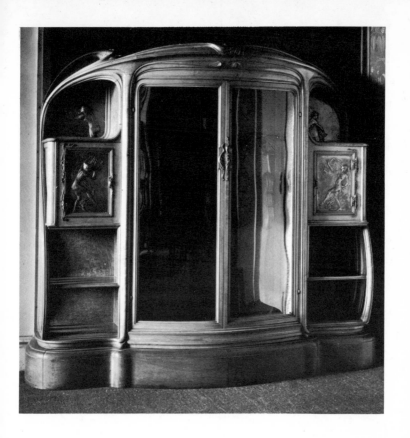

L'École de Nancy

At Nancy, the old capital of Lorraine, a form of naturalism developed in the 1890s which proved far more fruitful. With Gallé as its creative force, the *École de Nancy* took shape as early as 1890, even though the actual institution itself, *L'École de Nancy, Alliance Provinciale des Industries d'Art*, whose aim was to 'foster the renaissance and development of handicraft in the provinces', was not established until 1901. Apart from the interest in Nature, which provided the essential basis for the *École de Nancy's* florally influenced Art Nouveau, there were two other factors that were to prove significant in the development of the style, namely the local Rococo tradition and the influence of Japan (see 'Neo-Rococo' and 'Japanese and oriental influence', chapter 5).

150

8·5 Ceramics made for Bing
between the years 1898–1904.
From left to right: Vase
by Colonna, plate and
chocolate mug by de Feure,
vase by Delaherche.

Émile Gallé was the only son of a Nancy luxury-goods producer, who turned out *faïence* and high-class furniture in Neo-Rococo style. He studied philosophy, botany and drawing, and after a visit to the university at Weimar learned the glassmaker's trade at Meisenthal. In 1872 he paid a visit to London, where he admired the Victoria and Albert Museum, and two years later started regular production of glass at Nancy, having set up a workshop there as early as 1867. At the Paris Exhibition of 1878 he scored his first great personal success with his *clair de lune* glass. The 1889 Exhibition is regarded as his breakthrough as a glass artist, and also as his finest hour.[4] Throughout the 1890s his workshop extended its activities, reaching peak production and the height of its reputation at the time of the 1900 Exhibition, when close on three hundred workers were associated with the venture. It continued production in Gallé's style from the time of his death in 1904 right up to 1913, with Victor Prouvé as its manager. In 1936 the firm was wound up.

As far as his furniture was concerned, Gallé always remained to a certain extent in the French stylistic tradition (figure 2·8). The constructive nature and total effect were almost always linked with period style: large cupboards being designed in the Renaissance style, desks mainly in Louis XV and chairs in Louis XVI. But a common feature of almost all of them, especially the smaller pieces, is that the constructive elements – the actual structure – are transformed into stalks or branches springing out from constructive points. The decoration – both the inlay work and the carving – is floral in character, blossoming freely all over the surface. In this way each piece appears to have been transformed into a living thing, enclosed in its own world of flowers and plants. The many inlaid proverbs and quotations, taken from Hugo and from Symbolists like Maeterlinck, Verlaine and Prudhomme, emphasise the idea of a piece of furniture as a living object. In fact these pieces were called *meubles parlants*, just as his glasswork was referred to as *verreries parlantes*. His furniture, as well as his glass, was signed, and in the latter the signature was part of the actual

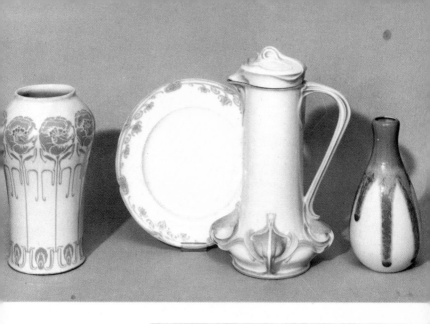

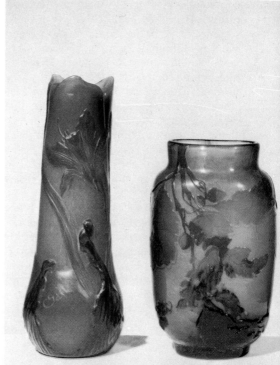

8·6 Gallé: In the vase on
the left the various layers
have been cut away to form
decoration in relief
(about 1900).
The *Oak Vase* (right),
made about 1890, is more
traditional: the flowing
plant forms do not fuse
with the shape of the vase.
Both vases are signed.

decoration, frequently braided in a pattern of flower and plant stalks.

Gallé's production of glass can be divided into four main groups.[5] First there are his pieces up to 1889, most of them with enamelled ornamentation and highly idiosyncratic. Secondly, we have a great many cased-glass vases from the 1890s with a decoration of flowers and leaves in his Art Nouveau-like style, many of them subtle in design, rich in colour and technically highly complicated. Apart from the work designed by Gallé himself, we have the 'standard Gallé' with a more conventional Art Nouveau flower pattern in one colour, against an opaque, white background. Thirdly comes a large and varied group of vases, serial-produced, with shapes, ornaments and colours repeated in almost endless combinations. Finally, there are Gallé's personal experimental pieces after 1889, exaltedly lyrical in feeling and of supreme technical complexity. Gallé occupies an exceptional place in Art Nouveau, and indeed in the whole history of glassware (figure 8·6).

By comparison with the work of the master, the glass designed and produced by the other Nancy craftsmen inevitably appears insipid. They adopted Gallé's techniques and decoration, occasionally achieving results which may appear fairly comparable. Here, in fact, it is possible to speak of a school in the real sense of the word. In this connection we need only mention Auguste Daum and his brother Antonin. They are less extravagant than Gallé. Their decoration tends to be confined to poppies and snowdrops, the corpus is often more traditional in design and the technique is usually coarser.

Among furniture designers Louis Majorelle ranks with Gallé. He began his training as a painter under Millet, but soon turned to furniture design. In the 1880s he worked in traditional French styles, and in the 1890s more especially in Neo-Rococo. In 1897–8, however, he adopted Gallé's floral shapes and in 1898 began his Art Nouveau production with a workshop employing thirty hands, the so-called *Maison Majorelle*, which was still flourishing in the 1920s and 1930s. Majorelle is more plastic in his decoration than

Gallé, and like several of the Nancy artists he first modelled his decorative details. He achieved his best results when he eliminated external Neo-Rococo and Neo-Baroque details, allowing the undulating and dynamic flow of the line to dominate the entire character of the object (figure 8·7). Soon after 1900 his form-language showed a greater air of calm: the ponderous Art Nouveau shapes disappeared, giving way to a simple, sober, and more internationalised style.

The other furniture designers of the Nancy School had all been trained as architects. Among its outstanding members were Émile André, Eugène Vallin and Jacques Gruber, who was notably influenced by the Louis XV style. The work of Vallin, Majorelle's senior by two years and more closely associated with him, is particularly reminiscent of Majorelle. Vallin has the same sculptural and dynamic form-language, based on floral and Neo-Baroque inspiration, though he subsequently abandoned the floral elements, using the curvature of the structure as a decorative element.[6] Artists of secondary importance, who all worked more or less in the style of Gallé and Majorelle, included Camille Gauthier and Poinsington, both of whom subsequently specialised in hotel furniture.

Art Nouveau also contributed to a revival in bookbinding. In every country there was experimentation with lettering and binding. But the most famous practitioner was the Nancy artist René Wiener who, with great originality, treated the whole of the book, cover included, as a decorative entity.

In jewellery the Parisian René Lalique enjoyed a position similar to Gallé's in glass. He trained at *L'École des Arts Décoratifs*, and from 1878 to 1880 in London. In 1885 he established his own firm and he took part anonymously in the 1889 Exhibition, when he was still only twenty-nine years old. Already by 1894 he had completed his first two pieces of jewellery for Sarah Bernhardt. In the following year he had a breakthrough at the *Salon du Champs de Mars*, and by 1900 success was assured: 'La victoire la moins

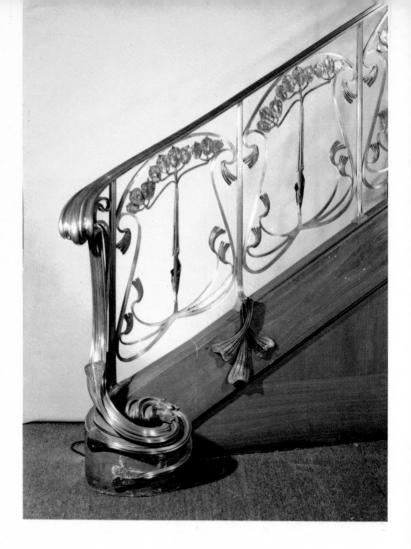

discutable de 1900, c'est l'œuvre de Lalique'.[7] From then on right up to 1914 he was the leading jeweller in Europe; but after the First World War he devoted most of his energy to glassware.

Like Gallé, Lalique was an innovator in the technical sphere. He improved the reducing machine for jewellery, and introduced a great many new materials, from horn to milky-white semi-precious

8·7 Majorelle: Bannister, forged iron, about 1900.
Majorelle was the least traditional of the Nancy artists,
and hardly any of them treated iron as freely and
plastically as he did – not even Horta. His major
work in this sphere was the iron stair-railings at the
Galerie La Fayette, Paris, a few years after 1900.

stones. In all of these he worked with the same mastery as in ena-
mel, the fashionable material of the age. Yet Lalique's importance
lies above all in the fact that he was able to raise jewellery above the
stylistic imitation and scale of values of the nineteenth century.
This was particularly significant because previously the value of a
piece of jewellery had been based on the costliness of the materials
and not on their artistic treatment and setting. He had, moreover, an
unusual knack of bringing out the special qualities of his materials,
both in his treatment of each one individually and in his use of
them together. In 1895 he painted his first nude, and Woman was
subsequently one of his favourite motifs. Women he depicted
with unusual sensuality, enveloped in their own hair, draped in
gauzy veils, entwined with snakes, or beset with insects (figure 2·11).

Lalique's interpretation of the form-conception of an entire style,
through the medium of the most precious materials, inevitably bred
a train of successors. Karel Citroen has divided the French jewellery
into two main trends, the 'hard' style and the 'soft' style. Georges
Fouquet, Eugène Grasset, Henry Auguste Solié and Eugène
Feuillâtre are representatives of the first style with its linear and
sharp design of animals and insects. Saint Yves, Lucien Heurtebise
and Paul Liénard represent the other with their predilection for
females and a more naturalistic and poetic use of flowers and plants
(see above note). In addition we have the famous firms of Vever,
Gariod and Christofle, who also made important contributions to
the style. Among the artists associated with Bing, both Colonna and
Gaillard worked on jewellery.

In 1900 the French were supreme. But already by 1902, at the
exhibition in Turin, the situation had changed considerably.
Other countries were now powerfully represented: England by
Voysey, Townsend, Crane and Ashbee; Scotland by 'The Four
Macs'; Belgium by Horta, van de Velde and Serrurier-Bovy;
and Germany and Austria by Hoffmann, Behrens, Pankok, Paul,
Koepping and Olbrich. What was more, the French exhibition was
based on entirely different principles: the aim of the French was

8·8 Horta: Ink stand, 1895–1900, made for A. Solvay, Brussels. Horta's dynamic feeling for form emerges in the asymmetrical and exuberant lines. However abstract his form may be, one notes that his lines and shapes almost always spring from a central point, like stalks growing from a root.

not to create a uniform interior but to exhibit every piece of furniture as an *objet d'art* in itself. They found themselves competing with whole rooms designed by such artists as Olbrich and Hoffmann, who made hardly any use of decoration, their rooms and furniture being eminently simple and yet devoid of the rustic features of the Arts and Crafts Movement. The Austrians and Germans, who had only lately taken up arms against 'stylistic tyranny', had approached the problem from a completely different angle from the French – they had simply abandoned decoration.

At the Liège Exhibition in 1905 the French were conspicuous by their absence and at the London Exhibition in 1908 Art Nouveau had disappeared completely. In the following year Edouard Dévérin published a number of interviews with leading artists in *La Revue*, entitled 'La crise de l'art décoratif en France'. Those interviewed, including Lalique and Majorelle, all declared that the hopes aroused by the Paris Exhibitions in 1889 and 1900 had been disappointed and noted that once again the trend was in the direction of Classicism. In France the disappointment was all the greater, since Art Nouveau had there promised so much and flowered so richly.

Belgium–Modern Style

Belgium was the native soil of Art Nouveau (see chapter 7), and in the hands of such talented artists as Horta, Hankar, Serrurier-Bovy, van de Velde and Wolfers the style spread rapidly. As in France, it was in furniture design and jewellery that it flourished most profusely, and here too we find that generally speaking the same aspects of the style were cultivated – the plastic-dynamic and the structural-symbolical. In Belgium, however, the floral touch was missing: in no other country, in fact, did Art Nouveau produce such abstract forms as here.

Victor Horta has been dealt with as an architect and there is little to add about his work in the applied arts. His form of expression was the same in every material, whether stone, bronze,

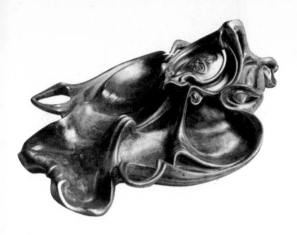

iron or wood: as robust in its linear rhythm and as plastic in its conception from the tiniest detail (figure 8·8) to the complete architectural treatment. His outstanding work is hardly to be found in his furniture, which occasionally reveals Neo-Gothic and constructive elements. It is in metalwork that his supreme mastery of form is revealed – in light fittings, in wrought-iron balcony grilles, in cast-iron details. His Art Nouveau style was at its best at the very end of the 1890s. Though he won first prize at the Turin Exhibition in 1902 for a suite of furniture, it was rather ponderous. A few years later his form-language had lost its vigour, and the ornamental innovation of his younger years was no longer apparent.

Paul Hankar also made his contribution primarily as an architect. In 1893 he designed a table which in its construction and form, as well as in its colour (black), shows strong Japanese influence. But his façade for a barber's shop in Ixelles – executed in cooperation with Crespin – shows his Art Nouveau fully developed. The façade must have been designed in 1895, since *The Studio* contains an article on it as early as the summer of 1896.

But the two most important furniture designers in Belgium were Gustave Serrurier-Bovy and Henry van de Velde. Serrurier-Bovy started his training as an architect at the *Académie des Beaux-Arts* in Liège, where he showed a particular interest in Gothic. In about 1884 he abandoned the study of architecture and set off on his travels round Europe, visiting England, where he came under the influence of William Morris. His first known work from 1894–5 reflects the influence of the Arts and Crafts Movement, although in

a letter to van de Velde about his *Cabinet de travail*, shown at the *Salon Libre Esthétique* in 1894, he says 'I consider the study exhibited in the year 1894 entirely free from any touch of old or English style'.[8] But what is particularly English about the work he produced in these years is the use of plain, unpainted wood, the absence of decoration – apart from the elaborate fittings – and the use of small, enclosed square plaques on constructive vertical elements, of the kind familiar to us from Mackmurdo and Voysey. On the other hand there was an un-English feature in the emphasis he placed on arched stretchers, an emphasis which was clearly structural-symbolical. He also reveals a flair for nicely balanced asymmetry, which is typical of him. This feature – a witness to Japanese influence – is perhaps his most important contribution to the furniture design of Art Nouveau. One practical aspect of this asymmetry is that it enables him to combine several pieces of furniture in one and the same construction (figure 8·9). A specifically Belgian feature is the slightly arched trusses which run above the panels, and which could not possibly have been borrowed from the English. This feature may be ascribed solely to Serrurier-Bovy and van de Velde. At the beginning of the twentieth century Serrurier-Bovy's decorative style underwent a simplification, as can be seen from his ornamentation: the square and the rectangle now gradually assume a more important role. It would be natural to regard this simplification as a result of the influence of the Austrian school in the years immediately after the turn of the century.

8·9 Serrurier-Bovy: Chair, table and
shelf combined, 1900. The English influence
has now passed, and an undulating
rhythm, which is typical of
Serrurier-Bovy, links each component –
even the constructional parts are curved.

159

Serrurier-Bovy had a considerable influence on his contemporaries. Max Osborn, for instance, writes that 'he took over the valuable role of intermediary. It was to his credit that he was the first to bring the new decorative forms from London to Brussels.'[9] Van de Velde pays him a similar tribute, declaring that he was 'unquestionably the first artist on the Continent who realised the importance of the English Arts and Crafts style and had the courage to introduce it to us and to defend it.'[10] This is a charming tribute from a fellow artist striving to attain the same goal. While Horta launched dynamic Art Nouveau, Serrurier-Bovy cultivated the English heritage, adding to it his well-balanced asymmetry and structural-symbolical stretchers and curved trusses. Bridging the gap between the English movement and the Continental styles that were coming into their own, Serrurier-Bovy is at one and the same time a link and the creator of Belgian Art Nouveau in furniture.

Henry van de Velde is another transitional figure, though of greater international importance, conveying as he did the English heritage and Belgian trends to the rest of Europe. He started his training as a painter in Antwerp at the age of eighteen, and spent a couple of years (1884–5) in Paris, where he came into contact with the Symbolists, and got to know Mallarmé, Verlaine, and Debussy. In 1889 he became a member of *Les XX*, and appeared to be heading for Neo-Impressionism. At this juncture, however, he passed through a crisis, and became absorbed in the writings of Ruskin, Morris, and Nietzsche. He now devoted himself to the problems of applied art, beginning a series of lectures on *Le réveil des métiers d'art et l'artisanat en Angleterre et ailleurs*. In 1893 he made his début as a decorative artist with the *appliqué* embroidery *The Watch of the Angels*. In 1894 he married and the fitting out of his new home gave him an opportunity of realising his own ideas, as Morris had done twenty-three years before. First of all he rebuilt his father-in-law's house, and in 1895–6 he erected his own, 'Bloemenwerf', at Uccle, near Brussels. Architecturally the house is of little interest; it is the furniture that is of

8·10 Van de Velde: Ink stand, brass, 1898. Van de Velde was the great theoretician of Art Nouveau, though his practice did not always live up to his theory. His best works were in metal, where the toothpaste-like forms often envelop the objects in a dynamic and very decorative way.

importance. At the same time he carried out the interior décor of *Maison Bing, L'Art Nouveau*. The typical feature of this furniture is the same structural and constructional interest we came across in the work of Serrurier-Bovy. In the same way, too, the particular quality of the material comes into its own. As yet, however, there is still something forced in the relationship between the graceful, gently undulating lines and the right-angled constructive elements. This dualism between simple wood-influenced construction and curved, undulating design always appears to be a problem in his furniture design. Bing and Meier-Graefe were among the more prominent visitors to his newly established house in 1895, and both were enthusiastic. Van de Velde's French guests, however, were not kind, and Toulouse-Lautrec exclaimed: 'Unheard of, eh? But in fact only the bathroom, the lavatories, and the nursery painted in white ripolin are really good.'[11]

In 1897 van de Velde made his real breakthrough with his exhibition in Dresden, and his link with Germany was now established. He was given several commissions in Germany, the *Habanna Compagnie* cigar store and the *Haby Hairdressing Saloon*, both in Berlin, completed in 1899 and 1901 respectively, and in 1898 he was in a position to set up his own workshop, *La Société van de Velde S.A.*, at Ixelles near Brussels. The painters Johan Thorn Prikker and Georges Lemmen and the potter Alfred William Finch also contributed to this enterprise. In 1900 he was at the peak of his creative powers as an Art Nouveau artist. In 1900–1 he toured Germany giving a series of lectures, and he was also commissioned to carry out the interior décor and to provide the furniture for the *Folkwang Museum* at Hagen in Westphalia, completed in 1902. In 1904 he was appointed to a professorship at Weimar, and in 1906 the *Kunstgewerbeschule* at Weimar was founded. By now, however, his style had diverged essentially from Art Nouveau and from about 1902 it developed into a more and more unembellished form-language.

If we consider his output as a whole from the end of the 1890s right up to about 1905, we are struck by his great versatility. It

comprises furniture design, light fittings, wallpaper, textiles, dress design, embroidery design, porcelain, pottery, silverware and a great amount of jewellery. In addition he wrote a great many articles expressing his theoretical views. In his conception of form he adopted a position midway between Horta and Serrurier-Bovy. In his use of detail he had Horta's asymmetrical, abstract, and dynamic qualities (figure 8·10), whereas in his furniture design he revealed more of Serrurier-Bovy's constructive striving (figure 8.11). But first and foremost he cultivated the structural-symbolical values of ornamentation and the scope of the various elements in a piece of furniture to symbolise and stress the construction. And yet whenever he resisted such constructive tensions, as in the writing-desk for Julius Meier-Graefe, 1897, or in silverware and candle-sticks from the period immediately after 1900, he achieved a markedly personal form of expression, embodying all the best qualities that the abstract, dynamic, and structural-symbolical aspects of Art Nouveau contain. It is perhaps as a metal and jewellery artist, working with material which appeared never to offer him any problems of resistance, that he achieved his very best work.

Philippe Wolfers was Belgium's leading jewellery designer during the Art Nouveau period. He was trained under the sculptor Isidore de Rudder and was a close friend of Hankar and Crespin. Though both Japanese and Neo-Renaissance influences can be seen in his work in the 1880s, Neo-Rococo gradually got the upper hand, reaching its peak in the years 1889–92. In the early 1890s, during which time he was constantly absorbed in the study of flowers and plants, his style became more and more floral and plant-like, until by 1895 the transformation to Art Nouveau was complete.

8·12 *Right* Voysey: Writing desk, oak with brass fittings, designed 1895. Voysey always allowed the structure of the wood to come into its own, and this feature, together with the exceedingly simple and constructive style, was to prove the most important and original influence in English design. This Arts and Crafts style assumed a strikingly sober and elegant form which is especially evident in the work of Voysey, Gimson and Heal.

In the 1890s the material in greatest favour among Belgian goldsmiths was ivory, of which the Belgian Congo provided ample supplies. Wolfers's work, *Civilisation et barbarie* (figure 8·13) approx. 1896–7, is characteristic both in its choice of material and in its symbolism. His jewellery is striking in its style, fanciful in its elegant asymmetry, refined in the treatment of material and of high technical quality. Towards the end of the century his style became gradually less floral and plant-like and more abstract, and after 1905 we find no further traces of Art Nouveau in his work.[12]

Belgium was the country where the Art Nouveau style came to flower earliest. On the other hand it was soon abandoned: van de Velde left the country in 1899, and no longer played any role in Belgium; Hankar died in 1901; Horta and Wolfers abandoned the style soon after the turn of the century – though Serrurier-Bovy continued up to his death in 1910. And yet it was in Belgium during the last decade of the nineteenth century that a style was created which, by virtue of its peculiar and varied development and the amazingly short and clearly delineated period of time at its disposal, occupies a very special place in the history of styles.

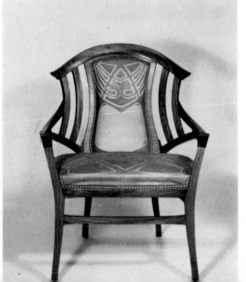

8·11 Van de Velde: Chair, with textile by Thorn Prikker, 1896. In van de Velde's furniture design the fluctuating lines constantly meet and are broken by the constructive rectilinearism, giving the object its peculiar tension.

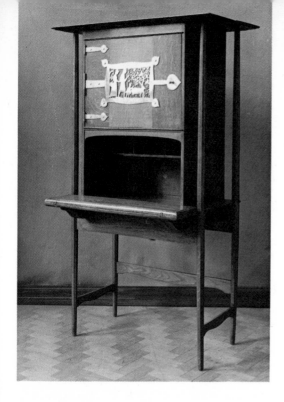

Great Britain – the Glasgow School

The development in Great Britain differed in one respect from the development in other countries: by the 1890s the shackles of Historicism had already been shaken off, and a form language had evolved in the applied arts based on principles laid down by the Arts and Crafts Movement. The soundness and simplicity of England's old decorative arts provided the background, and the tradition was followed without any revolutionary break. English proto-Art Nouveau, which was to play such a role on the Continent, came as less of a change in its native land.

The leading *avant-garde* furniture designers came from the circle associated with *Kenton and Company*. This firm was founded in 1890 and two years later changed its name to the *Cotswold School*. Its most important members were Ernest and Sidney Barnsley, Reginald Blomfield, Ernest Gimson, and William Lethaby. The style in which these more advanced designers worked

was simple and almost devoid of decoration, with marked emphasis on all constructive elements. The structure of the wood was allowed to come into its own, and this, together with its characteristic massiveness and ponderousness, gave the furniture a rustic air. The decoration consisted essentially of hammered metal and large decorative wrought-iron embellishments. Its rectilinear nature, the frequent use of frame and panel, and its lack of decoration combined to give it a sober and austere appearance.

The influence of Morris was apparent in these designers' preference for a bright, airy palette. Together with the furniture designer Ambrose Heal and the architect Charles Francis Annesley Voysey, who was the most important member of the group, these were the leading designers before and after the turn of the century. Their exceedingly simple and constructive style was to prove the most important and novel influence in English design.

Closer acquaintance in Great Britain with Continental Art Nouveau actually provoked a reaction against it. When George Donaldson, vice-president of the jury for furniture at the Exhibition of 1900, presented the *Victoria and Albert Museum* with a large gift of Art Nouveau furniture, its reception was very mixed. Four worthy citizens, among them Reginald Blomfield, gave voice to their feelings in *The Times*:

This work is neither right in principle nor does it evince a proper regard for the material employed. As cabinet maker's work it is badly executed. It represents only a trick of design which, developed from debased forms, has prejudicially affected the design of furniture and buildings in neighbouring countries.[13]

Opinion generally was hostile to Continental Art Nouveau, and Walter Crane, Lewis Day and Alfred Gilbert all attacked it vigorously. In Great Britain Historicism had been rejected, and a new, wholesome approach, based on tradition and simple constructive principles, partly of a rectilinear nature, had been adopted. It is therefore hardly surprising that Continental Art

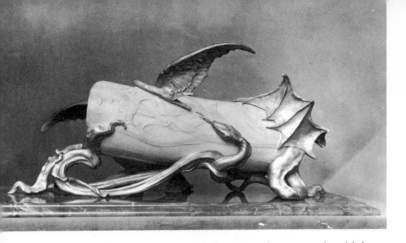

Nouveau, with its soft lines and Rococo elements, should have evoked no response. Nevertheless, it would be wrong to suppose that no Art Nouveau is to be found in Great Britain. In England we come across a special national development which might perhaps be called English Art Nouveau. It is unusually sophisticated, linear in its essence, and developed especially on the two-dimensional plane.

In furniture art the main structural characteristic – both in England and Scotland – of what might be called Art Nouveau, is that the leg is continued on and up, over the top of the furniture, often terminating as a free-standing upright with a broad over-hanging architectural cap. We also find a marked predilection for vertical elements in both countries, in the work of Voysey as well as in that of Mackintosh. The painting of furniture, generally in pale colours, was also a feature of the age. Another peculiarity was the use of a stretcher almost at floor level. At the same time inlay replaced carving, while various different materials might be introduced, such as pewter, mother-of-pearl, enamel and *repoussé* copper. This penchant for inlay work, in the place of more plastic decoration, illustrates the two-dimensional character of ornamentation and conception.

The most remarkable of the English furniture designers was Voysey, whose first pieces date back to 1893. All his furniture was executed in plain oak, and the ornamental fittings, such as lock and hinges, were so elaborate that they constituted the main attraction (figure 8·12). Yet Voysey's point of departure was a 'personal conception of tradition', and in his attitude to material and his

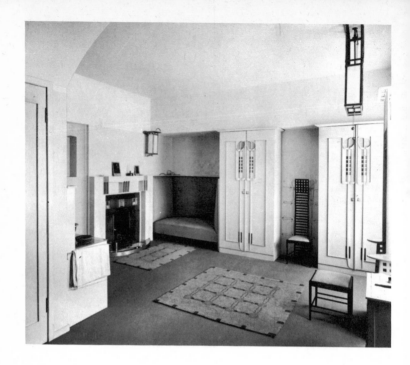

functionalism he far exceeded the bounds of Art Nouveau. As has been said: 'He was the first thoroughly successful exponent of simplicity of form in interior decoration.'[14] Similar furniture, but on a more commercial basis, was produced by *Heal & Son*, with Ambrose Heal as the leading designer. M.H.Baillie Scott, in common with Heal, cultivated the plain surface with rich inlay work, while Ernest Gimson and William Lethaby used a simpler form-language. The painter and designer Frank Brangwyn was more in contact with Continental Art Nouveau and designed for Bing in 1895–6.

The purest expression of the Art Nouveau style, however, is to be found in Scotland's Glasgow style, associated with the Glasgow School of Art. Its leading personality was Charles Rennie Mackintosh, and he and his contemporaries helped to mould what we are justified in calling a school – the Glasgow School, a Scottish Art

8·14 Mackintosh: Bedroom in Hill House, 1902–3. To unify the interior, Art Nouveau designers built furniture into the room as an integral part of the whole. No one did this with greater refinement than Mackintosh.

8·15 Mackintosh: Cabinet, white enamelled wood, about 1902. The doors are inlaid with opaque coloured glass. Against the greyish background stands a woman in a white robe, kissing the 'rose-ball' – the mark of the Glasgow School.

Nouveau. The members of this group were Francis H. Newbery, the headmaster of the art school, and his wife Jessie, a teacher of embroidery. The hard core of the group comprised the architects Mackintosh and Herbert McNair, and the two sisters Margaret and Frances Macdonald, who were married to Mackintosh and MacNair respectively. The Macdonald Sisters entered the school in 1891, and by 1893–4 the 'Four Macs' were hard at work with their linear drawings and posters. Somewhat apart from these, and less important, was Talwin Morris.

Mackintosh has already been dealt with in a previous chapter (see chapter 7). Besides being one of Britain's most revolutionary architects of the nineteenth century, and a pioneer of the Modern Movement, he was also the most sophisticated British decorator and designer of the 1890s (figures 8·14 and 8·16a). He never allowed the decoration or the ornament to overflow and dominate the entire piece, as was the case in Continental Art Nouveau. This was one of the foremost decorative principles of English artists, and a natural result of the relentless struggle of the Arts and Crafts Movement to achieve simple, austere decoration.

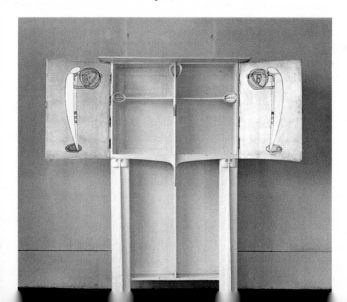

Mackintosh's colour scheme was very delicate: off-white, and pearl grey, with accents of pink and lilac in his personal motif, the rose-ball. But he could also strike deeper and darker chords in his interior decoration, and at the same time work in an entirely rectilinear style. This interesting dualism in no way indicates any split in Mackintosh's art. In his mature style rectilinearism as well as the use of the pliant line, the square as well as the rose-ball, black as well as white, are elements of a wider decorative system with great emphasis on the unerring interplay between ornament and surface (figure 8·15). Thanks to Mackintosh the unity of the interior was re-established – and on a very high artistic level.

The other members of the group produced work which is of secondary importance compared with Mackintosh's. The most prominent were the Macdonald sisters, who were especially noted for their metalwork in beaten brass and copper (figure 8·16 b and c). Mention has already been made of the elongated willowy figures of weeping women, the expressive movements of the hands, the symbolical content, neatly framed in the panel, and characterised by rows of thin vertical lines. It was this art which caused Meier-Graefe to exclaim:

In Glasgow British art was no longer hermaphrodite. It passed into the hands of women.[15]

Amongst the applied arts which blossomed in Glasgow under the guidance of Jessie Newbery[16], was embroidery. It can safely be said that 'an entirely new approach to embroidery was evolved at the Glasgow School of Art, an approach that was to lay the foundation for the embroidery of our own time . . . '[17]

The group exhibited at Liège in 1895, submitting as many as one hundred and ten different items, and their work was favourably reviewed by Hankar.[18] Although at the *Arts and Crafts Exhibition*

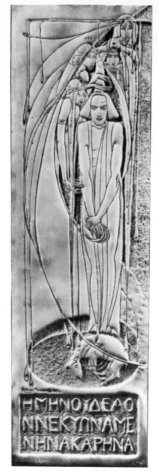

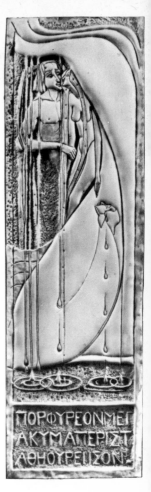

8·16a Mackintosh: Cutlery. The artist could change from the most sophisticated forms to a sober, simple style devoid of decoration.

8·16b and c Margaret and Frances Macdonald: Repoussé white metal plaques, *The Iliad*, 1899. The suffering and often symbolically exploited woman in the art of the Glasgow School was no new creation, but was inherited from the pre-Raphaelites.

Society in London in the following year they v ere far less successful, they were acclaimed in Vienna in 1900, in Dresden in 1901, in Turin in 1902 and subsequently in Venice and Budapest. However, the 'Four Macs' who had formed a distinct group from the middle of the 1890s, broke up shortly after the turn of the century. They had little, if any, influence on trends in the rest of Britain. Even Gleeson White's four very favourable articles in *The Studio* in 1897 hardly seem to have inspired anyone in England. Besides,

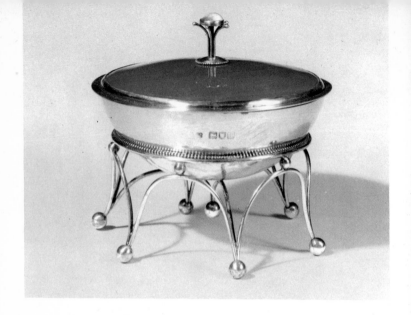

they had no intellectual leader, no cut-and-dried programme, and although they managed to create a style which flourished, especially in furniture design, metalwork, and embroidery, they created no *movement*. Shortly after the turn of the century the role of Art Nouveau was at an end, and the decorative play of the Glasgow School was already *passé* among those in the forefront of the battle.

The unusually sophisticated and linear English version of the Art Nouveau style probably reached its noblest expression in silverware with the work of Charles R. Ashbee, whom we have previously come across as a writer (see chapter 4). In 1887 he founded the *School and Guild of Handicraft*. Though the School was closed down in 1895, the Guild continued up to 1908, when it broke up, 'less, it must be confessed, as a result of outside competition, than of the impossibility of functioning as an oasis of handicraftsmanship in a machine age'.[19] Ashbee's designs for silver and jewellery after 1898 are particularly light and graceful, and his use of multiple wire threads, separating at their ends in tendril-fashion, is particularly characteristic. Caressingly entwining the object, these sophisticated linear shapes give it emphasis and throw the main form into relief (figure 8·17). Yet, though Ashbee was the most important, he was not the first. Alfred Gilbert had already

8·17 Ashbee: Silver dish, 1899–1900. The cover is enamelled red and set with a semi-precious stone. Typical of Ashbee is the interplay between the simple main form of the object and the grace and airiness of the stand.

8·18 Neatby: Ceramic tiles for Harrods, London, 1902. Neatby's colour scheme is typical of the period.

turned out jewellery in the Art Nouveau style, for example the President's badge and chain for the *Royal Institute of Painters in Water Colours*, London, 1891–6[20] (see also chapter 10). Another highly fashionable jeweller of the age, Alexander Fisher, had also been drawn in the direction of Art Nouveau as a result of Celtic influence, as in his girdle decorated with scenes from Wagnerian operas, 1893–6.[21]

But it was the firm of *Liberty and Co.* that really succeeded in spreading the English Art Nouveau-like style on a relatively high artistic plane. In 1899 the firm launched their so-called *Cymric* silver – a name derived from its Celtic inspiration – and in 1902–3 followed up this success with their *Tudric* pewter. The great bulk of their production was undertaken from 1901 by the Birmingham firm of *W. H. Haseler*, and it is in Birmingham that we find a group of designers who probably came closer to Continental Art Nouveau than anyone else in England. The leading designer in this group was

Arthur Dixon, the founder of the *Birmingham Guild of Handicraft* in 1895.

Among other silversmiths working in the style may be mentioned Fisher's pupil, Nelson Dawson, the sculptor George Frampton, and Gilbert Marks, who cultivated the wild rose, the cornflower, the narcissus and the spring anemone. The metal designer W.A.S. Benson, on the other hand, adhered more closely to William Morris's ideas, and never actually worked in the style.

A characteristic feature often to be found in English silverware at this time was the hammered surface, which naturally could be regarded as a guarantee that the object was hand-made. At a time when machine production was steadily gaining ground, the mark of the hammer on metal was almost a stylistic patent of nobility.

One of the artists who bears the stamp of the Arts and Crafts Movement in his furniture design, but who in his ceramic decorations worked entirely in the English Art Nouveau style, was W.J.Neatby[22] whose *chef d'œuvre* is the great hall containing the meat, fish and poultry department at *Harrods*, London, 1902 (figure 8·18) which was carried out in nine weeks. His work has great decorative charm: the Englishman's love of ornithology is given free rein, and the birds are placed with excellent effect.

The English version of Art Nouveau was in fact intensely pre-occupied with bird and plant life, in a more or less stylised form. Even though the dove and rose might be simplified, however, they were never reduced to the status of an abstract ornament; there was always a sense of innate life. Moreover, apart from Alfred Gilbert, the English version of Art Nouveau contained no Neo-Rococo or Neo-Baroque elements; the sculptural, plastic aspect was foreign to it. As early as the 1880s the English approach was linear, and this proved the characteristic feature of the style both in Scotland and in England. The main development flowed in other channels, and as already mentioned it was ironically enough in Liberty's products, at the level of commercial production, that the impact of Art Nouveau was felt in England, while the Arts and

Crafts Movement remained comparatively unaffected by stylistic developments abroad.[23] That the British influence, on the other hand, should have been so great on the Continent, is another matter; England had helped to provide the precursors of Art Nouveau, to prepare the ground and to introduce the blossoms – but the Continental fruit was not for English consumption.

Germany – Jugendstil

At the World Exhibition in Munich in 1876 applied arts were exhibited for the first time, emphasising the position enjoyed by the Neo-Renaissance style in Germany, where it flourished throughout the 1880s and 1890s. Neo-Rococo and more classically influenced trends, however, continued to live side by side with certain rustic tendencies.

> ... no important artistic-industrial institution engaged in the construction of furniture or fittings for rooms can limit its activity to one style only, or exclude either of the other styles.[24]

After the Chicago Exhibition of 1893 there was a wave of what Richard Graul in 1901 in *Die Krisis im Kunstgewerbe* called the 'kunstgewerbliche Anglomanie'. Compared with England, Belgium, and France, Germany arrived rather late on the scene. But now, at last – though they had not been represented at any exhibition in Paris, for instance, since 1867 – the Germans awoke from their Neo-Renaissance dreams and isolation. While the Japanese had exhibited in London ever since 1861, the first Japanese exhibition was not arranged in Berlin until 1882. From 1895, however, there was intense activity on every front. In that year the tireless and enterprising art critic Julius Meier-Graefe founded *Pan* – a progressive periodical devoted to the fine and the applied arts not only in Germany but in Europe as a whole. In the same year van de Velde held a course of lectures at the Krefelder Museum. Next year the critic and writer Hermann Muthesius was sent to London and attached to the German Embassy with special instructions to keep

the floral thriving side by side with the abstract-dynamic. This can be accounted for by the background against which *Jugendstil* came into being and the influences that produced it. In Germany, unlike most other countries, stylistic conceptions were entirely unfettered by national tradition. The inspiration on which *Jugendstil* was based came partly from England, though it is not always easy to trace any direct connection. The style developed essentially as two-dimensional ornamentation, with a marked floral bias, as in the work of Eckmann. Side by side with this we have the structural-symbolical aspect, with the emphasis on the dynamic and constructive, with van de Velde acting as mediator. In time the constructive and geometrical assumed increasing importance, largely through Austrian influence. Chronologically, too, it is possible to distinguish between these two aspects of *Jugendstil* in Germany, with the floral preceding and generally giving way to the more constructive kind in about the year 1900. The centre of *Jugendstil* – at any rate of its floral development – was Munich. Among the

8·19 Obrist: Wall hanging with embroidery, between 1892 and 1894. Rarely, in the whole Art Nouveau period, was there a more extreme whiplash ornamentation than this embroidery.

8·20 Koepping: Glass, 1895–6. Koepping was the most famous German glass designer. He obtained an extreme delicacy exploiting the possibilities of the material almost to breaking point.

abreast of English architecture and decorative art. In 1896, more-over, the periodical *Jugend* was started in Munich; it had nothing to do with the applied arts, but its columns provided a sounding-board for forward-looking German book-illustrators. In 1897 no less than four periodicals were launched – *Kunst und Handwerk* and *Dekorative Kunst* in Munich, *Deutsche Kunst und Dekoration* and *Kunst und Dekoration* in Darmstadt. In the same year the *Vereinigte Werkstätten für Kunst im Handwerk* in Munich was founded, and in the following year the *Dresdener Werkstätte für Handwerkskunst*. In 1899 van de Velde came to Berlin, and in the same year the artists' colony at Mathildenhöhe near Darmstadt began to take shape, sponsored by that great patron of art, the Grand Duke Ernst Ludwig of Hesse. We may well echo Richard Graul's words: 'The will to reform the arts and crafts was there, and where there's a will there's a way.'[25]

German Art Nouveau – *Jugendstil* – is less homogeneous in character than, for example, French or English, and in it we find

8·21 Obrist: Chair, about 1898. In the Art Nouveau chair one often finds an ornamental play with the construction. Here Obrist has limited himself to a decorative stressing of the corners.

8·22 Endell: Table and chairs, 1899. For the Art Nouveau artist form and construction *had* to be new. The search for originality for its own sake could be a dangerous temptation – as can be seen from this uncomfortable chair and insecure table.

artists who founded *Vereinigte Werkstätten für Kunst im Handwerk* were Hermann Obrist, Bernhard Pankok, Richard Riemerschmid and Bruno Paul, the other three leading *Jugendstil* artists in the Munich group being Otto Eckmann, August Endell and Peter Behrens. Characteristically, two of these had actually been trained as painters, while Endell had originally studied philosophy and Obrist botany and geology. The only one who had attended a school for decorative art was Paul, who had done so from the age of twelve to the age of twenty.

The first two artists in Germany to feel their way in the direction of what we might call *Jugendstil* in ornamental art were Obrist and Eckmann. After dedicating himself in 1888 to applied arts, Obrist founded an embroidery workshop in Florence in 1892, which he moved to Munich two years later. Here, in the same year, he exhibited thirty-nine embroideries which gave evidence of his keen perception of nature. Blades of grass, leaves and flowers were linked together in stars, patterns and wheels, without in any way losing their natural freshness. At the same time his work had a Japanese sophistication. One of these embroideries, *Peitschenhieb* (see figure 8·19), evoked the following description in *Pan*: 'This furious movement seems to us like the violent swirl of a lashing whip.'[26] Obrist participated very actively in the *Vereinigte Werkstätten*, exhibiting textiles once again in 1897. Several pieces of furniture

are known which were executed by him in 1898 in a sort of floral structural symbolical form, with the emphasis on the constructive (figure 8·21). In his ornamentation there seems to be a continual struggle between forms in movement and forms in a state of latent energy, and something similar can be traced in both his sculptural designs from 1902 and his bonelike furniture.

In the same year that he abandoned painting, namely in 1894, Otto Eckmann had completed his symbolical masterpiece, *Die Lebens-Alter*, where, in the undulating movements of the smoke, we find his first linear play of line to foreshadow *Jugendstil*. In 1894–5 he made an intense study of nature, and his floral fantasies were hailed by *Pan* when it appeared in 1895. The founding of the periodical *Jugend* opened up still greater possibilities for the young designer. From the point of view of art history, Eckmann's work in the naturalistic style was no novelty, for Carlos Schwabe had carried out book illustrations some four or five years earlier which bear a striking similarity to it. No less masterly are the monograms he designed for periodicals. He also worked with type faces, and his title page for *Die Woche*, 1900, as well as his type face *Eckmann Schmuck*, made him famous. He was also possibly the most influential of all the Art Nouveau book illustrators. The only artist worthy of mention in the same breath is the Frenchman Georges Auriol, with with his brushstroke type face which originated in about 1901.

8·23 Riemerschmid: Room for an art lover, made for the Paris exhibition, 1900. A striking feature is the ceiling frieze where the entrelac motif reminds one that the Celtic influence existed even in Germany.

August Endell, though not directly a pupil of Obrist, was very closely associated both with him and with Riemerschmid. His *magnum opus* as a *Jugendkunstner*, the huge decoration in the *Atelier Elvira*, 1897–8, has been dealt with elsewhere (chapter 7), and here it should be sufficient to point out that his ornamentation is more easily understood when seen in relation to Obrist's art. In Obrist's *Der Peitschenhieb* and Endell's *Elvira* decoration – two typical *Jugend chefs d'œuvre* – we find the same tension between a balanced conception of form and an intricate, whirling subsidiary movement. The result is a kind of conflict between denaturalised shapes and an effect of nature-illusion.

Obrist's bonelike form-language can also be traced in Endell's furniture (figure 8·22), and it is also present in the work of Bernhard Pankok and Richard Riemerschmid. Perhaps to a greater extent than any of the others, Pankok had a knack of fusing the various elements of a room to create a unity. This striving for a *vue d'ensemble* in interior decoration – the decorative synthesis of a room – was in fact one of the chief aims of the Art Nouveau artists. The rooms Pankok decorated for the Paris Exhibition in 1900 and the St Louis Exhibition in 1904 are perfect examples of this, on a level with van de Velde's *Folkwang Museum* interiors of 1902.

Richard Riemerschmid, who had already built his own house in 1896, but waited till 1898 before devoting his energies to the applied arts, was as versatile as most of the other leading German *Jugendstil* artists (figure 8·23). In his work, however, we find certain links with folk art, a tendency which Gmelin had already noted in 1893.[27] This might possibly be explained as the influence of the Arts and Crafts Movement, expressed in an interest in simple form and untreated wood. At its best Riemerschmid's furniture possesses a timeless simplicity that raises it above the *Jugend* period, and gives it an almost 'modern' appearance. Riemerschmid abandoned the *Jugend* style very abruptly, and by 1902–3 all traces of it had vanished. The same may be said of Peter Behrens: after a period during which he was greatly influenced by van de

Velde he gravitated away from the style, and by the time he had moved to Darmstadt in 1899 he had, in common with Riemerschmid, turned to the other constructive and abstract form of *Jugend* which inevitably involved a swift departure from it. We still find various *Jugend* features in Behrens's living-room for Ludwig Alter, exhibited in Turin in 1902. But in his dining-room from the same year little was left, and by 1903 all traces of the young painter's fluent linear rhythm had disappeared.[28]

Common to all members of the Munich Group was a markedly constructive attitude: all furniture was amply supplied with joints and struts, and the constructive elements were usually slightly arched, as were the top and bottom of the main body of the piece, other planes and edges being rectilinear. In this way there was a characteristic interplay of angles between straight lines and faint curves, which tends to give the style a slightly ponderous accent. This is particularly noticeable in the work of Bruno Paul, who in other respects designed very elegant furniture.

The other centre was Darmstadt, though it was not of such importance. Behrens can be considered a sort of link between the two groups, having settled in Darmstadt in 1899. In the same year the Austrian Joseph Maria Olbrich also joined the *Darmstädter Künstler-Kolonie*, as it came to be called. The other artists in the group were the painter and designer Hans Christiansen, especially known for his textiles, who stayed only till 1902, the Olbrich-influenced architect and designer Patriz Huber, and the sculptors Ludwig Habich and Rudolf Bosselt, both of whom surprisingly enough worked with a two-dimensional effect in *Jugend*; the former, however, left Darmstadt in 1906 and the latter in 1903. The last member of the group was the painter Paul Bürck, who left Darmstadt in 1902. As Behrens, too, left in 1903, the whole movement proved merely an interlude, dominated by Olbrich and the simple rectilinear Austrian style. It is easy enough to understand why, in 1906, even the Grand Duke of Hesse gave up the whole idea.

Apart from the art of the vignette and book illustration, it was in the realm of furniture design that German *Jugendstil* proved most capable of holding its own internationally. Though the Germans tended to be overshadowed by the French in glass, jewellery and pottery, there were nevertheless certain German potters of note, such as Max Laeuger and Julius Scharvogel. The reputation of the glass artist Karl Koepping spread far beyond the borders of his native Germany (figure 8·20). His objects are generally characterised by a rather flat base, but leaf-like forms emerge from the tall slender stem, and the stem itself will occasionally twist and turn in the same restless, often strained shape – 'des amusettes', as they were called by a contemporary art critic from Gallé's native land.

In Germany all the leading artists had more or less abandoned *Jugendstil* a few years after the turn of the century, as may be seen from the Turin Exhibition of 1902. F. Schmalenbach also mentions a number of quotations from the years 1900–5 by contemporary artists which show that they regarded the style as at an end.[29]

Jugendstil in Germany, perhaps more than Art Nouveau any-where else, was a phase – a two-dimensional interlude. The Germans seized on the constructive urge inherent in the style. This may be explained partly by the fact that they arrived on the scene so late that they were able to see more clearly the outlines of a more fruitful development, and partly by the fact that the style was not bound up with any national tradition as it was for instance in England and France. The younger generation was thus in a position to exploit to the full the experience of their predecessors – their struggles and their failures – and for them *Jugendstil* was to prove merely a wanton and ephemeral *Ereignis der Jugend* (incident of youth).

Austria – Sezessionstil

Austria was the last of the major European nations to join the move-ment for artistic renewal which was overrunning the Continent. In 1897 the so-called *Wiener Sezession* was formed by radical painters, with Gustav Klimt as the moving spirit. Among the other founders were Josef Hoffmann and the architect Joseph Maria Olbrich. In 1898 the applied arts were exhibited for the first time in Vienna. In the same year appeared the first two periodicals devoted to applied arts, *Kunst und Kunsthandwerk* and *Ver Sacrum*, the latter a sort of Austrian *Pan*. Two years later came *Das Interieur*. As in Germany, the style actually emerged from the pages of periodicals, but partly because the movement got off to so late a start in Austria, that is, not until about 1897–8, it began at what was more or less the second phase in Germany, the abstract and constructive. Floral Art Nouveau hardly existed in Austria; the Secession style was geometrically inspired, composed of rectangles and squares, and it soon evolved a hostility to ornament – which is a far cry from the essence of Art Nouveau.

This hostility to ornament might really be considered a counter-movement. Josef Hoffmann's remark that 'the pure square and use of black and white as dominant colours specially interested me,

8·24a Hoffmann: Vignette for *Ver Sacrum*, 1898. As Olbrich cultivated the circle, so Hoffmann cultivated the square. These ornaments, derived from the pages of the book, reflect in a very characteristic way the geometrical aspect of the Austrian style.

because these clear elements had not appeared in former styles',[30] is confirmed by the spirit of the age, and its striving to create something new; but it is also a reaction against Art Nouveau, which was already a fully fledged style when Hoffmann started to compose his squares. The use of the square and the circle as ornaments is likewise basically alien to the Art Nouveau artist, both because these ornaments lack asymmetry as an essential feature and also because we find no floral motifs; and if these motifs do exit – as for instance occasionally in the work of Olbrich – they lack the sprouting and growing effect which was the core and the symbolical background of Art Nouveau ornamentation, whether abstract or naturalistic. Nor do we find any structural-symbolical tendencies. But, most important of all, the Secession style in its ornamental principle is additive, irrespective of whether circles or flowers provide the basis. Art Nouveau aimed at a synthesis, a blend, above all, either in its indulating rhythm or in its enclosed outline. The Austrian addition of haphazard elements is quite alien to it. Nor has Austrian Art Nouveau any touch of Neo-Rococo or Neo-Baroque tradition in its form-language, and consequently nothing dynamic; though we do frequently find certain classical touches, such as festoons and fluting – and occasionally even bits of Biedermeier. There are good grounds for wondering whether one can, in fact, speak of an Austrian Art Nouveau. And yet there are a number of factors which link the Secession style with Art Nouveau – its origins in book illustration, its two-dimensional refinement, its search for renewal of ornament and unity of interior, and its reforming zeal.

In the work of Otto Wagner, beneath a surface cast in the classical mould, an architecture developed which was free from period tendencies and which looked to the future. In Wagner's

8·24b Olbrich: Vignette for
Ver Sacrum, 1898, showing
his linear and two-dimen-
sional style, as well as
predilection for the circle.

opinion the archaeological and historical attitude prevented any creation in the realm of decorative art,[31] and thanks to his inspiring work as a teacher this attitude was developed by his pupils. Three of them were to form the core of the Austrian Secession – the architects Hoffmann and Olbrich and the designer Koloman Moser.

Josef Hoffmann had been trained as a painter, and it was in the columns of *Ver Sacrum* in 1898 that he first developed his ornamental style (figure 8·24a). In Hoffmann's work the surface plays as active a part as the line itself. This is a feature we have noted in the work of English designers and it was a characteristic of the age, but in the work of Hoffmann it acquired a new meaning and effect. In the very first numbers of *Ver Sacrum*, furthermore, another feature can be noted which was to prove characteristic of his own style and the style of the rest of the Secession movement, namely the parallel, non-rhythmic repetition of similar elements. No less important was his unerring touch in placing the ornament in relation to the surface, so that not only the ornament but the actual plain surface was emphasised. When Hoffmann introduced his squares and straight lines into the realms of furniture, the transition was much easier, since the Japanese style and the Arts and Crafts Movement had already blazed the way, and already in 1898–9 the square had become his favourite motif. There were squares on floors and tables, on carpets and curtains and at the upper section of windows, where they seemed to be very much at home and where they were long used. Not surprisingly he was nicknamed 'Quadratl-Hoffmann' ('Square-Hoffmann'). Other special features were the use of black and white and of inlay work in precious materials, ebony, ivory and silver, of the kind familiar to us from England and Scotland.

Hoffmann's influence was considerable. As early as 1899 he was

appointed a professor at the Academy in Vienna, and in 1903, together with Moser and Czeschka, he founded the *Wiener Werkstätten* – an institution which was to play an important role in subsequent developments, but whose stylistic ideals and principles of mass-production were quite alien to Art Nouveau. Even the furniture designed for the Paris Exhibition in 1900 is austere, rectilinear and unornamented, and appears stripped of all elements of Art Nouveau. But in the clamour of praise that Art Nouveau evoked this furniture art was overlooked. In 1902 and 1903 Hoffmann designed furniture and silver which in its rectilinearism and uniquely simple, clear design belonged to an entirely different stylistic conception and to a different period (figure 8·25).

Joseph Maria Olbrich was another artist who developed his ornamental style in *Ver Sacrum*. While Hoffmann cultivated the square, Olbrich cultivated the circle – as an oriflamme, in rows, or in clusters. Like Hoffmann, Olbrich had an unerring knack of placing the ornament (figure 8·24b), though at times in his work we sense the Art Nouveau delight in allowing the ornament to spread across the entire object. For the first Viennese Secession Exhibition of applied art in 1898 Hoffmann had designed the exhibition hall in his characteristic style,[32] while Olbrich favoured a more stylised floral scheme of decoration with a tendency to geometrical pattern. At the exhibition in 1899 both these designers were well to the fore with furniture notable rather for the refinement of its proportions than for its decoration. In 1899 Olbrich made his way to Darmstadt, where he designed all the houses in the artists' colony, with the exception of Behrens's. Olbrich was a highly sophisticated draughtsman (figure 8·26), though he did not possess the curiosity and pioneering enterprise of Hoffmann: 'If one thinks of Olbrich's art as exaggerated brilliancy then Hoffmann's is timeless and true'.[33]

The third Wagner pupil, Koloman Moser, developed in the two-dimensional plane. He, too, had originally been trained as a painter, though his energies were to be directed mainly to poster and pattern design. Moser passed from a Beardsley-like linear

elegance to the geometrical style at about the turn of the century. He continued to exploit the sophisticated pose and the lofty format, though with the circle and the square as the principal decorative elements. Instead of the restless rhythm of Art Nouveau, there is a sense of calm pervading the motif. Stability has replaced lability, and the play of line has petrified into a mere accumulation of geometrical elements. Another characteristic feature of Moser's poster art is the forward facing position of the figures and the symmetrical composition, as for example in his poster for the 1902 exhibition of the *Wiener Sezession*. The figure is seen from straight in front, against an abstract background. This feature, which enhances the calm and stability of the composition, is best known to us from the posters of the Glasgow School, where the style had been developed as early as the middle of the nineties. This special poster composition was quite different from that of other schools and clearly developed in Glasgow earlier than in Vienna. The great article on the Glasgow School had appeared in *The Studio* in 1897, and book and poster art are in themselves a medium of propagation. Mackintosh's *Scottish Musical Review* came out in 1896, and Frances Macdonald's book work dates back to 1894. These facts show the direction of influence in poster art, and might well suggest a similar development in other fields.

There were also a number of other artists. *Die Flaeche*, which appeared in 1902–4, contained between six and seven hundred illustrations by contemporary popular artists, including Moser's pupil Max Benirschke, the Olbrich-influenced Marcel Kammerer, and J. M. Auchentaller, whose work appeared mainly in *Ver Sacrum*. In furniture design the trend was often referred to as the Hoffmann School, and included men such as Leopold Bauer and Otto Prutscher, both of whom worked as interior decorators. Among glass artists the most outstanding was the Tiffany-influenced Lötz Witwe.

Stylistically the square and the circle represent the antithesis of Art Nouveau, and yet these simple geometrical shapes, which the Austrians developed at the end of the 1890s, are, as Hoffmann said

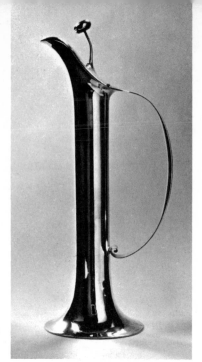

8·25 Hoffmann: Silver wine jug, about 1905. Although one can sometimes find traces of Art Nouveau in his design, Hoffmann not only broke with the style but anticipated the development of the 1920s and 1930s.

himself, undoubtedly a reaction against other styles and a search for one which was entirely new. But because Hoffmann and Olbrich were architects in Wagner's school, and did not remain illustrators, they were more concerned with architectural and constructional problems than with ornamentation. When they did use ornament its function was much the same as in a book, that is, it functioned as a vignette. And this brings us to the core of the Secession style in interior decoration and furniture design: it represents a striving to escape from period styles and is based on rational and constructive principles, making sparing use of geometrical ornaments placed elegantly in an entity consisting of simple planes. In a comparatively short period the ornament, too, disappeared, and as early as 1898 we find an architect such as Adolf Loos designing in a simpler style than Hoffmann and Olbrich. Loos represented the line which led direct to the *Wiener Werkstätten*, without proceeding via the Secession style, and thence on to the Modern Movement. The development in Austria was such that the style corresponding to Art Nouveau merely became an interlude on a two-dimensional

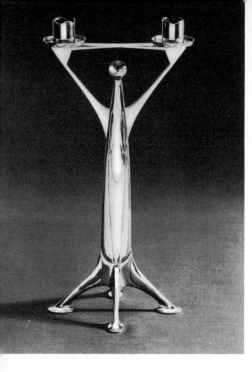

8·26 Olbrich: Candelabra in silver, about 1901. The lines of force and structure which the Art Nouveau artists cultivated to such an extent are here discreetly shown in feet and arms, giving the impression of tension in the material.

plane, lasting a mere two or three years.

Austria was not only the last country to make any contribution to the Art Nouveau style. It was also the first to abandon it.

Holland — Nieuwe Kunst[34]

In Holland, as the rest of Europe, forces were at work for a renewal of the applied arts. In 1877 the government had appointed a committee to investigate the position. In the following year the periodical *Kunst en Industrie* was launched and in 1881 the *Rijksschool voor Kunstnijverheid* was founded in Amsterdam. Three years later came the foundation of *Arti et Industriae*, an institution whose object was to improve relationships between art and handicrafts and industry. In 1885 the artists Dijsselhof, Nieuwenhuis, Zwollo, and Mendes da Costa cooperated to form *Labor et Ars*, in an attempt to emancipate themselves from tradition and academicism. In about 1890 Cuypers's teaching at the *Rijksschool voor Kunstnijverheid* was beginning to influence younger artists

such as Nieuwenhuis, Dijsselhof and Leon Cachet. At the same time Dijsselhof and Cachet began their experiments with the batik technique, and English influences also were markedly to the fore. Lewis Day's *Everyday Art*, 1882, had been translated into Dutch in 1884; Walter Crane's *Queen Summer*, 1891, was well known through *de Nieuwe Gids* in 1892; and in 1894 there appeared a Dutch translation of his *Claims of Decorative Art*, only two years after its publication in England. Roland Holst and de Bazel visited London in 1893, and in that year English graphic art was exhibited in the *Pulchri Studio* at The Hague. In 1895 there was an exhibition of Shannon and Ricketts's work in Amsterdam. In 1898 the periodical *Bouw – en Sierkunst* was established, with de Bazel and Lauweriks as editors, while at the same time *Arts and Crafts* opened in The Hague, with Thorn Prikker as artistic director. Finally, in 1900, the *t'Binnenhuis Inrichting tot Meubilering en Versiering der Woning* opened in Amsterdam, with the participation of practically all the Art Nouveau artists in Holland. In all there were three sources of Dutch Art Nouveau, or *Nieuwe Kunst* as it was called, in the applied arts: the Reform Movement, the influence of England, and impulses from Java, which have been dealt with above (see chapter 5).

Nieuwe Kunst, however, differs considerably from Art Nouveau in other countries. It exhibits none of the luxuriant fashionable traits familiar to us from French Art Nouveau, none of the linear symbolism of the Scots, and certainly none of the dynamic conception of Belgium. Nor shall we find many signs of structural symbolism. It reflects the two-dimensional aspect, proclaims its origin in book illustration just as clearly as in Germany and Austria, and flourishes most exuberantly in textiles and ceramic art. Moreover, Dutch Art Nouveau was devoid of the *fin-de-siècle* mood. It was simpler and more functionally conscious. It cultivated the lyre bird rather than the swan, the fern rather than the arum lily; it had no truck with woman-eating dragonflies! 'Dutch Art Nouveau, in contrast to that in countries such as France and Germany, is in no way sentimental or pathetic, but rather playful

and well-balanced.'[35] Only in painting and prints do we find a fusion with symbolism.

The Dutch Neo-Renaissance dominated design throughout the 1880s and well into the 1890s, but, as already mentioned, in the early 1890s the influence of P.J.H.Cuypers began to exert itself with results as far-reaching as in architecture. Although Cuypers may appear to be a child of Historicism, it would be more correct to regard him as the father of a rationalist trend. We can trace an unbroken line from his sober conception of design to the work of his pupils, Nieuwenhuis, Dijsselhof, Leon Cachet, Lauweriks and de Bazel. He was instrumental in switching the emphasis from ornament to construction, which was to prove a characteristic of Dutch Art Nouveau.

Dutch Art Nouveau can be traced back to the circle gravitating around *Architectura et amicitia*, which was established in 1893. In that year a rhythmical, nervous, linear style became the hallmark of Dutch painting. Painting and the applied arts parted company. L. Gans dates Berlage's *Nieuwe Kunst* production from 1894. In Berlage's furniture the constructive element was emphasised to an extreme degree, and in the ornamentation of fittings and the treatment of wood a clear English influence can be traced – a feature which also survives in the faintly Neo-Gothic-influenced furniture designed after the turn of the century. But first and foremost Berlage was always far more concerned with the main form and construction than with ornament. The same can also be said of Gerrit Willem Dijsselhof, whose furniture evinces a similar solidity. His *chef d'œuvre* is the so-called Dijsselhof Room, now in the *Gemeente Museum* at The Hague, originally executed for Dr van Hoorn in 1890–2 (some of the objects are from 1896) (figure 8·27). The peacock assumes a central position, and birds with long necks move gracefully about among linear plant stems; and also the room is completely free from Historicism. Dijsselhof's screen from 1894 in the batik technique embodies all the grace and linear charm of Dutch Art Nouveau. In their furniture both Carel Adolph Leon Cachet and Johan Thorn Prikker show a concern for construction,

8·27 Dijsselhof: Interior, 1890–2. Table and cupboard, 1896.
The so-called Dijsselhof Room has a special place in Dutch Art
Nouveau. The influence of the English Arts and Crafts Movement
is evident, as well as certain neo-Gothic features, while the
textiles reflect the inspiration of batik. In the centre panel
we find the symbol of the Aesthetic Movement, the peacock.

particularly the latter, who clearly reveals the influence of van de
Velde, with whom he collaborated in the *Haus Leuring* (1900–2). In
Cachet's textiles, however, we find the same batik-inspired design
as in Dijsselhof – who, incidentally, taught him the batik technique.
The illustrative work of the architect Karel Petrus Cornelis de
Bazel from the 1890s is also markedly batik-inspired in style.

Even more prominent, perhaps, among batik-inspired artists
was Theodorus Colenbrander, who devoted much of his talent to
ceramics (figure 8·28) and textiles. In the treatment of his motifs he
infused a virile element not to be found in the work of Dijsselhof
and Kok. The main form, however, was at all times firm and simple,
and he never adopted the typical Art Nouveau forms that we find
in the work of Jurriaan Kok. Kok's brittle play of line, with its
blend of floral caprice and batik-like convolutions, executed in the
most delicate pastel shades, harmonised brilliantly with his treat-
ment of the main form, where the long stem-like handles appear
almost to exceed the limits of what porcelain as a medium will
allow. Another artist who cultivated Art Nouveau in the graceful
Dutch manner was Frans Zwollo, originally an engraver. Potters
such as Christian J. van der Hoef, William C. Brouwer, and
Adolphe le Comte evinced a very different and more ponderous
style, with Javanese influence transformed into a personal and often
geometric form-language. By contrast, an artist such as Theodor
van Hoytema was far more floral and far more naturalistic.

In the work of Theodor Willem Nieuwenhuis, who specialised
in book illustration, we find snakes, jellyfish and peacocks dis-
porting themselves side by side, often in a floral setting, as in his
calendars. The Dutch strove continually to achieve a more sober
and simpler design, as was the case with the group working for
'*t'Binnenhuis*', de Bazel, Lauweriks, Dijsselhof, Leon Cachet and
Nieuwenhuis. Among the silversmiths, Jan Eisenloeffel, with his
simple Hoffman-inspired main forms, occupies a central position.
The architect Johannes Lauweriks continued to design silver in a
somewhat English-inspired Art Nouveau style right up to the time
of the First World War.

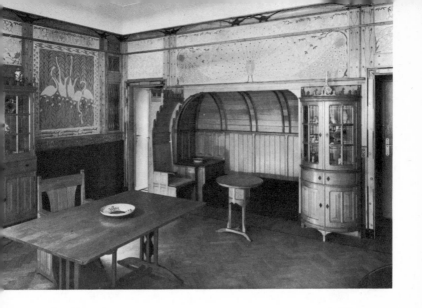

Summing up, we may say that Dutch *Nieuwe Kunst* has its own special character, striving to achieve an austerity of main form and a 'true' use of material, while laying emphasis on stylisation of a very special linear kind – though without the dynamic curves of the French or German line. It remained two-dimensional, gradually developing a penchant for geometrical forms. Apart from the work in book illustration produced by Dutch painters in the early 1890s (see chapter 6), Holland's most individual contribution was in pottery, a traditional Dutch craft. The Dutch version of Art Nouveau may be considered somewhat peripheral to its general development, and yet it is sufficiently characteristic to deserve a place of its own; and in the light of the results arrived at by Dutch scholars, there is no doubt that we are justified in regarding the contribution of *Nieuwe Kunst* to the Art Nouveau style as no less important than that of *Sezessionstil*.

In Holland, Art Nouveau tendencies appeared very early, in a milieu of Symbolist painters, and although many of them abandoned ornamental extravagances at an early period, in the work of talented men like Kok and Lauweriks, the style lived on longer than in most other countries – though in architecture and most of the applied arts the trend had gone beyond Art Nouveau as early as 1905.

8·28 Colenbrander: Earthenware. Vases from
1889, bowl from 1886. As the Belgian Wolfers
introduced ivory from the Belgian Congo
as a fashionable material, so the Dutchman
Colenbrander introduced the Javanese batik
style both in porcelain and in textiles.

The United States

In the United States one Art Nouveau artist stands supreme, both for his artistic production, and for his significance to Art Nouveau in Europe: Louis Comfort Tiffany. Tiffany was trained as a painter, but from 1878, when he established the *Louis C. Tiffany Company, Associated Artists*, he devoted himself exclusively to the decorative arts. His main object was to investigate the possibilities of glass. During the eighties and early nineties Tiffany produced a wide range of work in many spheres of applied art apart from glass. In 1893 he designed his own house and in the same year the chapel for the *Chicago Columbian Exposition*. These were followed by the high altar in the crypt of the *Cathedral Church of St John the Divine* in New York. The décor of these buildings, with lavish use of 'Tiffany Byzantine', including some of his finest windows, retains some of the heaviness which was always characteristic of his design for architecture. By now his reputation as a glass artist was international; in 1890 the *Four Seasons* was exhibited in Paris, and in 1895 he executed ten windows for Bing, designed by Nabis painters. His work came to be known as 'verre américain', and European glassware shows his influence in its design, technique and use of colour, while his Favrile Glass – hand-made glass – was to have many imitators.[36] In 1889 he had paid a visit to the Paris Exhibition, and Gallé's startling display certainly impressed him. On the other hand American glass also attracted attention there. It was with a view to making use of leftovers from window-glass production that Tiffany in the late 1880s became interested in blown glass, and in 1892 his firm was reorganised under the name of *Tiffany Glass and Decorating Company*; in a few years, *Tiffany Furnaces*, at Cirona, Long Island, was in operation.

Tiffany's first group of blown glass was shown at the Columbian Exposition in Chicago in 1893, where it proved an enormous success. Tiffany's glass vessels are generally thin and light, often with a tall, thin stem, occasionally suggesting flowers and stamens in a subtle Art Nouveau rhythm, occasionally revealing inspiration

from the Orient. He also encouraged the use of incidental effects, and work was done in cased-glass technique. In the catalogue of the Paris Exhibiton we read that in 'none of the specimens of this glass is there any application of decoration by painting'.

The period from 1896 to 1900 appears to have been the golden age of blown glass: Favrile Glass was produced in an endless variety of shapes and colours, from high-stemmed transparent pastel-coloured glass to bowls of the deepest hue with layers of glass laid one on top of the other to give an almost mystical effect. In 1900 the firm was reorganised as *Tiffany Studios*, a name it continued to bear right up until 1936. After 1900 Tiffany turned his attention also to pottery, jewellery and lamps.

Inasmuch as Art Nouveau was a transition from the nineteenth-century addiction to formulae of the past to the twentieth-century search for new values and forms, Tiffany contributed to it as an innovator and as an experimenter. But he made his contribution purely through individualistic. romantic originality, characterised by the preciousness of his material and its decoration.[37]

There is little doubt that his contribution to Art Nouveau will be recognised for all time as of the greatest significance, not only on a par with the finest and most original work produced in the

whole period, but also as an important contribution to the history of glass (figure 8·29).

Scandinavia

Each of the Scandinavian countries contributed in its own particular way to Art Nouveau, though without influencing its development: each, in fact, reflects the international movement from the standpoint of national traditions, often with obvious links with folk art.

Denmark, where the renewal movement was referred to as *Skönvirke*, produced pioneer work in ceramics, notably that of the architect Thorvald Bindesböll. As early as 1888 Bindesböll had devoted his talents to decorative art. Inspired both by the East and by William Morris, he created an idiosyncratic style which came to full fruition in his pottery.

Swedish Art Nouveau is usually referred to as *Jugend*. Its four main impulses[38] were the constructive character of furniture in England; van de Velde's organic shapes, with his abstract line ornamentation; the surface pattern, consisting of flowers, twigs and leaves; and the Vienna Secession. The greatest influence in the creation of a new Swedish domestic style, came from the artist Carl Larsson, with the publication of *Et Hem* (A Home), 1899.

In Norway the impulses of Art Nouveau derived as much from the Secession style as from *Jugend*, while the influence of the English Arts and Crafts Movement did not make itself really felt until after the turn of the century. A particularly important and entirely national impulse, moreover, was based on studies of *entrelac* and scroll ornamentation in the later Viking period and the eleventh and twelfth centuries thus creating a symbiosis of Art Nouveau and national elements, called *Dragon style*.[39] The painter Gerhard Munthe was the most important figure in the Reform Movement. While keenly alive to European trends and influenced by William Morris, he consciously based his design on national tradition. In common with Munthe, Frida Hansen took inspiration from the old native art of weaving.

In Finland Art Nouveau never became prominent, except in the work of the painter Axel Gallen-Kallela. Ceramics has always played an important role in Finnish applied art; Gallen-Kallela – whose influence was also of importance in other sectors of applied art – stimulated it to renewed activity. But it was the arrival of the Belgian painter Alfred W. Finch, who settled in Finland in 1897, that marked the start of the national revival.

In the rest of Europe a great many artists adapted themselves to the style. In Italy a floral version proved to be especially popular, *Stile Floreale* or *Stile Liberty*. The name Liberty indicates the influence clearly, while the *École de Nancy* provided an inspiration for the more floral version. In jewellery an artist like Bugatti was influenced by Lalique. In Leningrad Carl Fabergé also created Lalique-inspired jewellery for some years at the turn of the century which was of a high artistic and technical standard.

Conclusion

To sum up, what contribution did Art Nouveau make to the development of the decorative arts?

While it may be said in general terms that Art Nouveau created a new ornamentation, the new attitude to its use was perhaps of even greater significance. This new attitude was twofold. On the one hand there was the conscious effort to merge ornament and object, so that the shape itself actually became ornamental. On the other hand there was a concentration on the exact placing of the ornament and its relation to the surface. The technique was evolved by emphasising the relationship between decorated and undecorated surfaces thereby creating a state of tension between surface and ornament. This is why the style was so important in the art of book illustration. The experimental nature of Art Nouveau also resulted in the acceptance of several new forms and combinations of material, while at the same time less highly-prized materials, such as wrought-iron, copper, and various semi-precious stones, enjoyed a renaissance.

8·29 Tiffany: Glasses from the 1890s. Flowers
and twigs are sometimes suggested in both the shape and
the decoration of the surface, but often the form
is a purely abstract composition of flowing, graceful
lines. But Tiffany's blown glass owes its special
character most of all to its metallic iridescence.

In furniture the style was of prime importance. Furniture construction was subjected to fresh inquiry, and new types of furniture appeared – such as Riemerschmid's chair with the oblique strut running from the trailing edge to the front leg. The building up of the structure of a piece of furniture was emphasised in a new way. New pieces were invented, such as a sofa combined with cupboard and shelves, while other pieces disappeared, such as the *causeuse* and the *chaise longue*. An important new development was the idea of combining several pieces of furniture as an integral part of an interior. Art Nouveau re-introduced the artistic and spatial unity of interior decoration, after the disintegrating tendencies of Historicism. But, most important of all, it did away with clutter, sweeping away knick-knacks, bric-a-brac and wall-hangings. The principle of *horror vacui* was abandoned, and new rooms appeared, purged and purified, with emphasis on their essential components – walls, floor, and ceiling – and on light, space, and air. The cornice vanished, height was reduced and electric-light fittings, which displaced the paraffin-lamp, were given their own particular design and place. An entirely different range of colours was introduced, with emphasis on pale shades, such as milk-white, and on olive-green, pink and various tones of violet. The new feeling for materials also had a decisive influence on furniture. Light, untreated wood came into its own and – largely owing to the Arts and Crafts Movement – oak became the dominant material, particularly in England, Belgium, Holland and Scandinavia.

In silverware, too, there was a marked interest in the property of the material itself. Silver was no longer chased but embossed; from now on the shape of the object became the essential feature, whether structural-symbolical or traditional. In objects as traditional as cutlery the new, simple designs were little short of revolutionary. Semi-precious stones were introduced in silverware as decoration, contrasting with the smoothness of the surface in such a way as to emphasise both stone and metal. In jewellery the artistic treatment of the stone and its setting, rather than its mere value, became paramount.

In glass, the Art Nouveau movement produced two artists, Gallé and Tiffany, who already have an assured position in the history of glassware, both for their technical imagination and for their feeling for form, colour and decoration.

In ceramics a whole series of new designs was created, and experiments were conducted with glazes and techniques. One of the main problems concerned the handle – or rather the organic unity between handle and body – and in this sphere a number of new and original forms were created. Even more important was the sense which developed of the peculiar properties of the material, and the artistic renewal which took place as a result of the potter's own participation and interest in the actual process of production.

As a protest against cast-iron, Art Nouveau developed a predilection for wrought-iron and for copper, which may be traced back to the Arts and Crafts Movement. The regeneration that took place in wrought-iron work, and the high artistic level it reached all over Europe, is due to Art Nouveau and its skill in promoting the special properties of the material.[40] The surface was usually hammered in such a way that the object bore the unmistakable stamp of production by the human hand – in sharp contrast to the machine-produced article.

Art Nouveau involved a regeneration within every sphere of the applied arts, though in no other sector did it flourish so richly, so imaginatively and so independently as in furniture, jewellery, glass and wrought-iron.

9 Art Nouveau tendencies in painting

In the 1890s the terms Art Nouveau and *Jugendstil* were applied only to industrial art. Schmalenbach has pointed out that it was not until 1914 that the term *Jugendstil* was used of painting:

> This stylistic term was coined for industrial art, and was only applied to certain aspects of painting in a retrospective sense . . . so that when one speaks of *Jugendstil* in painting only external formal aspects are referred to.[1]

However, the term *Jugendstil-malerei* (painting) has been used more particularly by German scholars, as a label for German Post-Impressionism[2] and for Post-Impressionism in general. For us the natural approach would seem to be to adhere in the main to Schmalenbach's view, although we shall find that Art Nouveau was reflected in painting in an independent way in linear symbolism.

In chapter 7 we noted that Art Nouveau occupied such a special place in the art of building that a further investigation of this genre was called for. Are there also, one might ask, in European painting in the 1880s and 1890s features so closely associated with the Art Nouveau style that they are worth a closer study?

At a fairly early stage of European Post-Impressionist painting, features emerge which are in marked opposition to Impressionist conceptions of form. In fact, several of the Impressionists themselves reacted against Impressionism. The reaction was not least against dissolution of form. The object dissolved in atmosphere was no longer an aim in itself; the shape and outline of the object were re-established; outlines soon acquired a value of their own and the special qualities of line soon became a new and independent picture-forming factor.

Impressionism had clung to linear perspective, but as the 1880s advanced other space-creating effects were adopted – colour, surface, wavy lines. In fact, the illusion of depth ceased to be an end in itself, and the lively movement in the motif had to give way to the quieter effect of the rhythmically pronounced movement in the picture composition. As far as content was concerned, a shift occurred from the genre-bound everyday motif to one imbued with ideas, and often symbolical. Artists moved further and further away

from Nature as their direct model, abstracting, transforming and interpreting it afresh in various ways.

This development parallels what we have already noted in the applied arts, where two-dimensional problems were the most prominent and where the innate value of line – in a more or less wavy or whiplash rhythm – became the essential, and where the enclosed contours of objects became ends in themselves. In fact, we find certain important common features in the development of the arts and the applied arts in the 1880s and 1890s, partly as a result of common precursors, such as the Pre-Raphaelite Movement, Japanese and Oriental influence, the cult of line and, last but not least, the striving to achieve a *Gesamtkunstwerk*, with the individual artist working in several spheres. It is not surprising that the same style-creating tendencies should be expressed in the various genres. In Art Nouveau the basis for this artistic unity is provided by the innate value accorded to line and contour, the relationship of line to surface, the two-dimensional problem, the rhythmic influence upon Nature and the tendency to symbolise.

Although the main development in European painting – led by the French, through Neo-Impressionism, the School of Pont-Aven, Synthetism, Cloisonnism, Les Nabis, Symbolism, Primitivism and finally to Fauvism – bypassed Art Nouveau, nevertheless the influence of Art Nouveau is reflected in the painting of most of the national schools. By different artists a linear symbolism was developed in which the value of line and contour was not only descriptive, but had a deeper meaning, expressing the idea of the motif. This linear symbolism, which in turn was connected with Expressionism, was probably the most important contribution of Art Nouveau to the painting of the period.

The Late Pre-Raphaelite School

The Pre-Raphaelite Brotherhood was founded in 1848, with William Dyce, Ford Madox Brown and Dante Gabriel Rossetti forming the original inner core. The first two had been in contact with the

9·1 Burne Jones: *The Pelican*, pastel, 1881. Burne Jones forms a bridge between the Pre-Raphaelite Movement and the illustrators of the 1890s. From the early 1850s he was closely connected with William Morris and at the beginning of the 1890s the young Beardsley joined his studio.

9·2 Crane: *Neptune's Horses*, 1892. The theme
of animals or human beings growing symbolically
out of Nature was well known to the artists
of the time. But few could make the transformation
so convincingly naturalistic, while cultivating
the rhythmic play of line, as Crane.

German school of painters, the Nazarenes, in Rome, whose aims
the Pre-Raphaelites more or less shared: art, religion and ethics
were closely linked together in their programme; the study of Nature
played a dominant role, and naturally also a study of Trecento
art. The English artists, however, were particularly interested in
decorative art. The group was soon joined by Holman Hunt,
Edward Burne Jones, John Everett Millais and the young William
Morris. Their art ranged from the most blatant Naturalism to
sentimental and mystical medieval Romanticism. In the late Pre-
Raphaelite School, however, tendencies can be traced which are
directly associated with Art Nouveau. We have already seen (see
chapter 6) how artists such as Walter Crane, George Heywood
Sumner, Herbert P. Horne and Selwyn Image contributed to
English proto-Art Nouveau in the applied arts, and many of the
features visible in their artefacts are also to be found in their
painting.

In Burne Jones's pastel *The Pelican*, 1881 (figure 9·1), several
stylistic characteristics of the school may be seen, for example, the
predilection for narrow, upright formats, combined with a vertical
and serpentine use of line. In the work of Walter Crane we find the
same tendencies, most clearly, perhaps, in his design for a com-
position in mosaics, 1886–7. It represents *Air*, and shows his
theory of the line of movement, which is presented in a highly
decorative manner with the predilection for ornithological speci-
mens so characteristic of English decorative artists and of Walter
Crane in particular. Crane's *Neptune's Horses*, 1892 (figure 9·2),
presents the same rhythmic power, based on the restless movement
of the wave. Burne Jones, Crane and G. F. Watts represent the
core of late Pre-Raphaelite painting. While the first two gradually
transformed Naturalism into a cult of linearism with literary
undertones, the third continued to paint symbolic allegories, as
may be seen in a great many of his literary pictures from 1885 to
1900. William Morris's pupil Frank Brangwyn forms a link with
French painting in the 1890s; he lived in Paris during the years
1891–5, where he came into contact with Maurice Denis as well as

working for Bing. In his work an English love of line blends with the two-dimensional style of the French School in a prolific production of painting, drawings and lithographs.

Pre-Raphaelitism in a way occupies an isolated position in European painting; it was markedly English in character and exercised only a limited influence on the development of painting on the Continent. It was based not on pictorial, but on linear and literary values, and its importance was generally greater for the graphic and applied arts. In the case of Holland and Belgium, however, Pre-Raphaelite painting played a very special role.

The Pont-Aven School and Les Nabis

In 1901 Richard Muther devoted a chapter to French Symbolism in his book on French nineteenth-century painting and called it 'The Triumph of Line', a title which tells us a great deal about French painting at this period, though by no means all. This trend was clearly the only element linking developments in England with those in France, so different were the antecedents of contemporary painting on either side of the Channel.

The fountainhead of Synthetist tendencies and Cloisonnism in France is partly to be found in the reaction against Impressionism – against the dissolution of the motif, linear perspective, lack of content and the dissolution of line and form. Again and again we find the same striving to re-establish the pictorial elements, to achieve cohesion of form, synthesis. During the years 1884–6 Georges Seurat completed his masterpiece *La Grande Jatte*. In

this painting he carried out what has been called an objectivisation of the motif and its individual parts, with the emphasis firmly placed on contour and form-creating elements. In 1887–8 he painted *La Parade*, in 1889–90 *Le Chahut*, and in 1890–1 *Le Cirque*. In all these we find an entirely new kind of space and line effect. Seurat himself declared that before painting a new canvas the problem to be resolved was 'what curves and arabesques will cut the surface of it?'[3] A new pictorial conception, with the emphasis on the innate value of line, was in fact coming to the fore.

Seurat's importance was all the greater for the influence he exercised on so many of the young painters in the *Les XX* group in Belgium – van de Velde, Finch, Lemmen and van Rysselberghe. They all turned to the great master, impressed by his linear composition and technique, and it was they who in due course would turn to the applied arts. Seurat nourished them in their search for a new form of expression, and via the literary and symbolical milieu of Brussels they were led to the threshold of linear Symbolism.

In 1888 Émile Bernard painted *Bretonnes dans la Prairie*, in which we find a new and entirely different departure from Impressionism, even though the choice of motif in itself is no less Impressionist than the restless *Le Cirque* or the sun-drenched *La Grande Jatte*. The emphasis here is on the two-dimensional and clearly delineated surface. Three-dimensional depth is achieved by cutting and placing the figures above each other and making them smaller – features inspired by Japanese woodcuts. It is, in fact, characteristic that as early as 1885 Bernard had studied the woodcut and the emphasis placed in it on line and surface.

In the work of Louis Anquetin we find another striving to achieve enclosed form. In 1887 he developed his method of achieving colour synthesis. This consisted of viewing the landscape through variously coloured sheets of glass, a technique which he discovered in the following way. In his father's house there was a veranda with glass doors, consisting of square polychrome panes of yellow, green, red and blue glass, of the kind so frequently to be found in the houses and villas of the well-to-do in the 1870s and 1880s. By looking at

the landscape through coloured glass panes, the sixteen-year-old boy discovered that the various colours produced different moods. Whatever the time of day, the coloured panes all produced their own mood: green evoked a sense of early morning, blue the illusion of a moonlit night, red a sense of sunset and yellow a dazzling sunlight. This system gave him not only the key to a simple colour-scale but also a method of evoking moods. This colour-system, or emotional monochromism, was to prove of great importance to van Gogh, among others, who adopted it with enthusiasm. In his way Anquetin represents the same striving to achieve abstract simplification; his colour theory reveals another way of achieving delimitation of the surface and a synthetic effect.

These were the pictorial problems that young Paul Gauguin was to struggle with. In 1888 he painted *Jacob wrestling with the Angel*, in 1888 *Le Christ Jaune* and in 1889 *La Belle Angèle*. With their emphasis on line, outline and surface these paintings are markedly 'flat'. In order to distinguish surfaces from one another, a powerful, accentuated outline was introduced. 'What has been called "Cloisonnism" is the craze for using large, dark blue patches to emphasise the shape',[4] declared Paul Sérusier, a painter who learned this principle from Gauguin in 1889.

In the course of the years 1889–90 Synthetism developed into a conscious style among the Pont-Aven group, with Gauguin as its dominant personality. This form-language was a tool which in a striking manner proved capable of expressing the ideas of the group. It possessed a power of expression in the angular and violent lines and the simplified colours and colour-planes that achieved great sonority in the work of Gauguin, though in the work of Émile Bernard it became increasingly a style-creative end in itself. The Pont-Aven group, however, soon fused with painters such as Maurice Denis, Henri-Gabriel Ibels, Paul Ranson and Ker-Xavier Roussel – Paul Sérusier being the link between them. Later, Pierre Bonnard, Aristide Maillol and Edouard Vuillard joined them. In 1892 these painters founded the group of *Les Nabis* (i.e. The Prophets), developing a symbolism that was somewhat different

9·3 Ranson: *Deux Nus*, cartoon for tapestry, about 1890. Ranson has been labelled both Synthetist and Neo-Traditionalist. In fact he was both. In line and outline he gave free rein to the synthetic and rhythmic play of line, while his female figures always retained a classical calm.

from that known to us from the Pont-Aven School. The primitive and expressive strength cultivated by the latter was fused by *Les Nabis* with a literary-influenced trend in which content played a more important role. The form-language of Cloisonnism and Synthetism were, however, to some extent retained and developed.

In this period, during which he designed tapestry, Aristide Maillol was closely associated with Paul Ranson. In their treatment of figures both are rooted in classical tradition, but in the jagged, more elegant sweep of their line they reveal the rhythm of Art Nouveau. Ranson's figure-compositions in particular are character-ised by movement and by the play of the breeze on clothes and draperies. In the background float strange tentacles and animals – as, for example, in the tapestry designs *Nu dans un Décor Oriental*, 1890, and *Deux Nus*, approx. 1890 (figure 9·3).

In the earliest work of Maurice Denis we find a search for calm and restfulness. He, too, uses dark contours, trying in the same way to achieve the large form and the monochrome planes, but his line is calmer, which helps to create a monumental effect, as for instance in *Avril*, 1892. His sketches for costumes for Maeterlinck's *Sept Princesses*, 1891, are entirely Art Nouveau, foreshadowing van de Velde's designs nearly ten years later.[5]

Standing apart from this development in French painting we have Gustave Moreau and Odilon Redon. It seems possible to trace a direct line from Ingres via Chassériau to Moreau, in which the cult of exoticism as well as certain linear values are in evidence. Moreau's tragi-mythological symbolism is a far cry from that of *Les Nabis*, while his form-language is far more traditional. But in refinement of line and the sensual *fin-de-siècle* mood there are traces of Art Nouveau. Redon's introspective art contains none of this external pomp and circumstance; from a serious study of Nature he penetrated gradually to an investigation of the human psyche, where the enclosing form-language gave the introspective content its appropriate form.

Henri de Toulouse-Lautrec's supreme importance for Art Nouveau was in the sphere of poster art, but in painting too, and

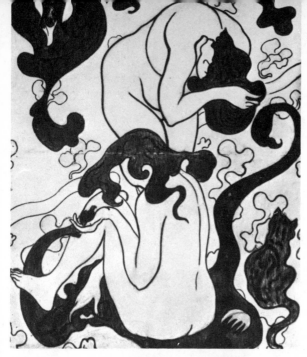

particularly in his portrayal of women, he interpreted the French *fin-de-siècle* type with greater subtlety than any of his contemporaries, at times verging on caricature. His portrait of Yvette Guilbert is especially characteristic; and, as has been remarked of his women:

Their inordinately long arms, swathed in three-quarter-length black leather gloves, stand out like hieroglyphs of decadence on the white surface of the paper.[6]

While the Pre-Raphaelites developed a sophisticated linear form-language in their Romantic Symbolism, the French Symbolists elaborated a form-language in which not only the line and contour but also the actual surface emphasised the expression. In this search for a two-dimensional form of expression, they enhanced the monumental effect of painting, and through its symbolism their art acquired new meaning and content. In the group of *Les Fauves*, especially in the painting of Derain, Bonnard and Matisse round about the year 1905, we find precisely these qualities, and in addition a feeling for figural, rhythmic composition which might also be traced back to Art Nouveau.

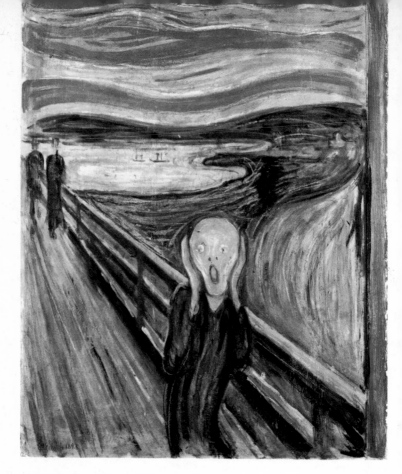

Flemish and Dutch Symbolism

In Belgium, as we have seen (chapter 7) the 1880s and 1890s witnessed an upsurge of cultural activity. With *Les XX* Belgium, and to a lesser extent Holland, occupied an important position at the meeting point of cultural trends passing between England and France. The link with England was established by the presence of English artists at the exhibitions of *Les XX*, but also in other ways. Knowledge of English art was spread first and foremost by articles on the theory of art by writers such as Ruskin, Morris, Day and Crane. This influence was particularly important in the case of van de Velde. There were also other more direct links. Fernand

9·4 Munch: *Shriek*, 1893. The mood behind themes like *Evening on* 209
Karl Johan Street, 1892, and *Shriek* was explained by Munch: 'I was
walking along the road with two friends. The sun was going down; the sky turned
blood-red, and I felt a breath of wind. I stood still, dead tired. Across
the blue-black fjord and the town were tongues of blood and fire. My friends
walked on; I remained behind, shaking with fear, feeling the great cry of Nature.'

Khnopff, for instance, was of British descent, had an English wife
and spent several years in England. He had already made the
acquaintance of the Pre-Raphaelites at the World Exhibition in
Paris in 1878. As a pupil of Moreau he was an early enthusiast of
French Symbolism. The Dutchman Jan Toorop also had a British
wife; and we find him in London for the first time in 1884, and
again in 1886 and on many subsequent occasions till 1889. Like
van de Velde, however, he was particularly attracted to the painting
of Seurat. His Javanese associations are peculiar to him and to
Dutch art, during this period. Toorop spent the first eleven years
of his life in Java, and many impressions from his youth recur in
his mature art.

To the cosmopolitan milieu in Brussels the young Seurat-
inspired painter van de Velde sought admittance in 1889. 'I would
so much like to break a lance with you [the *Les XX* group] since
that is the only encouragement and honour I could expect.'[7] Van
de Velde began his painting career as an Impressionist in the latter
half of the 1880s, switched to Neo-Impressionism in 1888–9 and
developed a special interest for Seurat in 1890, writing two articles
about him in *La Wallonie*, in which he discussed Seurat's theory
of colour and the importance of line in his painting. In his abstract
Ornament of Fruit, 1892 (figure 9·5), we find a linear rhythm similar
to that of Ranson among *Les Nabis*. In his *appliqué* embroidery
The Watch of the Angels, 1893, however, the motif is suitably
figurative, but the actual technique, with the large, clearly defined
monochrome planes, emphasises the line and its abstract, rhyth-
mical value. In 1894 van de Velde did not exhibit with *La Libre
Esthétique* because he had already turned his attention to the
applied arts. Instead he delivered a lecture to the group which,
characteristically enough, he called *L'Art Futur*.

Fernand Khnopff was the leading Symbolist painter of Belgium,
and his close association with the poets Maeterlinck and Verhaeren
accounts for the literary symbolism in his art. His first symbolical
work, *Sphinx*, goes back to 1884, and in the first half of the 1890s he
completed his most important works, among them *The Offering*,

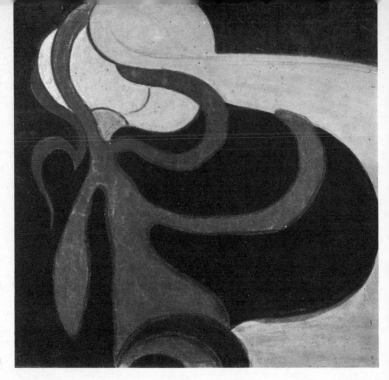

1891, *I Lock My Door Upon Myself*, 1891, *La Poésie de Stéphane Mallarmé*, 1892, *Comme des flammes, ses longs cheveux*, 1892, and *Arum Lily*, 1895. The Pre-Raphaelite influence is particularly clear in works like *I Lock My Door Upon Myself*, which are sustained by a cloistered loneliness and a calm, introspective resignation. His female type shows the same influence, and one notes also that his titles are frequently English. Again, his preference for unusual formats, either tall and narrow or very short and wide, are another symptom of the same trend. In *La Poésie de Stéphane Mallarmé*, we find a great deal of the same mood as in *I Lock My Door Upon Myself* – a meditative calm, an air of ecstatic timelessness. Both in its form and in its motif this picture is a complete expression of Khnopff's poetic symbolism.

Jan Toorop was Khnopff's Dutch counterpart. He, too, moved over to Symbolism in 1890–1, and was likewise a good friend of Maeterlinck and Verhaeren. We find his style fully developed as early as in the cartoon *Faith Giving Way*, 1891, in which the composition teems with lean, lanky figures depicted in rhythmic,

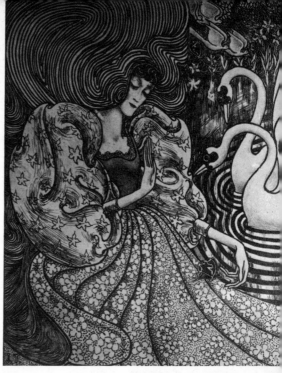

9·5 *Left* Van de Velde:
Ornament of Fruit also
called *Plant Composition*,
1892. Nature is so
abstracted as to be no
longer recognisable.
However, the lines of the
onion-like object clearly
illustrate the idea of growth
and budding.

9·6 *Right* Toorop: *The Girl
with the Swans*, 1892. In
Toorop's paintings hair and
clothes are often trans-
formed into an ornamental
play of line, which has a
decorative value of its own.
The effect is obtained
through the parallel lines
and rhythmic movement.
The danger is, however, that
the single form may be so
subordinate to linear laws
that it degenerates into
mere ornament.

linear movements. Suffering is an essential component of the picture, and the figures are seen either peering ahead, as though into eternity, or else with eyes secretively closed. In the next few years there followed a series of pictures which in varying degrees all had a religious or mystic element. In the lithograph *The Girl with the Swans*, 1892 (figure 9·6), we find a sophisticated sweep of line, elongated forms and a rhythmical movement. In *Apocalypse*, 1892, or *Oh, Grave, Where is Thy Victory?*, 1892, the latter with a characteristically English title, the religious symbolism is pre-dominant, while his masterpiece, *Three Brides*, 1893, reflects a mystic cult of Woman. Here we find an interpretation of the female which recalls Munch's *Three Stages of Woman*. Toorop's painting, how-ever, always runs the risk of culminating in a decorative play of line, and this kind of painting proved a dead end. Involuntarily one recalls the words of the Dutch Nabi, Jan Verkade: 'Pictures don't exist, only decoration.'[8]

The work of Johan Thorn Prikker closely resembles Toorop's, with its linear form of expression, as well as its symbolism. In *The*

Bride, 1893, we find a sensual, erotic symbolism, while the line coils its suggestive spiral rhythm through bodies, lights, columns, and the bride herself. Thorn Prikker and the English-born imitator of Seurat, Alfred W. Finch, were both associated with van de Velde at an early stage, became interested in the applied arts, and worked for him in the 1890s. In 1904 Thorn Prikker took up a teaching appointment at the School of Applied Art in Krefeld, while Finch as early as 1894 devoted himself mainly to ceramics, making his way to Finland (see chapter 8).

On the whole, in Holland, Art Nouveau linear rhythms played a greater part in drawing than in painting, as in the work of Roland Holst, Theo van Hoytema, Anton der Kinderen and George Lemmen. At the same time Dutch Symbolism, with its literary undertones, was in its external form-language essentially influenced by the Art Nouveau emphasis on the innate value of line.

Germanic Expressionism

From time to time in the history of European culture an infusion of vitality has come from the North – not only vitality, but a tragic sense of life infused by this vitality.[9]

With these words Herbert Read introduces Edvard Munch, in whose work man and his passions became the central motif. Munch himself formulated his programme as a painter as early as 1889 as follows:

No longer should interiors be painted, with people reading and women knitting. They should be living people who breathe and feel, suffer and love.[10]

Munch came from a middle-class family. His mother and sister died when he was only a boy, and it seems that from an early age he was haunted by a fear of death. In painting influenced by Art Nouveau, Munch is perhaps the most gifted artist. He managed to give the line not only a formal and expressive value of its own, but a meaning closely related to the idea of the motif. Quite apart from this, there was no one who plunged so deeply or so bitterly into the *fin-de-siècle* mood.

Munch's earliest artistic training was as a Naturalist; he was soon a member of the bohemian clique of artists at that time living in the Norwegian capital. In Paris, which he first visited in 1885 and where he studied from 1889–92, he became the pupil of Bonnat, whose academic approach must have been foreign to him. But he also met Strindberg, Mallarmé and Meier-Graefe. He had an opportunity too of visiting exhibitions by Impressionists, Symbolists, Synthetists and *Les Nabis*. Through his work for the theatre he was affected by enthusiasm for the latest trends in music, though it was Nietzsche who had the greatest influence on his intellectual development. In his *Thus Spake Zarathustra*, Munch heard an echo of his own ideas on the creative artist and his position in society – genius as the lonely, tragic figure who interprets life through the medium of art and in the process sacrifices his own flesh and blood, and is finally destroyed. This idea is embodied in *Funeral March*, 1897, in which a coffin is depicted held aloft by nude female figures. Munch's conception of Woman, too, is characteristic, reflecting an ambivalent attitude, a mixture of devotion and fear, which made her at one and the same time Madonna and Vampire.

The *Life Frieze* started to take form in 1889–90, and Munch sums it up briefly in these words: 'It will deal with love and death.' Furthermore, he expressly mentions Nature as the setting for this cycle of pictures:

... through the frieze the curving shoreline winds its way; beyond lies the sea, which is always in movement, and beneath the crowns of trees teeming life is lived, and its joys and sorrows. . . .[11]

The titles alone – *Kiss, Evening, Melancholy, Fear, Evening on Karl Johan Street, Puberty*, all from between 1890 and 1892 – are highly revealing. These were followed by *Vampire, Madonna, Jealousy, Shriek*, all from 1893, *Ashes*, 1894, *Woman in Three Stages*, 1895, a sequence which ended for the time being in *The Dance of Life*, 1900.

It was in 1891 that a change of style took place in Munch's art.

9·7 Hodler: *The Day*, sketch, 1899. Like Rodin and Minne before him, Hodler was preoccupied with rhythmic problems, not only of line but of gesture and movement.

After a short Neo-Impressionistic phase in 1891, we find a much greater discipline of form. It is, however, with *Shriek*, 1893, (figure 9·4) that all the sporadic trends in the direction of simplification of form – which can be traced back to the latter half of the 1880s – merge in a single work. In the winter of 1891–2 Munich was absorbed with the idea of painting a picture of an experience he had had in Oslo. The dizzy perspective and the clutching lines seem to be sucking the figure in the foreground into the depths, and the inner tension from which he suffers breaks out in wavy lines which seem to reflect the mood of the whole setting as in *Evening on Karl Johan Street*. With this traumatic interpretation of a subjective experience, just as in *Shriek* – emphasised by the expressive play of line and enhanced by colour — Munch made his boldest contribution to the painting of the nineties. We find the same expressive effects in *Madonna*, 1893–4, on an even higher artistic level, and here, as in *Shriek*, the ornamental Art Nouveau-like forms go far beyond the decorative: they convey the content.

In his landscapes of the 1890s he strove with the aid of a synthetic conception of form to achieve the same concentrated mood as in his figure pictures – particularly in his night studies, to which he devoted himself assiduously at this time. In these pictures twilight obliterates all non-essentials, emphasising the large monumental forms. Munch in this way raised landscape painting by means of line and contour to the level of the psychic, and succeeded in fusing figure and landscape so that the latter became expressive of the figure. His restless, almost vagrant existence in the 1890s and the first years of the new century, however, resulted in a nervous breakdown in 1908. In 1909 he returned to Norway for good, and at the same time a change took place in his style and cycle of motifs.

'Jugendstilmalerei' in Switzerland, Germany and Austria

In the 1890s the *avant-garde* Swiss painters were particularly influenced by France. Among them were such widely different artists as Ferdinand Hodler and the South Tyrolean Giovanni Segantini. As early as 1885 Hodler had come in contact with

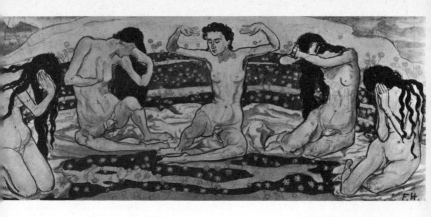

Symbolism. In 1890 he made his first sketch for *The Night*; and
during his stay in Paris in 1891 he became familiar with the work
of *Les Nabis* and with Pre-Raphaelite painting, although he was
also influenced by Puvis de Chavanne. In the course of the 1890s he
developed a monumental figure style, the special feature of which
was rhythmical harmony within a group of figures. The individual
figures link up with one another in a subtle, graceful movement,
emphasising the cyclic and often literary symbol. His subjects
include *Sleep*, *Day*, *Night* and *Spring*, with a human figure sym-
bolising the universal. In *Day*, 1899–1900, (figure 9·7) rhythmic
alteration and the repetition of hand and body movements create
the same tension between outer movement and inner calm as is
found in the work of Georges Minne and Rodin in the 1880s.
Another essential feature of his art is that the outline of the figure
or the landscape serves to emphasise the content and the idea of the
motif. This is an important principle in Expressionism and it reflects
the same trends as in the linear symbolism of other countries.

Giovanni Segantini, a self-taught artist, revealed to a far greater
extent the influence of Symbolism and of the *fin-de-siècle* mood.
Like Munch, tragic events from his childhood left their mark on
him in later life. In his compositions of the 1890s we constantly
find Woman in the guise of Mother, for instance in *The Two Mothers*,
which depicts the human mother and the cow-mother side by side
in the cowshed; *The Angel of Life*, dedicated to the joys of mother-
hood; and *Child Murderess*, 1894, showing the vain mother whose
hair is entwined in a leafless tree on a barren, snow-covered heath.
In his work, too, as in the work of many of his contemporaries

such as Gauguin, Munch and Hodler, landscape plays a predominant role in creating symbols, emphasising mood, while man appears as an integral part of the natural scenery. This is the case in his cycle presenting the life and nature of man.

German *Jugendstil* painting did not, as in several other countries, come into being as a reaction against Impressionsim, nor did it evolve in close contact with literary and symbolical trends, as in most other European countries. There was in fact no Impressionism to react against, nor was there any *avant-garde* painting. So Germany, as we saw previously, was late in joining the movement.

Two important factors which helped to prepare the way for this new painting were the Munch Exhibition in Berlin in 1892 and the *XI Group*, founded in the same year by eleven artists in imitation of *Les XX*. Among the *XI* may be found leading German painters of the Art Nouveau period, such as Max Klinger, Walter Leistikow and Ludwig von Hoffmann. In Klinger's painting we do not find so many of the external formal qualities of Art Nouveau, but in his attempts to fuse painting and sculpture we recognise the idea of *Gesamtkunstwerk*. With his *Judgment of Paris*, 1885–7, the pattern was set, with frame and motif, sculpture and painting blending.

Ludwig von Hofmann was a landscape painter who to a greater extent than any other German painter in this period expressed in his work an emotional mood. He depicted the silent glide of the sailing-boat or the winding course of a river through a sun-drenched wood – often with a bevy of laughing young female bathers. But in this typical landscape from the 1890s he often inserted a being of a symbolic nature – a mystic creature emerging from the depths of a river pool, or a face sketchily glimpsed in a woodland setting. Gradually, however, he concentrated on the decorative aspect of painting, and in his work we find the contemporary interest in line, in flowing rhythm and gliding forms, which become an end in themselves. Form in his work does not however, as with Munch, possess a profound significance, either as expression or as content: it becomes an external means of conveying mood.

In Munich the *Münchener Sezession* was already founded in 1892. Here we find painters such as Franz von Stuck, Carl Strahtmann and Hugo von Habermann. Von Stuck was at an early age influenced by Symbolism, and we find a close resemblance to Khnopff and his theatrical demonism, for example in *Sin*. Like his Belgian colleagues – and many other Art Nouveau artists – he uses sex as a basic theme, with the serpent and other oriental effects emphasising the sinful and sensual. We find something of the same in the work of Strahtmann, who blended academic tradition with new style-elements, but whereas von Stuck and Strahtmann represented female figures with morbid and sinful *fin-de-siècle* features, and gave them titles such as *Salome*, *Judith*, *Salambo*, or *The Snake Bride*, von Habermann generally preferred the piquant woman, whose hair, shawl and veil supplied the external props for a decorative *Jugend* fantasia.

When the *Wiener Sezession* was founded in 1897, with the periodical *Ver Sacrum* as its organ, the aim was to put Austrian art in touch with the new international trends, and to direct the attention of the public to genuine art, away from all that was popular and sentimental. 'Business or art, that is the crux of our secession', wrote the enthusiastic champion of the movement, Hermann Bahr, in the first number of *Ver Sacrum*. Among its founders were Gustav Klimt, Josef Hoffmann, Koloman Moser, Alphonse Mucha and Joseph Olbrich, but precisely because the object was not only to create *new art* at all costs, but good art, we do not find painting so obviously cast in the Art Nouveau mould as was the case in many other countries.

The dominant personality in this milieu was Klimt, who was at his best when representing the female figure. His nudes and portraits are inspired by a sensual delight which permeates both his interpretation of personality and his pictorial conception. His figures exist in an abstract space where they appear to soar freely in a realm of sex which is generally infused with a note of tragedy and is at times almost voluptuous, as in *Salome*, 1909 (figure 9·8). His decorative play however, where gilt and gold-leaf are directly

218

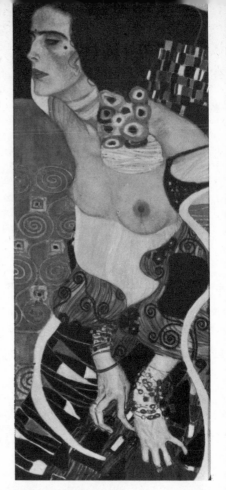

9·8 Klimt: *Salome*, 1909. Klimt was here aiming at a complete fusion of figure and background in a decorative play of small patches of colour. The pattern of a frock or the glittering tints of jewellery are repeated in the ornamental composition of the background, and in this way the figure is integrated within the ornamentation.

applied, has no profound connection, as far as content is concerned, with the motif or the person presented: a formal fusion does take place, but it often lacks any profound significance. Among his chief works are the Vienna University murals, 1900–3, which at one time enjoyed a *succès de scandale*, and the mosaics on the walls of the *Palais Stoclet* in Brussels, 1910.

One of the artists following in Klimt's footsteps was Rudolf Jettmar. He also cultivated decoratively ornamental painting, but with him sex played a more subordinate role. His rounded forms and closed form-language are best displayed in his prints.

Conclusion

In an attempt to analyse the role of Art Nouveau in the develop-
ment of painting, one is inevitably forced to the conclusion that it
represents a reaction against Impressionist painting, except in the
Germanic cultural sphere, where Impressionism had played a less
significant part. In essence the style was a reaction against the
dissolution of surface and line, and in painting it marked the end of
the illusionistic conception of form. The significance of outline and
the juxtaposition of surfaces were re-established after the dis-
integrating tendencies of the 1870s and 1880s. But not only was
contour re-established: the actual line and its course were given
their own particular value, acquiring the status of a fully valid
pictorial means. This means may either be of importance to content,
with the line enhancing the mood of the picture by virtue of its
suggestive effect, or else it can evoke ornamental values in the
painting. In the first case new sources of inspiration were opened
up, particularly in landscape and figure painting, where Man and
his setting fuse to evoke a mood to an extent which was previously
almost unknown in the history of painting. This trend is a fore-
runner of Expressionism, while the other tendency, with the
emphasis on the decorative and the ornamental and their particular
value in the painting, foreshadow abstract painting. Though it
would be incorrect to speak of an Art Nouveau school of painting,
the trends inherent in this style are clearly visible, introducing
features which were to prove of fundamental importance to the
future development of European painting.

10 Art Nouveau tendencies in sculpture

Trends in sculpture 1875–1900

The sculpture of the 1870s and 1880s was in the main influenced by Neo-Baroque and realistic trends, and had a literary, often anecdotal, content. In addition there was the work of Hildebrand, representing a classical tendency, and that of Rodin and the Impressionists. Neo-Baroque and Impressionism shared several features in their conception of form,[1] and if we consider the development in the 1890s as a reaction against both these trends, it is worth while examining these common features more closely, as they were to provide a point of departure for the sculptural development of the 1890s.

Neo-Baroque and Impressionistic sculpture is essentially not static. The figure is generally presented in movement, or standing at a point of balance that has been artificially selected, as for example in the work of Degas. In content and form Neo-Baroque and Impressionist sculpture strives to achieve contact with its surroundings. The relationship of sculpture to space also goes hand in hand with this conception. With the help of an openness of form and light-and-shade effects the sculpture takes possession of space, incorporating it in the form itself. The composition, too, is dependent on this restless and extrovert approach. The agitated mass, the open and complicated composition, combine to produce the broken, complicated and jagged outline against which the 1890s not surprisingly reacted.

In their choice of motif artists at this time ranged from grandiose allegorical pathos to the highly intimate, sentimental and romantic. One of the most generally accepted slogans of the time was: 'Sculpture must primarily represent ideas, not things.'[2] Hildebrand expressed a somewhat similar view when he declared: ' . . . We are producing *representation* and not *perception*.'[3]

The development in the 1890s is, where form is concerned, a reaction against these Neo-Baroque and Impressionist trends. A change takes place in the conception of form, composition and outline. In contrast to the open, pierced form of the preceding

period, the concentration is now on the closed form, as for example in Rodin's *Balzac*, 1892–7; the figure no longer bristles, nor do single features disturb the sense of unity. The static element is sought for its own sake, and now and again the column in all its simplicity appears as a monument, as in Obrist's *Design for an Architectonic Sculpture*, 1902. Outline now clings to the figure, enclosing it completely. Even the contour line may acquire its own innate value, through the rhythmic play of line. In his voluminous correspondence of the 1890s the Norwegian sculptor Gustav Vigeland refers constantly to line, even repeating it three times in quick succession.[4] We realise, too, that the reaction against Rodin was fairly strong. In 1901, discussing Rodin's sculpture, Vigeland declared: 'It is not enough merely to give form a push here and there, knocking dents in it.'[5] And the remark he made in 1896 adequately expresses the new trends of the 1890s:

With every day I realise more clearly that sculpture must be stricter: statues must not be allowed to pop up and shoot into the air.[6]

Granite was now introduced, while wax, at one time fashionable, was abandoned.[7] We recognise a general effort to re-establish the closed form and the monumental effect of sculpture.

During the 1890s a great deal of attention was devoted to the problem of the relationship between a sculpture and its base. The theorist Theodor Lipps declared that 'the plastic presentation of a form demands also the presentation of the base on which the form stands "in one cast" or at any rate in the same material.'[8] But the art of the 1890s went much further: the idea was that the figure should grow out of its base, out of the actual mass of material, whether this was stone or bronze. The base was given a characteristic Art Nouveau shape, particularly in the sliding movement of the lower part, which often gives the impression that it is supporting the weight of the monument and transmitting it to the ground. Probably we are here faced with a structural symbol. In surface treatment we find a noticeable tendency to a summary, fluid form, almost suggesting at times a film of moisture, for instance in

10·1 Minne: *Well with Kneeling Boys*, marble, 1898. In this great work of the period we see the characteristic relation of figure and base: the figure seems to merge into the base, becoming part of it. This reflects the idea of unity, both aesthetically and between the sculpture itself and the material of which it is made.

Meunier's *Antwerp*, 1900. Yet another trend in the sculpture of the 1890s was the rhythmic repetition of a motif. Rodin had had recourse to this in his *Burghers of Calais*, and in the 1890s we can trace examples of a single figure repeated in several phases of a movement, creating in this way a rhythmical movement of subordinate parts, for example in Georges Minne's *Well*, 1898, and in Vigeland's *Fountain*, 1900–14.

The cycle of motifs characteristic of the 1890s was quite unlike that of the 1870s and 1880s. In the first place it was less anecdotal, less narrative in essence. Allegory, mythology, and the historical motif were relegated to a subordinate position. With the increased emphasis on plastic values, content came to be of minor importance. The single figure, depicted in a simple pose, presented problems enough. But there also arose an entirely new cycle of motifs, derived from the human psyche. Interest centred on the life cycle of Man, the inner tension involved in it, and Man's relationship to Nature. The days of chained slaves and children picking flowers were past; the sculptor now wrestled with deeper problems of humanity.

All these features reflect trends and tendencies familiar to us from the 1890s, but does this in fact mean that we can speak of an Art Nouveau School in sculpture? If not, are we justified in speaking of Art Nouveau sculpture? The answer to the first question will have to be 'No'. There is neither sufficient material to enable us to speak of a School or a movement, nor was there a sufficiently conscious effort in sculpture capable of producing a common sculptural form-language. On the other hand, in the work of individual artists stylistic tendencies are reflected in a way which can only be explained through the influence of Art Nouveau.

Belgium and France – Minne

The most important sculptor in this area was the Belgian Georges Minne. Minne started his career as a painter and illustrator, and in the exciting milieu of Brussels he was at an early stage associated

with Maeterlinck and the other Symbolists and exhibited together with *Les XX*. His first illustrations to Maeterlinck's *Les Serres Chaudes* and Grégoire le Roy's *Mon coeur pleure d'autrefois* reveal, typically enough, English influence. In 1898 Minne completed what was to prove his life's work – and the *chef d'œuvre* of Art Nouveau sculpture – *Well with Kneeling Boys* (figure 10·1). This piece was carved in marble, and exhibited in 1906 in the Folkwang-Museum, Essen.[9] In 1896 he had already produced *Kneeling Youth*, and in 1897 *The Boy Carrying Relics*. In these two works he discovered his principal motif – a kneeling youth with his arms crossed on his breast. In *The Well* each of the boys crosses his arms on his breast, enclosing this movement by placing his hands on his shoulders. In isolation each figure would have been enclosed within its own crystalline sphere, but in *The Well* the motif has been repeated five times, in a circle of kneeling boys, each one deviating only slightly from the main motif – in the turn of the head and the placing of the hands. They are linked together in a supple rhythm which creates a movement running from figure to figure, without in any way interrupting the static effect. The actual form-language is abstracted, giving line an entirely new value, not only the closed margin of the outline, but the play of line that abstraction creates.

Minne produced no more pieces in this elevated style. After the

10·2 Barlach: *The Beggar Maid*, bronze, 1907. Here the enclosed form has a deeper relation to the motif. The outline is heavy and firm and the lines of the cloak emphasise the main form and the crouching position. We can also see the search for unity between figure and base.

death of his countryman Constantin Meunier in 1905, however, he approximated to Meunier's style both in form and motif, and in the years 1909–11 he changed his form-language entirely, adopting instead a strong realism. Subsequently his art underwent several stylistic changes. In the work of Meunier himself, who abandoned painting for sculpture when he was fifty, we find only one of the external features of Art Nouveau, the flowing and at times almost veiled form which he occasionally imparts to the surface.

In France Aristide Maillol is probably the only important artist who should be mentioned in this context, even though Gauguin's sporadic preoccupation with sculpture should not be ignored. Gauguin's reliefs are based on the same conception of the surface as his painting. The bold, wavy line provides a highly expressive effect, for example in *Soyez amoureuses, voux serez heureuses*, 1890. Maillol's reliefs from the latter half of the 1890s reveal a great deal of the elusive sense of the two-dimensional that he had developed as a tapestry designer in the early 1890s. His figures take shape without any illusionistic effect, against an abstract background. The style is firm and tends towards the linear, as for example in *La Source* from about 1898. The straight downward sweeping line of the folded draperies parallel to the woman's legs emphasises the rhythm, as well as giving the lines a very definite value. The veiled surface recalls Art Nouveau to a certain extent. In reliefs such as *La Méditerranée*, 1902, and *Le Désir*, 1904, he discovered more or less the form he was to retain for the rest of his life. But his idealising abstraction and classical conception of form took him far beyond what might be called Art Nouveau tendencies in sculpture.

Among sculptors who for a time adopted the form-language of Art Nouveau were Alexander Charpentier and Jean Dampt, both founders of the *Les Cinq* group. Dampt was an enthusiastic student of Nature but considered that stylisation was necessary. Early in the 1890s we find in their work a tendency to a gliding, linear rhythm in the outline, and an inclination to emphasise the intrinsic value of the line, particularly in the relief. Dampt's *Grandmother's Kiss*,

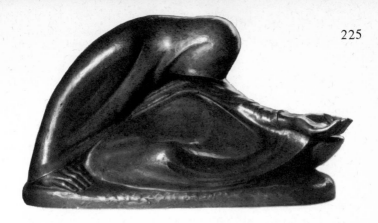

1892, in which the child's head actually protrudes from the mass in an almost repellent manner, reveals how far an artist could go in straining the relationship of the figure to the base. There is, of course, no difficulty in tracing more or less incidental Art Nouveau tendencies in the sculptors of the 1890s, particularly in the curl of a lock of hair or the sweep of a garment. We find it in the work of Eugène Grasset as well as in that of Victor Prouvé, for example in the latter's female head *La Nuit*, 1894.[10] When Louis Pierre Roche or Raoul Larche used Loïe Fuller as their model, in about 1900, the result was unmistakably Art Nouveau. But this was due more to the external sculptural effects than to a plastic solution in accordance with the more profound Art Nouveau sculptural principles, even though Loïe Fuller's celebrated veil and dress were reproduced with all the Art Nouveau rhythm one could possibly imagine. On the whole it would appear that French sculpture committed itself to the Art Nouveau style only by approaching its purely external form-language,[11] as did sculptors like L'Alliot, Blairsy, Godet, Marchand and Mourot-Vauthier, although there is no doubt that research will be able to throw more light on this question.

Germany – Barlach and Obrist

In the German cultural sphere Ernst Barlach is the outstanding figure in sculpture. In the latter half of the 1890s he drew for the periodicals *Simplizissimus* and *Jugend*, and his first sculptures are also from this period. However, it was not until 1902 that he evolved his stylised decoratively-influenced form-language.[12] His

style is at its most full-bodied in the terracotta figure *The Beggar Maid*, about 1907 (figure 10·2). This closed form-language, with the unusually simple outline, was one that Barlach was to cultivate more or less for the remainder of his career, and even though the line often plays a dominant role, with this artist we enter the realms of Expressionism.

The most original contribution to sculpture during the Art Nouveau period was that of Hermann Obrist, with his two designs for a column, one before 1902, probably 1898 and the other from the period 1902–5. The former shows an oblique cone-shaped monument, the principal idea of which is an upward spiral movement. It seems to express a basic and universal idea, Man's eternal striving to reach upwards. It is surmounted by a winged figure, stretching out its arms to help the various figures of the spiral to reach the top. This idea, which in its widest sense represents a human cycle, is also to be found, somewhat later, in the work of Gustav Vigeland, and Munch, too, gave some thought to this motif and actually produced a clay model. He is said to have accused Gustav Vigeland of stealing the idea of the human column from him. Munch also worked at sketches in oils for *The Human Mountain* in 1910. The idea, in fact, of a column as a universal symbol for human effort and aspiration was a motif peculiar to the 1890s. No less interesting was Obrist's second column design, his *Design for an Architectonic Sculpture*, of 1902–5, where a partially completed column rises up from a rough stone block, like an uncompleted piece of sculpture, only partly released from the raw material. The very idea reflects the formal conception in the 1890s of the relationship between statuary and base. With this monument Obrist made an important advance in the direction of abstract sculpture. In his opinion the most important aim was 'to give life to a mass, irrespective of whether this is done with the human form or with other forms'.[13] In the profoundest sense he had managed to depict the tension between formlessness and form – between Nature harnessed and unharnessed.

Obrist's later works, such as *Well for Krupp von Bohlen*, 1913,

reveal some of the boniness familiar to us in his furniture. Here we find a blend of crystalline and structural-symbolical forms, while the artistic poise which he had at the turn of the century seems to have vanished, leaving merely the skeletal construction behind.

Among other German sculptors in touch with the style may be mentioned the animal sculptor August Gaul, and Franz Metzner, best known for his *Mounument for the Battle of the Nation* in Leipzig, 1898–1912. In Hugo Lederer's *Bismarck Monument*, Hamburg, 1901–6, we find a compactly closed form – almost a column-like sculptural effect. In Munich and Darmstadt there were also sculptors who were influenced by the style: Hermann Hahn with his rhythmic form-language and fluent surface treatment, Franz von Stuck and Georg Wrba.

Scandinavia – Vigeland

The Norwegian Gustav Vigeland in his early days worked in the Impressionist style, but in 1893, after a short visit to Paris, we can trace a reaction against Impressionist modelling. In his drawings somewhat later in the 1890s, we find the closed line effect constantly repeated. The form is enclosed in the line of play of a contour, which clearly reveals the new stylistic tendencies, as in *The Oppressed*, 1895, *The Waltz*, 1896, and *The Wave*, 1897–8 (figure 10·3). At the end of the 1890s the surface is smooth and gliding, one shape merging almost caressingly into another, while a film of moisture seems to envelop the figure. The style, in fact, has been called 'veiled'.[14] The relationship to the base is also characteristic,

the figure virtually growing up from the material and fusing with it. In the linearity of contour, in the striving to achieve a closed, sculptural effect, in the grouping of figures, in the surface treatment, and in the relationship between figure and base, Gustav Vigeland is one of the most typical representatives of the new stylistic trends in sculpture in the 1890s. His idea of presenting universal aspects of life in a continuous series of reliefs has its parallel in Munch's *Life Frieze*, which was also conceived in the 1890s. Vigeland, however, continued the development of this basic theme, giving it new form in the bronze tree-groups around *The Fountain*, 1901–14, where Man's relationship to Nature and to Woman is portrayed. The tree is the symbol of Nature, depicted now as a dreamland, now as a forest of love, now as an all-devouring, animal-like creation (figure 3·1a).

Vigeland finally gave the theme monumental form in what he himself called his 'religion' – the 17-metre-high monolith, modelled from 1924–5. This monolith is a column of human figures, with dead bodies at the bottom and living ones farther up, culminating in a child holding out his hands to heaven. Although this column is relatively late, he had been toying with the idea since youth, the first sketches dating from 1909, and it is inspired by the same basic ideas as Obrist's designs from the late 1890s.

In his wrought-iron work Vigeland found a perfect expression for the linear tendencies of the turn of the century. The grillework round the *Nordraak* statue, 1911, reveals his fusion of the *Dragon style* and Art Nouveau. The massive gates at the entrance to the Vigeland Park in Oslo, the largest sculptural one-man show of the twentieth century, also show Art Nouveau tendencies.

The work of the Swede Carl Milles is not such a full-blooded expression of the trends of the 1890s. But in a granite group such as *Sea God*, 1913, can be found relics of the linear form-values of the 1890s. Another Swedish sculptor of the period was Carl Johan Eldh, who was very prolific in a sensual style influenced by Rodin and Meunier. In *Nude*, 1908, and *The Marble Girl*, 1909, the Dane Kai Nielsen shows a conscious search for closed form. The artist

aims to present 'the face enclosed in the compact unity of the mass', and the 'form is retained in the mass by fine, convex curves; each indicates the outline of its own curving shape.'[15] But perhaps the most Art Nouveau minded of them all was the Finnish sculptor Carl Vilhelm Vallgren with his gracious statuettes and small decorative bronzes.

England – Gilbert

The position in England was very different. Edmund Gosse summed it up as follows in 1894:

> The final word about the New Sculpture may be that its vital impulse and the ambition which has led it so far, have been centred in carrying out with careful, sensitive modelling a close and reverent observation of nature.[16]

For many years to come English sculpture was to continue along these lines, and the Art Nouveau-influenced reliefs and sculptures one comes across in *The Studio* and other art periodicals around the turn of the century represent only purely external sculptural aspects of Art Nouveau. The most Art Nouveau-influenced of all English sculptors at the time was Alfred Gilbert. We have already seen (chapters 5 and 6) how, after his studies on the Continent, he had got entangled in Mannerism, and how, at the end of the 1880s and the beginning of the 1890s, he had adopted a decorative form-language that contained a great many of the elements of Art Nouveau. His sculpture – such as the *John Howard Memorial*, Bedford, 1892–3, the *Shaftesbury Memorial Fountain*, 1887–93, the *Memorial to H.R.H. the Duke of Clarence and Avondale*, the *Albert Memorial Chapel* of the Saint George Chapel, Windsor, (first sketch 1892, completed 1928), and the *Memorial Font* to the son of the fourth Marquess of Bath, 1900 – all bear the stamp of a Neo-Baroque conception of form. It is only in details and ornament that he creates new forms. Nor is his interest in Nature that of the Art Nouveau artist, but of the Mannerist. His *Virgin* who has grown into a rose-tree, for the Tomb of H.R.H. the Duke of

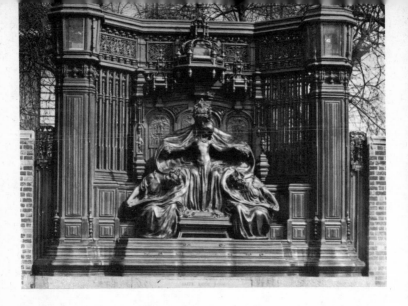

Clarence, 1892, is purely medieval, and has none of the form-language of the 1890s. On the subject of the Art Nouveau style Gilbert is said to have exclaimed: 'L'Art Nouveau forsooth! Absolute nonsense!' In the real sense of the word, then, he is not an Art Nouveau sculptor, but a genuine Neo-Baroque Mannerist, and in jewellery he became the Cellini of his age even before he was forced to leave for Bruges in 1904 in tragic circumstances, bitter, overworked and financially ruined. Nevertheless, much against his will – and rather paradoxically – Gilbert came nearer than anyone to following Art Nouveau tendencies in sculpture in England. The Art Nouveau conception of form that he cherished in his younger days cropped up again in the *Memorial to H.M. Queen Alexandra* at Marlborough Gate, St James's, which he executed as late as 1922 when he was seventy-eight (figure 10·4). This monument can rightly be described as Art Nouveau sculpture, even though the rich framing, reminiscent of Gothic and Mannerism, clearly shows his real stylistic background.

An interesting example of the Mannerist-inspired design of the 1890s is Ernest Lewis's door-knocker, dated '94, which until recently was regarded as dating from 1594![17]

English sculpture, however, remained on the whole aloof from the new sculptural ideas of the 1890s – ideas which were to prove of such significance to the future development of European sculpture.

10·4 Gilbert: *Memorial to H.M. Queen Alexandra*,
Marlborough Gate, London, finished 1922.
Gilbert remained faithful to the sculptural
conception of his youth. In spite of the
traditional elements, the form language of Art
Nouveau was always present in his work.

231

Conclusion

Rodin shook sculpture out of its classical calm, and stripped it of its literary and official pathos, abandoning its empty smoothness, and directing attention to new, optical values in the world of sculpture. The 1890s, in turn, re-established essential sculptural values, but in sculpture even more than in painting, caution must be exercised in attaching the label Art Nouveau. Art Nouveau, after all, is essentially a stylistic term for the applied arts. But inevitably sculpture, too, was influenced by the strong stylistic currents of the age. There was no 'conscious' Art Nouveau school in sculpture, nor would it be possible to say that sculpture made its contribution to the evolution or development of the Art Nouveau style. Nevertheless, the stylistic tendencies and aims familiar to us from Art Nouveau are clearly reflected in the sculpture of the 1890s, and they must have made their contribution to the development of sculpture, particularly to the closed form, the striving for synthesis, the emphasis on the innate value of line, and the predilection for a pliant but clearly defined outline. More superficial and less important is the contribution of Art Nouveau to ornamental sculpture, such as statuettes and *bibelots*. Undoubtedly, too, the stylistic trends of the Art Nouveau movement helped to liberate sculpture not only from Naturalism and Neo-Baroque, but also from Impressionism.

11 Eclipse

The decline of Art Nouveau was swift. The popularity enjoyed by the style in Paris in 1900 evaporated within two years: in Turin in 1902 it was clear to everyone that it had already passed its peak. One by one artists abandoned the style, each altering his form-language and striving towards simplicity, a more practical approach and less emphasis on decoration. In England the reaction developed more rapidly and more sharply than in other countries. 'When we speak in this country of the "New Art",' wrote Lewis Day in 1903, 'it is with an inflection of irony in our voice,' and he continued, 'It shows symptoms not of too exuberant life, but of pronounced disease.'[1] Art Nouveau had little chance of gaining popularity in England, particularly since its linear system was well known from proto-Art Nouveau without finding much response. This system was hardly likely to be of interest in an age when everything had to be 'new'. But the most deep-rooted reason for the reaction is to be found in the development of the English Arts and Crafts, where a sober style had been evolved, based on traditional lines and simple structural principles, partly of a rectilinear nature.

The situation in France was somewhat different. The French felt more or less responsible for creating the style. But Gallé died in 1904 and with him went the inspiration of the Nancy School, which reverted to traditional design. The French, as we have seen, stayed away from the Liège Exhibition in 1905. The first fine careless rapture of Art Nouveau seemed to have been lost. A feeling of tradition re-asserted itself, especially in the direction of Louis XVI and Empire. At the London Exhibition of 1908 Art Nouveau was completely eclipsed, the official French view being that 'the dominant, in fact almost the only, note struck by the French furniture section showed an emphasis on the revival of period styles, especially those of the eighteenth century.'[2]

In Belgium, Horta's youthful aim to create a personal form-language and to cast off the shackles of Historicism had long been achieved and his own efforts had inspired an international style. Soon after the turn of the century he abandoned it himself. Van de Velde left Belgium. Hankar died in 1901, Serrurier-Bovy in 1910.

Wolfers's Art Nouveau style became less floral and plant-like towards the end of the century and after 1905 we find no more Art Nouveau in his work.

In Germany, the leading artists abandoned *Jugendstil* soon after the turn of the century, as the Turin Exhibition in 1902 already indicated. A critic describing German interior decoration at the St Louis Exhibition in 1904 declared that 'the sins of *Jugendstil* had been completely overcome.'[3] As a matter of course, a number of artists belatedly adopted the style, and continued using it up to the First World War; and German commercial excesses in bronze, copper, pewter, and glass were widespread. This popularisation and simplification of the style (which can also be seen in Belgium and France) was instrumental in bringing Art Nouveau into disrepute with the succeeding generation.

It was the generation of 25 to 30 year olds at the end of the 1890s which was to carry the development on in the 1900s. They were in opposition to the stylistic development of the nineteenth century. The theoretical premises were patently at hand and they had the confidence that the new century was theirs. This lively generation could exploit to the full the experiences of their predecessors – their struggles as well as their failures.

In Austria, because Art Nouveau developed there so late, the symbolical, floral, and stalk-abstracted forms used in the rest of Europe were bypassed, and decoration was based on geometrical figures. This form-language fitted in naturally with the new tendencies towards emphasis on construction and harmony of form and material. The geometrical stylisation, the additive ornamental principles, the reaction against ornament, and finally lack of interest both in structural symbolism and in the growing and bursting force of Art Nouveau, explain why Austria gave up the style so quickly. The road Austrian artists chose led them – as far as applied art and architecture are concerned – to quite new stylistic ideals. Through the *Wiener Werkstätte* and the new movement which developed there, they found their way directly to the Modern Movement.

Why did Art Nouveau disappear?

Art Nouveau failed to fulfil the general European desire for a lasting international style. But why did Art Nouveau break up and vanish after so short a time?

There are many reasons: the theory of art and architecture quickly developed beyond the Art Nouveau stage because Art Nouveau offered no solution to the problem of how to relate the machine to aesthetic norms; Art Nouveau theories were, in fact, based on the artist, and on a purely individual artistic approach to the artefact. It was perfectly natural for society in the nineteenth century to turn to the artist to solve the form-problems posed by machines and to insist on beauty of form; yet pictorial artists had no special aptitude for designing everyday objects nor of coping with the problems posed by machines. Only Bauhaus could offer a solution. Art Nouveau was largely an 'artist's style', and did not satisfy the demand for simple design suitable for mass production.

The new ideals, with their insistence on the special nature of materials, were also completely ignored by Art Nouveau artists. Their aim was to fuse all formal elements in a decorative whole, without regard to material, whether this were stone, metal or wood. Furthermore, the functionalist idea of honesty of construction never really penetrated Art Nouveau. The constructive idea was interesting enough, but it was not an end in itself: the construction, moreover, was not to be freely exposed but incorporated into the decorative system. Art Nouveau was first and last a style which depended on ornament.

People were certainly tired of Historicism's variety of ornament. But the Art Nouveau artists did not abandon it, they created a new world of ornament instead. The younger architects and engineers, however, regarded such disguises and embellishments with disapproval; ornament was ruthlessly scrapped and the Art Nouveau style lumped among the other excesses of the nineteenth century. Once the style appeared fully developed in 1892–3, it spread at a tremendous rate, receiving enormous publicity in all periodicals, at

times even seeming to be a fashion rather than a style – a view supported by its superficial and purely external decorative aspects. Most people failed to grasp either its deeper significance or the earnest desire for stylistic expression that had brought it about.

So much might have been expected: a new century was about to be born, and there was a desire to launch it with a new style. But the elegant and sophisticated costumes offered by Paris and Brussels were no practical everyday garments. The greater the disappointment, the quicker the rejection: this rule was true of Art Nouveau, and if we consider it against the background of commercial design produced by second- and third-rate artists, which followed in the wake of the genuinely artistic, it will be easier to understand what actually happened.

Art Nouveau never became as universal as had been hoped and expected: few styles have acquired such an essentially individual and national expression. Furthermore, many designers tended to look back to the past in order to discover what to avoid, rather than to look forward to discover what was needed.

The inability of Art Nouveau to appreciate the formal potentialities of the machine and the machine product is also bound up with its relation to social problems. Art Nouveau failed to provide the solution of form-problems on the broad social basis which several of the radical artists had hoped to find. The Art Nouveau style never became a style for the masses, but remained an 'artist's' style for the select few. In its sophisticated form it could never hope to solve social problems – it remained a style for the rich catering only for the needs of the upper classes. To a large extent it was a jewellery style, a *de luxe* furniture style, a style for connoisseurs of glassware and elegant textiles.

At the same time as Symbolism in art perished, the symbolical aspect of Art Nouveau also lost its significance. Furthermore, in so far as Art Nouveau was an anti-movement, a reaction against what had gone before, it ceased to have any meaning once the stylistic chaos of the nineteenth century had been tidied up. Sufficient force and indignation were there to make a clean break with the

past, but not sufficient to build for the future. Inevitably, as had happened so many times previously in the stylistic history of Europe, there followed a return to the familiar norms of a classical form-language.

The achievement of Art Nouveau

What, then, were the achievements of Art Nouveau, and what place has it secured in the history of Art?

Out of the questing, struggling movement that went on in all the countries of Europe in the last quarter of the nineteenth century there gradually arose an independent style. It had roots deep in the nineteenth century, and its formal predecessors can be traced to several countries in the course of the 1870s and 1880s; but not until the beginning of the 1890s did it emerge as a fully developed style. It flourished in the latter half of the 1890s, reaching its apogee in about 1900, after which rapid decline followed although it lingered on in a Continental version right up to the first World War.

Art Nouveau prepared the ground for modern developments in architecture and all the various branches of applied art. In fact in the sphere of applied art it was an entirely new departure. Interest was focussed on purely aesthetic values, instead of on antiquarianism which had been dominant in the latter half of the nineteenth century. This change was due in part to the reforming zeal which to some extent provided the background for the movement. The style was thus partly an anti-movement, reacting against Historicism as a phenomenon in itself and also against its formalistic conception. Formal qualities were cultivated in a way which entailed a complete revaluation of the attitude to interior decoration and to applied art as a whole. Several minor arts were completely rejuvenated, and the value of this contribution cannot be overestimated, since its influence is still apparent.

But not only was stylistic pastiche ended. Designers tackled their problems at the roots, thus preparing the ground for further development. Every sector of the applied arts was infused with new

life and enjoyed a period of glorious fruition, whose full significance, as far as quality is concerned, will be recognised in the historical development.

The picturesque lack of planning in 'historically minded' interior decoration yielded to well-planned spacious decoration. All elements became part of a whole, as in the unified space conceptions of the Rococo, which had been lost since the early days of the Victorian period. A feeling for unity in interior decoration was thus established. An entirely new, refined colour scheme was developed, based on olive-green, cream, greyish-pink, pale violet and milky white: in short, light replaced darkness.

In architecture the Art Nouveau style occupies an important position, but its historical significance is more limited, both chronologically and with regard to the actual number of major works executed. The few works that exist, however, richly deserve their place in the history of architecture. The importance attached to plastic values in architecture may perhaps be seen as one of the factors which have contributed most to modern architecture, and Corbusier's preoccupation with sculptural forms (for example in *Notre Dame du Haut*, Ronchamp, 1949–54) may well reflect this feature. No less important was the Art Nouveau architects' discovery, and cult, of architectural structure and its potentialities as an artistic means of expression.

Where Art Nouveau sculpture is concerned, there were marked stylistic features in various countries which can only be explained on the basis of an Art Nouveau conception of form. Many sculptural problems of form are probably in their essence far removed from the linear effects of Art Nouveau, but the emphasis on the closed contour and the firm sculptural delimitation which were prominent around the turn of the century can only be explained in terms of Art Nouveau. It is not the running or extended figure that is cultivated, but the kneeling, sitting, bent, or hunched form. In a wider sense the Art Nouveau style helped to re-establish such basic sculptural qualities as stability, rhythm and monumentality.

In painting, we have seen how Art Nouveau, by exploiting the

innate value of line and its suggestive power, emphasised the *Stimmung* (mood) of the content, thus foreshadowing Expressionism. No less important was the influence that it imparted to painting by underlining the value of the ornamental for its own sake. Shapes and colours, lines and surfaces, were imbued with a significance independent of the content, merely by virtue of their decorative effect. These tendencies can be traced from the Glasgow School to the Vienna Secession. When the first non-figurative painters, such as Kandinsky in his first water-colours, worked with non-figurative problems, one is tempted to see in their work a continuation of the experiments and experience garnered under the aegis of Art Nouveau. The Art Nouveau style may also have assisted in sponsoring Surrealism: an artist such as Salvador Dali thought a great deal about the style, and if we consider some of Gaudí's decorative fantasies we shall see that they were not very far removed from Surrealism. The importance of Art Nouveau, however, in both non-figurative painting and Surrealism, has not yet been sufficiently investigated, though this undoubtedly offers a fascinating field of research.

Even though the Art Nouveau style in architecture and painting points the way to the twentieth century, this is not where it belongs. Nor does it belong to the nineteenth century. Art Nouveau is an independent transitional phenomenon, a separate style which had deep roots in the nineteenth century as far as theory of art, art history, and the history of style are concerned, but whose entire aim was to shake off its stylistic heritage and create something completely new. Just as certainly as it had its roots in Historicism, so Art Nouveau foreshadowed the Modern Movement. In many respects, it led the way into the twentieth century, clearing the ground and preparing for the artistic development we have all experienced.

Not only because of its historical importance, however, but also because of its artistic qualities, the style has every claim to a special place in the history of art – but more especially in the history of style and in the history of applied art.

Notes

1 Introduction
1 Salvador Dali, 'De la beauté terrifiante et comestible de l'architecture Modern Style', *Minotaure*, Paris, 1933, No. 3–4, pp. 69–76.

2 The style defined
1 Émile Gallé, 'Le décor symbolique' (Lecture delivered 17 May 1900 at l'Académie de Stanislas, Nancy), *Écrits pour l'Art*, Paris, 1908. p. 219.
2 Information kindly given to the author by Madame Perdrizet-Gallé, April 1953.
3 Hans Curjel, 'Neue Perspektiven', *Baukunst und Werkform*, 1952, No. 9, p. 18.
4 This part of the chapter is based mainly upon the author's research, published in *Sources of Art Nouveau*, Oslo/New York, 1956, pp. 75–83, where detailed references to the quotations may be found.

3 The ideological background
1 Quotation from the Norwegian feminist Aasta Hansteen's article 'Tidens Tegn' (Token of the Time), *Nyt Tidsskrift*, Christiania (Oslo), 1894, p. 675.
2 The author is indebted to Mr. Edward Lockspeiser. See the chapter 'The Orient and the Art Nouveau', in *Debussy, His Life and Mind*, vol. I–II, London 1962–5, vol. I, pp. 113–21.
3 J. Meier-Graefe, *Entwicklungsgeschichte der Modernen Kunst*,' I–III, Stuttgart, 1904–5, vol. II, p. 621.
4 Christopher Dresser, 'Principles in Design', part III, *The Technical Educator*, London, vol. I, 1870, p. 121.
5 Quotation from James McNeil Whistler, *Mr Whistler's Ten o'Clock*, London, 1888, p. 16 (lecture delivered 1885).
6 S. Tschudi Madsen, *Sources of Art Nouveau*, Oslo, New York, 1956, p. 435.
7 See Hilton Kramer, 'The Erotic Style: Reflections on the Exhibition of Art Nouveau', *Arts*, New York, 1960, vol. XXXIV, pp. 22–6.
8 Hans Hofstätter, *Geschichte der europäischen Jugendstilmalerei*, Cologne, 1963, p. 43.
9 See H. Jackson, 'The Discovery of the Celt', *The Eighteen-Nineties*, London, 1913, pp. 178–89.

4 Art theory of the time

1 J.W. Mackail, *William Morris and his Circle*, Oxford, 1907, p. 12.

2 Printed in German in *Pan*, vol. V, Berlin, 1899.

3 See Henry Nocq, *Tendances nouvelles, enquête sur l'évolution des industries d'art*, Paris, 1896, pp. 67–99. First published in *Journal des Artistes*, September 1894.

4 Quotation from the lecture 'The Art of the People', 1879, in *Hopes and Fears for Art*, London, 1882, p. 58.

5 'Our Arts and Industries', *Art and Handicraft*, London 1893, pp. 114–49.

6 C.R.Ashbee, *Should We Stop Teaching Art?* London, 1911, p. 2.

7 F.L.Wright, 'The Art and Craft of the Machine', The Hull House Lecture, delivered 1901; *F.L.Wright on Architecture, Selected Writings 1894–1940*, New York, 1941, p. 24.

8 Published twelve years later in *Kunstgewerblichen Laien-Predigten*, Leipzig, 1902, pp. 35–6.

9 E.Grasset, *Méthode de composition ornementale*, Paris, 1905, vol. 1, p. 21.

10 T.Howarth, *Charles Rennie Mackintosh and the Modern Movement*, London, 1952, p. 282.

11 Louis Sullivan, *Kindergarten Chats and other Writings*, New York, 1947, p. 187.

12 For following chapters and detailed references to quotations, see also 'The Cult of Plant and Line', S.Tschudi Madsen, *op. cit.*, pp. 164–87.

13 Owen Jones, *On the True and the False in the Decorative Arts*, London, 1863, vol. I, p. 46.

14 E.Grasset, *op. cit.*, vol. II, p. 7.

15 H. van de Velde, 'Prinzipielle Erklärungen', *Kunstgewerblichen Laien-Predigten*, Leipzig, 1902.

16 L.Sullivan, *Kindergarten Chats and other Writings*, New York, 1947, p. 189 (first published in *The Engineering Magazine*, 1892).

17 In *Renaissance im Kunstgewerbe*, Neue Ausgabe, Leipzig, 1901, p. 74 he gives the impression that the book is written in 1889. This, however, is doubtful. (See also *ibid.*, p. 65.)

18 H. van de Velde, *ibid.*, p. 102 ff. See also his article 'Ein Kapitel über Entwurf und Bau moderner Möbel', *Pan*, vol. III, 1897, pp. 260–4.

19 Statement given by Jessie Newbery in 1898; see Gleeson White, 'Some Glasgow Designers', Part III, *The Studio*, London, 1898, vol. XII, p. 48.

5 Trends leading up to Art Nouveau

1 See Clay Lancaster, 'Oriental Contribution to Art Nouveau', *The Art Bulletin*, New York, vol. XXXIV, 1952, p. 302.

2 Information kindly given to the author by Auguste Vallin.

3 E. de Vogue, *Remarques sur l'Exposition de 1889*, Paris, 1889.

4 Clay Lancaster, *loc. cit.*, pp. 304 sq.

5 *Dekorative Kunst*, No. 7, vol. I, 1898, pp. 14 sq.

6 N. Pevsner, *High Victorian Design*, London, 1951; K. Scheffler, *Das Phänomen der Kunst. Grundsätzliche Betrachtungen zum 19. Jahrhundert*, Munich, 1952; *Idem, Verwandlungen des Barocks in der Kunst des Neunzehnten Jahrhunderts*, Vienna, 1947; M. Zweig, *Zweites Rokokko*, Vienna, 1924.

7 H. van de Velde, *Renaissance im Kunstgewerbe*, Berlin, 1901, p. 72.

8 H. Nocq, *Tendances nouvelles*, Paris, 1896, p. 14.

9 Quoted by Gaudí's admirer, Marius-Ary Leblond, in J. J. Sweeney, 'Antonio Gaudí', *The Magazine of Art*, New York, May 1953, pp. 195–205.

10 John D. Sedding, 'Our Art and Industries', *Art and Handicraft*, London, 1893, p. 142.

11 For this and the following section and for detailed references, see also 'Historicism' in S. Tschudi Madsen, *op. cit.*, 1956, pp. 84–129.

12 See note 11.

13 Among the great examples of this style are, significantly, Garnier's *Opéra de Paris*, 1861–75, his *Théatre* and *Casino de Monte Carlo*, 1878, Charles Girault's *Arc de Triomphe* in Parc du Cinquantenaire, Brussels, 1905, and his *Petit Palais*, Paris, 1897–1900 – if this building should not rather be called Neo-Rococo (see André Chastel and Jean-Jacques Gloton, 'L'Architecture en France autour de 1900', *L'Information d'histoire de l'art*, Paris, 1958, vol. III, No. 5, pp. 128–41 (p. 135)).

14 H. O'Neill, *The Fine Arts and Civilisation of Ancient Ireland*, London, 1863, p. 49.

15 For this part and for detailed references, see also the chapter 'Arts and Crafts Movement' in S. Tschudi Madsen, *op. cit.*, pp. 139–47.

6 Early Art Nouveau

1 Walter Crane, 'Of Wall Paper', *Arts and Crafts. Essays*, London, 1893, pp. 52–62.

2 Christopher Dresser, 'Principles in Design', Part III, *Technical Educator*, London, vol. I, 1870, p. 121.

3 Illustrated in *The Studio*, vol. XVI, p. 186, now in the William Morris Gallery, Walthamstow.

4 Illustrated in S. Tschudi Madsen, *op. cit.*, p. 160, fig. 88.

5 Nikolaus Pevsner was the first to draw attention to Mackmurdo, stressing his importance in an article, 'A Pioneer Designer, Arthur H. Mackmurdo', *The Architectural Review*, London, vol. LXXXIII, 1938, pp. 141–3. See also archives and files in the William Morris Gallery.

6 J. Hatton, 'Alfred Gilbert, RA', The Easter Art Annual, *The Art Journal*, London, 1903, pp. 1–32. (47 illustrations of his early works).

7 The term proto-Art Nouveau was first used by the author in *Sources of Art Nouveau*, 1956, as a name for early English tendencies in the arts and crafts, which foreshadowed the Continental movement. In his book *Art Nouveau – Jugendstil*, 1962, however, Robert Schmutzler uses the same term for style tendencies in European painting around 1800.

8 Illustrated in S. Tschudi Madsen, *op. cit.*, p. 176, figure 94.

9 Information kindly given to the author by Miss Y. Hankar, April 1953.

10 Illustrated in Henry-Russell Hitchcock, *Gaudí*, New York, 1957, figs 1–2.

11 Cf. the richly illustrated book by A. Cirici-Pellicer, *El arte modernista catalán*, Barcelona, 1951.

12 Illustrated in Robert Schmutzler, *Art Nouveau – Jugendstil*, Stuttgart, 1962, figure 236.

13 First published in *The Engineering Magazine*, August 1892; quotation from Louis Sullivan, *Kindergarten Chats and other Writings*, New York, 1947, p. 190.

14 Published as *Ornements typographiques. Lettres ornées, têtes de page et fins de chapitres*, Paris *s.a.* (about 1895).

15 All illustrated in Ernest Maindron, *Les affiches illustrées 1886–1895*, Paris, 1896, pp. 56, 64, 166, 157.

16 In 1869 he made a composition for a wallpaper in Egyptian style, where the linear rhythm, however, reminds one very much of his Art Nouveau-like drawings. Illustration in *Revue des Arts Décoratifs*, Paris, vol. XVII, 1897, p. 184. He also made designs for wrought-iron (see illustration in an article devoted to him in a special number of *La Plume*, 1894).

17 Walter Crane admits to being influenced from Japanese prints as early as 1865. However, none of Grasset's posters before 1880 have been preserved according to Robert Koch, 'The Poster Movement and Art Nouveau', *Gazette des Beaux-Arts*, vol. L, 1957, p. 289.

18 Robert Koch, *loc. cit.*, p. 287.

19 Robert J. Goldwater, 'L'Affiche Moderne, A Revival of Poster Art after 1880', *Gazette des Beaux-Arts*, vol. XXII, 1941, p. 177.

20 Robert Koch, 'Artistic Books, Periodicals and Posters of the "Gay Nineties" ', *The Art Quarterly*, 1962, vol. XXV, No. 4, p. 373, figure 4.

21 Eleanor N. Garvey, 'Art Nouveau and the French Book of the Eighteen-Nineties', *Harvard Library Bulletin*, 1958, vol. XII, p. 381.

22 Maurice Denis, *Théories 1890–1910*, Paris 1920, p. 11.

7 Art Nouveau in architecture

1 Information kindly given to the author by the present owner of the firm, Monsieur Jean Schwarzenberg. For the English influence, see also Octave Maus, *Trente années de lutte pour l'Art 1884–1914*, Brussels, 1926, and H. Liebaers, 'William Morris in Vlaanderen', *De Vlaamsche Gids*, Brussels, 1946, pp. 592–7.

2 *L'Émulation*, Brussels, vol. XVIII, 1893, cols. 168–70.

3 Henry-Russell Hitchcock, *Architecture: Nineteenth and Twentieth Century*, London, 1958, p. 287; see also p. 450 with reference to Miss Elizabeth Aslin.

4 Illustrated in S. Tschudi Madsen, 'Horta. The Works and Style of Victor Horta before 1900', *The Architectural Review*, London, vol. CXVII, 1955, p. 388–92.

5 Octave Maus mentions that the house was under construction in 1892. O. Maus, 'Habitations Modernes', *L'Art Moderne*, Brussels, vol. XX, 1900, pp. 221–3.

6 For illustrations of interiors, see S. Tschudi Madsen, *Sources of Art Nouveau*, Oslo/New York, 1956, pp. 228, 249, 437 and Hitchcock *op. cit.* pl. 130.

7 Letter from architect J.J. Eggericx to the author, 4 April 1953.

8 E. Kaufmann, '224 Avenue Louise', *Interiors*, vol. CXVI, 1957, pp. 88–93.

9 Illustrated in Henry-Russell Hitchcock, 'Art Nouveau Architecture', P. Selz, *Art Nouveau*, New York, 1959, p. 126.

10 Charles de Mayer, *Paul Hankar*, Brussels, 1963, p. 8.

11 Information kindly given by Miss Yvonne Hankar to the author, April 1953.

12 Illustrated in *The Studio*, London, vol. VIII, 1896, p. 178 and in Ch. de Mayer, *op. cit.*

13 Illustrated in Ch. de Mayer, *op. cit.* Date kindly given to the author by Miss Yvonne Hankar.

14 Illustrated in S. Tschudi Madsen, *op. cit.*, 1956, p. 111.

15 Other buildings in Gothic inspired Art Nouveau in Nancy: *Maison Bichaton*, 1902, *Maison Lejeune*, 1902, *Maison Lombard*, 1903.

16 James Grady, 'Nature and the Art Nouveau', *The Art Bulletin*, 1955, vol. XXXVII, No. 3, p. 189. For good illustrations on Gaudí see Henry-Russell Hitchcock, *Gaudí*, New York, 1957.

17 Robert Schmutzler, *Art Nouveau-Jugendstil*, Stuttgart, 1962, p. 224.

18 John Malton, 'Art Nouveau in Essex', *The Architectural Review*, London, vol. CXXVI, 1959, p. 101.

19 For further information concerning the British influence see 'The British Influence', S. Tschudi Madsen, *op. cit.*, pp. 303–8.

20 Nikolaus Pevsner, *Pioneers of Modern Design*, New York, 1949, p. 118.

21 L. Gans and R. Blijstra have made a list of nearly 350 Art Nouveau buildings in Holland, as in *Forum*, Amsterdam, 1958. No. 10, pp. 330–2.

22 Carrol L.V. Meeks, 'The Real *Liberty* of Italy, the *Stile Floreale*', *The Art Bulletin*, 1961, vol. XLIII, p. 113. This is a very thorough study of the Italian architecture of the time.

8 Art Nouveau in applied art

1 For further information on Samuel Bing, see Samuel Bing, 'L'Art Nouveau', *The Architectural Record*, vol. XII, 1902, pp. 281–5, and Robert Koch, 'Art Nouveau Bing', *Gazette des Beaux-Arts*, Paris, New York, vol. LIII, January 1959, pp. 179–90.

2 H. Guimard, 'An Architect's Opinion of "l'Art Nouveau"', *The Architectural Record*, vol. XII, 1902, pp. 127–33.

3 Gabriel Mourey, 'The House of Art Nouveau Bing', *The Studio*, London, vol. XX, 1900, pp. 164–80.

4 Ada Polak, *Modern Glass*, London, 1962, p. 24.

5 This classification is made by Ada Polak, *ibid.*, pp. 28–9. See also her article, 'Gallé Glass: Luxurious, Cheap and Imitated', *Journal of Glass Studies*, New York, vol. V, 1963, pp. 105–15.

6 The discussion on the minor artists from *L'École de Nancy*, mainly from S. Tschudi Madsen, *op. cit.*, pp. 348–57.

7 Helmut Seling 'Silber und Schmuck', *Jugendstil. Der Weg ins 20. Jahrhundert*, Heidelberg-München, 1959, p. 349. (See pp. 341–54). An informative article is also: Karel Citroen, 'Zierat der Jahrhundertwende', *Kunst in Hessen und am Mittelrhein*, No. 5, 1966, pp. 39–69.

8 H. van de Velde, 'Gustave Serrurier-Bovy', *Zeitschrift für Innendekoration*, Darm., vol. XIII, 1902, p. 50.

9 *Zeitschrift für Innendekoration*, Darm., vol. XI, 1900, No. 1.

10 H. van de Velde, *Renaissance im Kunstgewerbe*, Berlin, 1901, Neue Ausgabe, p. 63.

11 Two last quotations from M. Joyaut, *Henri de Toulouse-Lautrec 1864–1901*, vol. I–II, Paris 1926, vol. I, p. 167, p. 168.

12 Discussion on Philippe Wolfers based on S. Tschudi Madsen, *op. cit.*, pp. 336–42.

13 *The Times* (London), 15 April 1901. More detailed account of the event in S. Tschudi Madsen, *op. cit.*, p. 300.

14 Elizabeth Aslin, *19th Century English Furniture*, London, 1962, p. 78.

15 J. Meier-Graefe, *Entwicklungsgeschichte der modernen Kunst*, I–III, Stuttgart 1904–5, vol. II, p. 620.

16 G. White, 'Some Glasgow Designers, Part III', *The Studio*, London, vol. XII, 1898, p. 48.

17 Barbara Morris, *Victorian Embroidery*, London, 1962, p. 147.

18 P. Hankar, 'Exposition d'Art Appliqué, Mai 1895', *L'Émulation*, Brussels, vol. XX, 1895, col. 65–9.

19 Shirley Bury, 'The Liberty Metalwork Venture', *Architectural Review*, London, vol. CXXXIII, 1963, pp. 108–11.

20 See Graham Hughes, *Modern Jewellery*, London, 1964, p. 113, No. 196.

21 Catalogue No. M.10–1943. Victoria and Albert Museum.

22 For Neatby, see also Aymer Vallance, 'Mr W. J. Neatby and His Work', *The Studio*, London, 1903, vol. XXIX, pp. 113–17; P. G. Konody-London, 'Keramischer Wandschmuck und dekorierte Möbel von W. J. Neatby', *Kunst und Kunsthandwerk*, Vienna, 1903, vol. VI, pp. 362–74.

23 Shirley Bury, *loc. cit.*, p. 108.

24 L. Gmelin, *Deutsche Kungstgewerbe zur Zeit der Weltausstellung in Chicago 1893*, Munich 1893, pp. 26 sq.

25 Richard Graul, *Die Krisis im Kunstgewerbe*, Leipzig, 1901, p. 41.

26 Georg Fuchs, 'Hermann Obrist', *Pan*, Berlin, vol. II, 1895–6, p. 324.

27 L. Gmelin, *op. cit.*, pp. 26 sq.

28 The living room and dining room illustrated respectively in W. Rehme, *Architektur der neuen freien Schule*, Leipzig, 1902, pl. 77, and in *Deutsche Kunst und Dekoration*, Darmstadt, vol. XIV, 1903, p. 6.

29 F. Schmalenbach, *Jugendstil. Ein Beitrag zur Theorie und Geschichte der*

Flächenkunst, Würzburg, 1935, p. 74.

30 Letter from Josef Hoffmann to the author, September 1954.

31 O. Wagner, 'Die Kunst der Gegenwart', *Ver Sacrum*, Vienna, vol. III, 1900, pp. 21–3.

32 Illustrated in *Ver Sacrum*, Vienna, vol. I, 1898, p. 7.

33 Klaus Jürgen Sembach, 'Möbel', in Helmut Seling, *Jugendstil. Der Weg ins Zwanzigste Jahrhundert*, München, 1959, p. 84.

34 L.Gans, *Nieuwe Kunst, De nederlandse Bijdrage tot de Art Nouveau*. Utrecht 1960. And for the recent research on Dutch Art Nouveau see: *Nieuwe Kunst rond 1900*, Haags Gemeentemuseum. (Catalogue). The Hague, 1960; R.Blijstra, 'Een onderschatte stroming in de architectur', *Forum*, Amsterdam, No. 10, 1958, pp. 304–13; L.Gans, 'Nieuwe Kunst, De Herleving van de Nederlandse Kunstnijverheid', *ibid.*, pp. 314–23; D. Dooijes, 'De Nederlandse typografie en de "Jugendstil" ', *ibid.*, pp. 324–9; K.A. Citroen, 'Renaissance in edel metaal', *Forum*, Amsterdam, No. 11, pp. 339–44; Bettina H. Spaanstra-Polak, 'Jugendstil in de Nederlandse schilderkunst en grafiek', *ibid.*, pp. 345–57.

35 L. Gans, *op. cit.*, p. 129.

36 Herwin Schaefer, 'Tiffany's Fame in Europe', *The Art Bulletin*, New York, vol. XLIV, No. 4, December 1962, pp. 309–28.

37 H. Schaefer, *op.cit.*, p. 328.

38 Elizabet Stavenow-Hidemark, *Svensk Jugend*, Nordiska Museet, Stockholm, 1964.

39 S. Tschudi Madsen, 'Dragestilen. Honnör til en hånet stil'. *Vestlandske Kunstindustrimuseums Årbok 1949–50*, Bergen, 1952, pp. 19–62.

40 *Idem*, 'Uedle metaller i edlere form', *Nordenfjeldske Kunstindustrimuseums Årbok 1957*, Trondheim, 1958, pp. 8–84.

9 Art Nouveau tendencies in painting

1 F. Schmalenbach, 'Jugendstil in der Malerei', *Jugendstil Ein Beitrag zur Theorie und Geschichte der Flächenkunst*, Würzburg, 1935, pp. 138–48 (p. 138).

2 Ernst Michalski, 'Die Entwicklungsgeschichtliche Bedeutung des Jugendstils', *Repertorium für Kunstwissenschaft*, vol. XLVI, Berlin, 1925, pp. 133–49.

3 J. Rewald, *Georges Seurat*, New York, 1948, p. 55.

4 C.Chassé, *Gauguin et le groupe de Pont-Aven*, Paris, 1921.

5 Collection Jean Claude Coulon, Paris. Illustrated in Agnes Humbert, *Les Nabis et leur époque 1888–1900*, Geneva, 1954, pl. 10.

6 Hans H. Hofstätter, *Geschichte der europäischen Jugendstilmalerei*, Cologne, 1963, p. 82.

7 O. Maus, *Trente années de lutte pour l'art 1884–1914*, Brussels, 1926, p. 134.

8 Quotation from R.Schmutzler, *Art Nouveau-Jugendstil*, Stuttgart, 1962, p. 125, note 128. (Jan Verkade: *Le tourment de Dieu*, Paris, 1923, p. 94.)

9 Herbert Read, 'Edvard Munch', *Oslo Kommunes Kunstsamlinger*

Yearbook 1963. Edvard Munch 100 år, Oslo, 1963, p. 130.

10 Edvard Munch, Preface to the *Edvard Munch Exhibition*, Blomquist 1929, Oslo, 1929, with quotations from his diary from St Cloud, 1889.

11 *Idem*, Preface to the *Edvard Munch Exhibition*, *Livsfrisen*, Blomquist 1918, Oslo, 1918.

10 Art Nouveau tendencies in sculpture

1 For a more detailed form analysis, see Arne Brenna, *Form og komposisjon i nordisk granittskulptur 1909–26*, Oslo, 1953, pp. 206 sq.

2 M.H.Spielmann, *British Sculpture and Sculptors of Today*, London, Paris and New York, 1901, pp. 2 sq.

3 Adolf Hildebrand, *Das Problem der Form in der bildenden Kunst*, 3rd ed. in French: *Le problème de la forme*, Leipzig, 1903, p. 94.

4 Letter from Gustav Vigeland to Sophus Larpent 31/5 1896, University Library, Oslo, letter No. 192.

5 Letter from Gustav Vigeland to Sophus Larpent 7/9 1901, Vigeland-Museet, Oslo, letter No. 133. Gustav Vigeland, *Om Kunst og Kunstnere*, by Ragna Stang, Oslo, 1955, p. 127.

6 Letter from Gustav Vigeland to Sophus Larpent 14/7 1896, University Library, Oslo, letter No. 192.

7 Arne Brenna, *op. cit.*, 'Granitten', pp. 19–22.

8 Theodor Lipps, *Aesthetik. Psychologi des Schönen und der Kunst*, vol. I–II, Leipzig, 1923 (first ed. 1903), vol. II, p. 153.

9 Replicas in the Vienna Museum and in the open in Brussels and Ghent.

10 Illustrated in J. Cassou, E. Langui, N. Pevsner, *The Sources of Modern Art*, London and New York, 1962, figure 253.

11 Berthold C. Hackelsberger, 'Plastik' in Helmut Seling, *Jugendstil. Der Weg ins 20. Jahrhundert*, Munich, 1959, pp. 279–305 (p. 289).

12 E.g. the plaquette for Justus Brinckmann, 1902, and the well (Wandbrunnen), 1904, both in Helmut Seling, *op. cit.*, figures 13, 238.

13 Quotation from B.C. Hackelsberger, *loc. cit.*, p. 301.

14 Arne Brenna, S. Tschudi Madsen, *Gustav Vigelands Fontenerelieffer*, Oslo, 1953, pp. 45–52.

15 Quotations from Arne Brenna, *op. cit.*, p. 50.

16 E. Gosse, 'The New Sculpture 1879–94', *The Art Journal*, London, 1894, p. 311.

17 Jennifer Montagu, *Bronzes*, London and New York, 1963, pp. 122–3.

11 Eclipse

1 Lewis Day, *Moot Points*, London, 1903, pp. 82 sq.

2 *Exposition franco-britannique de Londres 1908*, vols, I–II, Paris, 1908, vol. I, p. 245.

3 J.A. Lux, *Die Geschichte des modernen Kunstgewerbes in Deutschland*, Leipzig, 1908, pp. 209 sq.

Bibliography

The most important books on the period have been discussed in the Introduction. The following four books are also worth consulting: H.R. Rookmaker, *Synthetist Art Theories*, Amsterdam, 1959; Edv. R. de Zurko, *Origins of Functionalist Theory*, New York, 1957; Jean Roman, *Paris: fin-de-siècle*, Paris, 1958; Alf Böe, *From Gothic Revival to Functional Form*, Oslo, 1957.

A great many specialist articles and monographs on different aspects of the subject are referred to in the Notes.

Art Nouveau artists were particularly interested in theory. The following is a selected but it is hoped reasonably comprehensive list of their theoretical writings:

Charles R. Ashbee: *A Few Chapters on Workshop Reconstruction and Citizenship*, London, 1894. *An Endeavour Towards the Teaching of John Ruskin and William Morris*, London 1901.

Peter Behrens: *Feste des Lebens und der Kunst*, Jena, 1900.

H.P. Berlage: *Gedanken über den Stil in der Baukunst*, Leipzig, 1905.

Walter Crane: *The Claims of Decorative Art*, London, 1892. *Line and Form*, London, 1900.

Hans Christiansen: *Neue Flachornamente auf Grund von Naturformen*, 1889.

Lewis F. Day: *Everyday Art: Short Essays on the Arts Not-Fine*, London, 1882. *Some Principles of Everyday Art*, London, 1890.

Maurice Denis: *Théories 1890–1910*, Paris, 1920.

Christopher Dresser: *The Art of Decorative Design*, London, 1862. *Modern Ornamentation*, London, 1886. *Principles of Decorative Design*, London, 1880. *Studies in Design*, London, 1876.

August Endell: *Um die Schönheit*, Munich, 1896. 'Formen Schönheit und dekorative Kunst', *Dekorative Kunst*, vol. II, 1898, pp. 119–25. 'Möglichkeiten und Ziele einer neuen Architektur', *Deutsche Kunst und Dekoration*, vol. I, 1897–8, pp. 141–53.

Émile Gallé: *Écrits pour l'art, 1884–9*, Paris, 1908. *Le décor symbolique*, Discours de réception, Nancy, 1900.

Eugène Grasset: *La plante et ses applications ornementales*, Paris, 1899. *Méthode de composition ornementale*, Paris, 1905.

Hector Guimard: 'An Architect's Opinion of "L'Art Nouveau", ' *The Architectural Record*, New York, vol. XII, 1902, pp. 127–33.

Josef Hoffman: 'Einfache Möbel', *Das Interieur*, Vienna, vol. II, 1901, pp. 193–208.

Victor Horta: *Considération sur l'art moderne*, Brussels, 1925.

Owen Jones: *The Grammar of Ornament*, London, 1856. *The True and the False in the Decorative Arts*, London, 1863.

Adolf Loos: *Ins Leere gesprochen, 1897–1900*, Berlin, 1925. *Trotzdem, 1900–30*, Innsbruck, 1931.

Charles Rennie Mackintosh: Manuscripts, Print Room, Art Department, University of Glasgow.

Arthur Mackmurdo: *History of the Arts and Crafts Movement*, (ms. in private possession).

William Morris: *The Collected Works of William Morris*, London, 1910–15.

Henri Nocq: *Tendances nouvelles. Enquête sur l'évolution des industries d'art*, Paris, 1896.

Hermann Obrist: *Neue Möglichkeiten in der bildenden Kunst (1896–1900)*. Jena, 1903.

Joseph Maria Olbrich: *Ideen von Olbrich*, Vienna, 1900.

Richard Riemerschmid: 'Kulturpflichten unserer Zeit', *Deutsche Bauzeitung*, Berlin, 1925. 'Künstlerische Erziehungsfragen', I–II, *Flugschriften des Münchener Bundes*, Munich, No. 1, 1917, pp. 3–20, No. 5, 1919, pp. 3–13.

John Sedding: 'Design', *Arts and Crafts Essays*, London, 1893, pp. 405–13.

Paul Sérusier: *ABC de la peinture*, Paris, 1942.

Giuseppe Sommaruga: *L'Architectura di Giuseppe Sommaruga*, Milan, 1908.

Louis Henry Sullivan: *The Autobiography of an Idea*, New York, 1924. *Kindergarten Chats*, New York, 1947.

Louis Tiffany: *The Art Work of Louis Tiffany*, New York, 1914.

Charles Harrison Townsend: Notes and Cuttings, Victoria and Albert Museum, London. 'Originality in Architecture', *The Builder*, London, vol. LXXXII, 1902, pp. 133–4.

Henry van de Velde: *Zum Neuen Stil*, Ausgewählte Schriften von Hans Curjel, Munich, 1955.

Eugène Emmanuel Viollet-le-Duc: *Entretiens sur l'architecture*, vols. I–II, Paris, 1863–72.

Charles A. F. Voysey: 'Domestic Furniture', *The Journal of the Royal Institute of British Architects*, London, vol. I, 1894, pp. 415–18. *Individuality*, London, 1911. *Reason as a Basis of Art*, London, (no date).

Otto Wagner: *Moderne Architektur*, Vienna, 1895. 'Die Kunst der Gegenwart', *Ver Sacrum*, Vienna, vol. III, 1900, pp. 21–3.

Oscar Wilde: *Art and Decoration*, London, 1920.

Frank Lloyd Wright: *On Architecture. Selected Writings 1894–1940*, New York, 1941.

Acknowledgments

A great deal of research on the Art Nouveau period has been undertaken since the publication of my book *Sources of Art Nouveau* ten years ago. Detailed studies have brought to light fresh material, and a number of new and fruitful approaches have been attempted. Moreover, with the passage of time certain problems tend to be regarded in a new light even by the most convinced scholar. It is in the hope that I have been able to coordinate the mass of new material now available, and in the conviction that I have established useful contacts with the many scholars whose studies I have been allowed to draw on, that I have undertaken this task.

I should like to express my special gratitude to Mr Douglas Cooper for the care with which he read my typescript, and for the many useful suggestions he made. The responsibility for the opinions expressed in the book is of course entirely my own.

Acknowledgment is due to the following for the illustrations (the number refers to the page on which the illustration appears): Frontispiece A. Brenna, Oslo; 8 Trustees of Christ Church and Upton Chapel; 19 (top), 114, 116 Monica Hennig Schefold; 19 (bottom), 35, 40, 52, 67, 75, 76 (top), 80, 81, 82, 139, 163, 169, 170 Victoria and Albert Museum; 22, 23, 85, 128 Eric de Maré; 26 Gulbenkian Foundation; 39, 57, 89 British Museum; 52 M. Rigal, Paris; 64, 86, 144 (left and right), 149, 151 (top and bottom), 154 Musée des Arts Décoratifs; 68, 117 Jacques André, Nancy; 72, 201 William Morris Gallery, Walthamstow; 76 (bottom) Colchester and Essex Museum; 83 Royal Institute of British Architects; 90, 119 A. Zerkowitz, Barcelona; 91 Chicago Architectural Photo Co.; 95 Mark Peploe; 105, 122 Conzett and Huber, Zürich (photo Franco Cianetti); 106, 107, 113, 157 ACL, Brussels; 110 Photo Luty; 121, 123 Foto MAS, Barcelona; 127 Behram Kapadia; 135 Bildarchiv Foto, Marburg; 146, 148, 175 Det Danske Kunstindustrimuseum, Copenhagen; 161, 162 Nordenfjeldske Kunstindustrimuseum, Trondheim; 165 M. Wolfers, Brussels; 166 Bedford Lemere and Co., Croydon; 167 University of Glasgow Department of Fine Arts; 168 T. and R. Annan and Sons, Glasgow; 171 Harrods Ltd.; 174 Historisches Stadtmuseum, Munich (Foto Weila); 176, 177, 187 S. R. Gnamm, Munich; 179, 211 Rijksmuseum, Amsterdam; 186 Hessisches Landesmuseum, Darmstadt; 191, 193 Gemeentemuseum, The Hague; 196 Metropolitan Museum of Art, New York; 203 Bayerischen Staatsgemäldesammlungen, Munich; 207 Mora Lacombe Collection; 208, 227 Nasjonalgalleriet, Oslo (Foto O. Vaering); 210 Kröller-Müller Museum, Otterlo; 215 Kunsthaus, Zürich; 218 Galleria d'Arte Moderna, Venice (Foto Giacomelli); 223 Folkwang Museum, Essen; 225 Kunsthalle, Hamburg; 230 National Buildings Record.

Index